MIRIAM SCHAPIRO

SHAPING THE FRAGMENTS OF ART AND LIFE

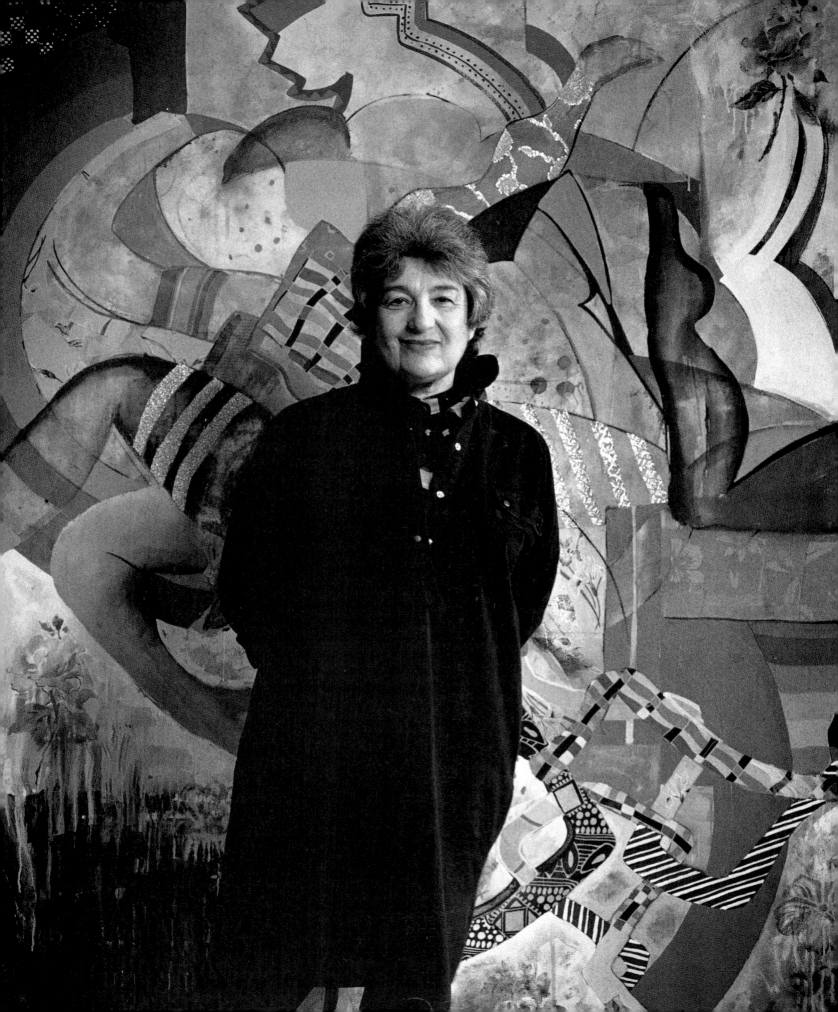

MIRIAM SCHAPIRO

SHAPING THE FRAGMENTS OF ART AND LIFE

THALIA GOUMA-PETERSON

FOREWORD BY LINDA NOCHLIN

Harry N. Abrams, Inc., Publishers, in association with the Polk Museum of Art

Exhibition Itinerary for *Miriam Schapiro: A Retrospective*

Polk Museum of Art
Lakeland, Florida
December 11, 1999–March 5, 2000

Miami University Art Museum
Oxford, Ohio
March 17, 2000–June 2, 2000

Lowe Art Museum, University of Miami
Miami, Florida
February 22, 2001–April 8, 2001

Lenders to the Exhibition

Aaron and Marion Borenstein, Fort Wayne, Indiana
Grey Fine Arts Gallery, New York University, New York
Steven Jacobson, New York, New York
Judith and Alvin Krauss, Roslyn Heights, New York
Miami University Art Museum, Oxford, Ohio
Catherine S. Muther, San Francisco, California
Orlando Museum of Art, Florida

Dr. and Mrs. Leon Oxman, Manhasset, New York
Santa Barbara Museum of Art, California
Miriam Schapiro, Wainscott, New York
Bernice and Harold Steinbaum, Westbury, New York
Carrie Steinbaum, Miami, Florida
Sarah Steinbaum, Miami, Florida
Steinbaum Krauss Gallery, New York, New York

PROJECT MANAGER: Margaret Rennolds Chace
EDITOR: Elisa Urbanelli
DESIGNER: Dana Sloan

Library of Congress Cataloging-in-Publication Data

Gouma-Peterson, Thalia.
 Miriam Schapiro : shaping the fragments of art and life / Thalia Gouma-
 Peterson ; foreword by Linda Nochlin.
 p. cm.
 Includes bibliographical references and index.
 ISBN 0–8109–4377–8 (Abrams: hardcover)/ISBN 0–8109–2565–6 (Mus: pbk.)
 1. Schapiro, Miriam, 1923– . 2. Artists—United States—Biography.
 3. Feminism in art. I. Schapiro, Miriam, 1923– . II. Title.
 N6537.S34G68 1999
 709'.2—dc21 99–18149

Printed and bound in Japan

Harry N. Abrams, Inc.
100 Fifth Avenue
New York, N.Y. 10011
www.abramsbooks.com

Unless otherwise noted, works are in the collection of the artist.

CONTENTS

ACKNOWLEDGMENTS

Thalia Gouma-Peterson

I began work on this book in 1990. In that year, at the end of the first of a planned series of four formal interviews, Miriam Schapiro casually said, "I thought you might like to look at my notebooks," and pointed to ten bulging shopping bags. Indeed I did, and I spent much of the following year in her Soho loft reading and taking notes on the more than one hundred spiral notebooks in those shopping bags, the earliest going back to 1952. Crammed with factual information and documentation, reflections upon art and the creative process, and comments on her emotional states, they were a treasure trove, out of which I came to trace continuous and changing patterns of development over forty years. They gave me new insights into Miriam Schapiro's life and work that I had not discovered during our twenty-year friendship, and deepened my understanding of her art. I am grateful to Miriam for entrusting me with those records of her most private moments. They inform the text of this book.

I first met Miriam Schapiro in 1977 at the College Art Association meetings in Los Angeles. She was participating in a panel on "The Decorative in Contemporary Painting" and discussed her new monumental work *Anatomy of a Kimono*. At the end of the discussion I went up to tell her how I had been struck that in both *Lady Gengi's Maze* and *Anatomy of a Kimono* she used subjects and motifs that one would normally associate with the sheltered and oppressed life of women in the Orient, and through her formal treatment gave them a new freedom and assertiveness, reversing the original connotations. She liked that idea, asked me who I was, told me that she belonged to a new collective that was starting a journal, *Heresies*, and invited me to write something for it. I told her that my major field was Byzantine art. She didn't give up and responded, "I understand that there were women doing some wonderful embroidery in the Middle Ages."

Since then it has been my pleasure to get to know Miriam as a friend. I have visited her frequently in New York City and East Hampton and have been able to see firsthand the development and changes in her work as it progressed from year to year. I still remember with awe when, in 1980, I walked into her studio and saw her new large house-shaped paintings *Dormer, New Harmony, Eye Dazzler,* and *Heartfelt* hanging together on one wall, glowing with vitality. In 1995, the same wall was occupied by her monumental fan *Mother Russia*, a tribute to the women artists of the Russian avant-garde of the 1920s. Including portraits of the women and representations of their work, the fan was both a culmination of Schapiro's abiding concerns and an indication of new directions. The complexity and variety of these and her other paintings and femmages have been a source of inspiration for the writing of this book. I thank her for sharing her work and her life with me.

This book and retrospective exhibition would not have been possible without the commitment and enthusiastic support of Bernice Steinbaum, Miriam Schapiro's dealer for the past fifteen years. Daniel E. Stetson, Executive Director of the Polk Museum of Art in Lakeland, Florida, I thank for organizing the exhibition. His contribution has been essential to the success of this project. I am equally grateful to Margaret Rennolds Chace, Vice President of Harry N. Abrams, for her continued support throughout this project. I thank Linda Nochlin for agreeing to reprint her groundbreaking 1973 article on Miriam Schapiro, and for generously contributing reflections on Miriam's recent work.

Carl A. Peterson, my husband, has lived with this book from its inception, patiently and critically read every one of the numerous drafts, and helped bring the text to its final shape. His love, unflinching support, and devotion enabled me to bring this project to completion during a very serious illness.

I thank Lisa Siegrist for her fine editorial work on my article on Miriam Schapiro, published in *American Art* in the spring of 1997. I especially thank Elisa Urbanelli, my thoughtful, perceptive, and gifted Abrams editor, for her excellent, sound advice, and Dana Sloan for her sensitive design. I also thank Joanne Isaac of the Steinbaum Krauss Gallery, who, as Schapiro's archivist, assembled transparencies and slides and provided detailed responses to my numerous requests for information and documentation.

I wish, finally, to thank The College of Wooster for a research leave in 1995–96, during which time a substantial part of this book was completed, and for a grant from the Henry Luce III Fund for Distinguished Scholarship, which has made it possible to illustrate this book on Miriam Schapiro's art so richly and abundantly, in color.

MIRIAM SCHAPIRO: LIFE WORK

Linda Nochlin

Twenty-five years ago, writing of Miriam Schapiro's recent work, I declared: "In . . . paintings and large-scale collages of great richness and complexity, Miriam Schapiro raises the issue of feminism and art: more specifically, of feminism in relation to abstract art." I went on to explore the importance of the medium of collage in this endeavor, for collage is a technique that calls the much-vaunted purity of High Art into question by its very nature, bringing the most banal elements from the real world into the fictive realm of representation. The implications of collage not merely as formal strategy but as meaningful content seemed central to Schapiro's project at the time. It appeared that the introduction of richly patterned fabric, lace or patchwork, into works of grand scale and major ambition held portents for the future of art.

Schapiro's career over the last quarter of a century has borne out this contention in a variety of ways. But through all the variegated projects that mark this era runs the thread of formal innovation vitally engaged with human—specifically feminist—meaning. Schapiro has invented an art that puts both ordinary women—represented by their handkerchiefs and mementoes, their patchwork quilts, shawls and fans—and famous women artists—from Cassatt to the powerful vanguard women of early twentieth-century Russia—into her picture frame, the latter in her aptly named "collaborations." Schapiro, in short, has made a place for women in her art, and made it in a way that is completely contemporary and splendidly seductive in its sensuous pictorial fabric.

The artist was, of course, well known as an innovative abstractionist before the advent of the feminist movement, the triumphant construction of *Womanhouse* with Judy Chicago and a bevy of women artists in Los Angeles in 1972, and the creation of the first *femmages*—her own term—in the same years. After this critical point, in the early seventies, she went on to produce her various "collaborations" with earlier women artists, appropriating Cassatt's tranquil image of her mother reading for a collage in which delicately patterned fabric and an aggressively decorative frame provide a new, more ambiguous, context of meaning for one of her important feminine art-ancestors. Very different, but equally invested in a new interpretation of collage technique, was her series of works based on Japanese inspiration, gigantic canvases like her *Anatomy of a Kimono* of 1976, a work in ten panels, in which the richness of the applied fabric articulates a majestic yet quirky harmony of pattern and color. In 1983, in *Wonderland*, one of her most important—and polyvalent—works of the period, Schapiro plays the retro delicacy of a cross-stitched domestic motto—a found object by an anonymous craftswoman—at the heart of the large-scale work against the anarchic richness of color and texture bursting out from this modest centering to crash against patterned restraining borders. Within these borders, the variegated colors and textures of the applied fabric play against rows of silhouetted coffee cups, collaged aprons joust with abstract patterns in a wild and wonderful *tour de force* of fantasmal domesticity.

In the late eighties and early nineties, Schapiro painted her respects to another woman artist, as different as possible from the anonymous cross-stitcher of *Wonderland*: the mythic Mexican Frida Kahlo. In works like *Conservatory (Portrait of Frida Kahlo)* of 1988 or *Frida and Me* of 1990, Schapiro plays down the much vaunted martyrdom of this

Mexican woman artist in favor of her pride and power: the image of this heroine is a regal, frontal one. Schapiro invests her subject, easily recognizable by her winglike eyebrows, with a seductive richness of exuberant, all-over patterning, in a pictorial context that includes objects derived from pre-Columbian and Mexican folk art. In this collaged myth, Kahlo is positioned as the triumphant guardian of an Edenic world of exuberant floral decoration.

Finally, it is important to consider one of Schapiro's more recent, and most effective, series: *Collaboration Series: Mother Russia* (1993–94). Here, the artist returns once more to the strategies of collage-based appropriation that have marked so much of her work. In turning to major women artists of the recent past, it is clear that Schapiro is establishing a genealogy, generating an identity by imbricating herself with history. This strategy is of great importance for women artists, who, unlike their male colleagues, have often felt themselves cut off from strong roots, from competition with the past, above all, exiled from that fruitful "anxiety of influence" (Harold Bloom's term) that has traditionally inspired male artists. And who could provide a more stimulating model for achievement than the heroic band of Russian women artists of the earlier twentieth century? And who, besides Miriam Schapiro, would think of deploying their portraits, and specimens of their work, in the arc of a giant fan? Here, in *Fan: Mother Russia*, we have photo-portraits of Sonia Delaunay, Udaltsova, Popova, Exter, Stepanova, Rozanova, Goncharova et al., around the exterior border of the fan, and examples of their work in the central portion. The inscriptions are Cyrillic, the colors—red, black, and white—that of the Revolution itself. The fan reminds us, no matter what the eventual fate of the revolutionary project, that for an incandescent utopian moment women artists worked as creative equals with their male colleagues in creating the art of the future. Think back to France of that period, where the major artists—Matisse and Picasso in the lead—were all assertively male, and women functioned as wives, mistresses, or models: muses at best but never makers of important art. Russia was different, and Schapiro's fan commemorates that decisive difference, reminding contemporary women artists that their predecessors played an important role in forging the tradition of the new. Which leads me back to my article of 1973, a time when Miriam Schapiro herself was playing a major role in destabilizing the canons of modernism and raising the issue of feminism and art.

Miriam Schapiro: Recent Work

(*Arts Magazine*/November 1973)

In her most recent works, paintings and large-scale collages of great richness and complexity, Miriam Schapiro raises the issue of feminism and art: more specifically, of feminism in relation to abstract art. At the same time, these works, in their impassioned yet controlled sensuous extremism, their deliberate juxtaposition or interweaving of seemingly contradictory pictorial strategies, constitute a daring way out of the reductive corner into which mainstream abstraction has painted itself in the last few years. Taken as a group, these works constitute a radical statement of Schapiro's identity as an artist working in the vanguard of contemporary abstraction and, at the same time, as a feminist struggling with other women to create a valid imagery of women's consciousness. In the collages, the artist's private delight at Bloomingdale's remnants counter, her sym-

pathy with the patient ad hocism of patchwork quilts, her responsiveness to the delicate patterns of Persian miniatures are set in fruitful tension with the bold brushwork of gestural painting and the rigorous formal articulation of illusionistic abstraction. Schapiro's collages serve to remind us that enrichment—the sanctioning of previously "unacceptable" realms of substance or experience to inclusion within the kingdom of High Art—has been a strategy of avant-garde innovation as significant as reduction and exclusion; and that collage has been a major vehicle of enrichment. At once a technique and a weapon, part self-revealed artifice, part self-confessed reality, collage has over and over again forced a testing of previously established strictures of form and content by confronting the supreme aesthetic value of the canvas with the aesthetic non-value of newspaper or oilcloth, ticket stubs and waste paper, rubber tires or, in this case, fabric scraps. Too often, the implications of collage material as a meaningful *content*, activated rather than suppressed by its new context, have been neglected. But as we shall see, the implications of the introduction of patterned fabric—patchwork—into works of imposing scale and major ambition are central to Schapiro's intention and achievement.

While these may be characterized as feminist works, there is nothing pastel or passive —i.e., stereotypically "feminine"—in the collages, in which Schapiro has placed the raw material of everyday domesticity—chintzes, checks, cretonnes—in the novel ambience of bold, often disturbing, abstract structure; frameworks at times stringently geometric, at others, explosive, in which the innocently displaced drygoods spring to unsettling new life.

In some of the smaller works and in the large *Lady Gengi's Maze*—and the very title is significant in its evocation of the oriental, the feminine, and the formally complex— there are references to the sophisticated exoticism of Persian miniatures, their proliferation of patterning contained within firm linear boundaries, the evocative mystery of their deep yet surface-oriented domestic spaces, of sensuous energy contained by formal convention. Yet at the same time, the very scale of *Lady Gengi's Maze* (72 × 80") immediately differentiates it from the miniature, as does the tension generated by the opposition between the rich, multifarious textures of the three hovering carpet or quilt-like forms and the austerity of the symmetrical linear or asymmetrical black and gray elements which suggest powerful yet equivocal spatial existence in front and in back of them. In addition, the three framed forms are differentiated among themselves, progressing from the brushy, overtly painterly surface of the left-hand square, two corners of which establish the spatial ambiguity of the composition by equating the *literal* boundary of the canvas at the upper left with the *figurative* limit established by the linear edge of the foreground enclosure, to the splendid patchwork exuberance of the central diamond shape, down to the more muted colors, smaller, less assertive patterns and more ragged shapeless swatches of the lowest "carpet." Brilliantly framed in gold, this form is pierced at its center by a jagged hold-shape, an evocative formal wound revealing the steps behind, which, at the same time, can be read as part of the surface of the sinking rectangle itself. The latter configuration with the central hold more forcefully asserted as a spatial penetration, a gap torn in the fragile tapestry of interwoven textiles surrounding it, serves as the motif of the related *Flying Carpet*.

Mysterious evocation, a sense of content created by powerful spatial effects in which bold foreshortening and perspective illusion is constantly contradicted by the equally powerful surface reinforcement of brilliant color has been a characteristic of Schapiro's style since the middle sixties. In *OX* of 1968, for instance, the literal power of the splayed word-image formed by the interpenetrating letters "O" and "X," heightened

by enormous scale and the vivid opposition of bright red-orange figures against a silver background is countered by the tender pink recessive planes of the inner lining of the central image. Here, the pathos and mystery of the hole, with its implications of hidden depths and organic vulnerability, are tellingly played against the cool authority of the contemporary central image grounded in the literalness of the surface.

The expressive and formal potentialities of this mode, which Barbara Rose characterized as Abstract Illusionism, reached their climax in Schapiro's series of paintings created in collaboration with the computer in 1970–71. To make these paintings, the artist fed the programmed drawing, a simple figure "rather like a new letter in an imaginary alphabet," into the computer, which could produce a theoretically limitless series of variations—or literally, of viewpoints—of the original drawing. Several of these "viewpoints," those most in accord with the artist's projected vision, would then be selected for transformation into large-scale work. At this stage, the artist's choice and feeling would dictate which portions of the computer-projected permutations of an individual image would be selected, which rejected, which portions strengthened by color, which merged with the background of the canvas, which elements treated as flat planes and which as recessive orthogonals. Works from this series like *Keyhole* or *The Palace at 3:00 A.M.* demonstrate the artist's uncanny ability to create anthropomorphic or architectural analogies by means of purely abstract relationships of form and color. In at least one of this series, *Iris (Homage to Georgia O'Keeffe)*, the reference both to organic forms and the Women's Movement is explicit.

In the fall of 1971, Judy Chicago joined Miriam Schapiro as a co-director of the Feminist Art Program at the California Institute of the Arts. The explicit aim of the Program was "to help women to restructure their personalities to be more consistent with their desires to be artists and to help them build their artmaking out of their experiences as women." This intention found its concrete expression in the communally created art project *Womanhouse*, an environment created for and by women in an abandoned house on Mariposa Street in Hollywood in 1971–72. In the context of the Feminist Art Program and *Womanhouse*, Schapiro worked in modes and on imaginative levels which, on the surface of it, would seem utterly different from those embodied in the large-scale, powerfully complex abstractions of her almost contemporary computer series. On first glance, it would seem that the little *Dollhouse* that Schapiro created for *Womanhouse* in collaboration with Sherry Brody, with its miniature scale, its profusion of rich, decorative materials, the literalness of its cozy spaces, and the concreteness of its references to woman as maker of the home, might constitute a rejection of abstraction as alien to the woman artist's deepest needs and desires. But not at all: on closer inspection *Dollhouse* reveals a range of complexity and contradiction far beyond the reach of little girl's toys or stereotyped notions of women's place. Each lovingly furnished room is disturbed by some impending menace: a rattlesnake is curled up on the parlor floor, a grizzly bear stares through the nursery window at the tiny monster in the crib; mysterious men lurk outside the kitchen window. Above all, this dollhouse is specified as the home of a woman *artist*, complete with doll-sized studio and a male nude model, accompanied by a postage-stamp-sized replica of one of Schapiro's large-scale abstractions. Far from constituting a rejection of her identity as an artist, more specifically as an abstract artist, *Dollhouse* is a conscious and artful articulation of the rich imaginative substratum from which art-making, specifically, woman's art-making, and even more specifically, Miriam Schapiro's art-making, can arise.

It is within this context of consciously feminist art activities that the insistent intro-duction of patchwork into Schapiro's collages assumes its full significance. The patch-work quilt has recently become a burning issue in certain feminist art circles. On the one hand, the existence of these brilliant stitched creations seems to offer proof of women's ability to create a valid art form apart from the male-dominated institutions of High Art: indeed, one spokeswoman for the quilt makers, Pat Mainardi, in a provocative article in the *Feminist Art Journal*, asserts that women quilt makers anticipated recent developments in abstract art by more than a century. On the other hand, quilts may be viewed more as tokens of women's traditional ability to triumph over adversity, to make the best of things in the face of continual oppression. Denied the means of access to his-torical significance and major stylistic innovation in the art of the past, women fulfilled their aesthetic potentialities within the restricted, safely ahistorical areas of the decora-tive and the useful.

Schapiro shapes the multiple implications of patchwork to a variety of formal and expressive ends. In *Mimi's Flying Patches*, one is overwhelmed by the sheer exuber-ance of the scraps of fabric as they burst forth from the implicit "art" boundaries of the silver interior frame, at times smothering it with a welter of burgeoning pattern, at times playfully draping themselves over its edge to form the artist's nickname. In one of the larger works, *Window on Montana*, the mood is more somber, weightier. A certain sense of depth, both physical and psychic, is created by the contrast of the window-shaped configuration of lighter, more delicate and flowery fabrics in the center and the darker, more ominously paint-streaked patches at the peripheries of the work. A mood of nostalgia is evoked too, but the deliberate dimming of the brightness of colors in some areas, reminding us that the passage of time has its effects on calico and chintz, that patchwork is, after all, like art, a part of history. In *Euridice*, larger shapes of fabric both define and in turn are defined by the suggestively expressive brushwork of the rose-colored central veil—a reference to Schapiro's own artistic past, perhaps, as well as to the revival of fifties pictorial values in the present—with its overtones of the lightness of air, the warmth of fire. And perhaps nowhere are the claims and counterclaims of hard-edge, expressive brushstroke and patchwork made more explicit than in the aptly titled *Explode*, where the angular fragments of brilliantly patterned textile literally burst out upon us from the light-colored, red-framed "picture space" in an aggressive assault upon the actual space of the world, a kind of patchwork liberation.

Not all women artists are feminists; not all feminist artists wish to incorporate their feminist identity into their art works, and, certainly, even if some of them do, none will do it in the same way. Miriam Schapiro's collages are unique and deeply personal statements: they are by no means programmatic or didactic in their intentions or their effects. They do, however, in their splendor and novelty, suggest one of the many possi-ble modes of interaction between feminism and art, in which the woman artist's con-sciousness of her identity can function with the same force and validity as did the Abstract Expressionists' awareness of their identity as Americans in the forties and fifties. The impact of the Women's Movement has already made itself felt in the art world in a variety of significant ways. It is predictable that in the seventies, women, freed from the demands of traditionally feminine roles and the compulsion to react against them by adopting equally stereotyped masculine stances, or perhaps by operating in an area of creative tension generated by the very consciousness of opposing options, will play an increasingly dominant role in the shaping of art.

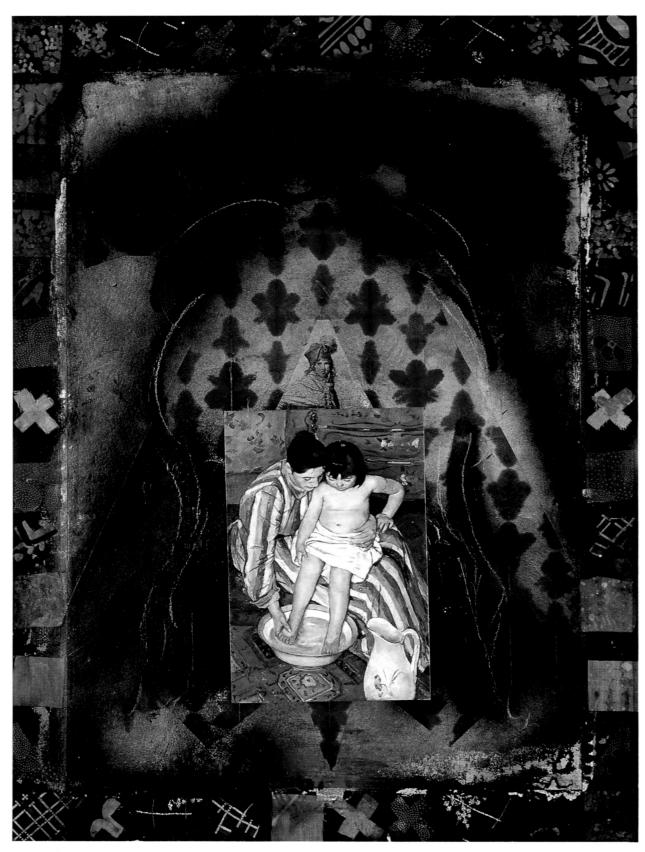

Collaboration Series: Mary Cassatt and Me. *1976. Spray paint, paper, and fabric on paper, 30 × 22"*

INTRODUCTION

If I repeat the shape of my being enough times will that shape be seen?
—Miriam Schapiro, 1970[1]

My art is an art of becoming.
—Miriam Schapiro, 1996

During a career that continues to possess an ever-changing vitality after more than forty-five years, Miriam Schapiro has repeatedly posed a question central to feminist debate since the early 1970s: how can a woman artist negotiate her position as an artist and a woman in twentieth-century American culture? Schapiro's answers have evolved slowly and sometimes painfully in a body of work that both reflects and structures her life. Her gestural paintings of the fifties, her symbolic and self-exploratory *Shrines* of the early sixties, her geometric abstractions of the mid- and late sixties, her decorative fabric collages of the seventies, and the autobiographical figural compositions of the eighties and nineties—all have been for her a source of "beauty, hope, and joy" and have enabled her to make her life meaningful.[2] But these same paintings have also dealt both obliquely and overtly with what she has identified as the most profound conflict in her life—the struggle to become and be recognized as an artist. Schapiro described her feelings in 1991: "I am always in such conflict about my nurturance and my selfishness, about being alone, that a tension has developed inside me which I believe is characteristic of my status in a society that really doesn't recognize the actuality of the cultural entity— WOMAN ARTIST."

Aware of the separateness of male and female spheres from an early age, Schapiro reminisced in 1977:

I was raised in a patriarchal home—as we all were. I watched both my parents work their whole lives. . . . I early identified with my father, an artist. Although today I admire my mother for striving to exceed her limitations, as a child I was acutely conscious of them. My mother's view of the world was not a "world" view; she lived "inside," at home, and in fact felt considerable anxiety about venturing outside. My father shared his art with me and taught me to love all art. My mother was a dreamer and con-

stant reader. I chose to see her dreaming and her reading, her having a "world of her own," as a validation of my own inner life. My mother was also a splendid housekeeper. About her domestic gifts I was and am ambivalent. When I talk of work, I mean "outside" work. . . . Somehow my conditioning rigidly reinforced a perverse sense of the world as being a place where only a man could work.[3]

The sentiments expressed in this passage bring to mind Simone de Beauvoir, who also believed that only by "leaving behind the unredeemed and unredeemable domestic sphere of contingency for the public sphere of economic activity" could women achieve "transcendence."[4] Schapiro's desire to be an artist was an integral part of her wish to enter the public sphere; and the theme of the struggle of the woman artist—whom she frequently cast as a dancer or actress—to face the public became a leitmotif in her art, starting with her paintings of the early fifties.

In examining the contradictions of her life through art, Schapiro has recognized the canvas as a site for critical exploration and has claimed through it the authority to give shape to her being. In 1975, at the height of the feminist movement, she commented on her lack of historical connections to women artists and on her ambivalence about her identity as a woman artist. She recalled how, as a young woman in the fifties, she retreated to the library for inspiration and read up on the lives of famous artists, but was not able to "find a woman artist of the stature of Velasquez or Vermeer." This left her with a confusing message, a feeling she was "in a woman's body with a man's concerns. Perhaps something was wrong."[5] It resulted in her developing "a monster image" of herself as someone who was neither clearly female nor male. This ambiguous and fractured image, which she has carried with her for five decades and which regularly surfaces as a theme in her art, can in hindsight be seen as her response to the opposing constructions of gender.

Her gestural paintings of the fifties based on photographs of old-master works, movie stars, and movie stills gave way in 1958 to more fully internalized compositions, with clearly articulated formal structures revealing fragments of her inner life and personal desires. With their self-allusive titles, such as *Autobiography* and *Mother and Child*, and the personal symbolism that informs them, these paintings point to the increasingly autobiographical direction that Schapiro's art would take in the next decades. In moving toward autobiography, she was entering an unmapped terrain for, as Shoshana Felman suggested in 1993, *"none of us, as women, has yet, precisely, an autobiography."* The only way to achieve a story, Felman argued, is "through the bond of reading, that is *the story of the Other* (the story read by other women, the story of other women, the story of women told by others)."[6] Painfully aware of the absence of women from the histories of cultures, Schapiro began to look further into herself, becoming increasingly more conscious of her otherness, her loneliness, her isolation, and her feelings of guilt. It was only in the seventies, when she was able to bond with other women, past and present,

and read, see, touch, and feel their stories, that she began to gain access to her own story. But even then she asked in her journal (1970), "If I repeat the shape of my being enough times will that shape be seen?" That is, she continued to doubt whether the shape she gave to her being/her story would be recognized by the dominant patriarchal culture. Throughout her work she has marshaled the stories of other women, reading the stories both told about them and by them and giving shape to their missing autobiographies while trying to access her own. This complex endeavor is at the center of Schapiro's art and started in the early seventies with her commitment to the women's movement.

At various points in her life, especially in the seventies and early eighties, Schapiro had hoped that she might be able to make the antithetical roles of artist and homemaker "seamless" and resolve "the painful and contradictory pulls in opposing directions," which she had felt intently in the fifties and six-ties.[7] In 1971 she founded, with Judy Chicago, the Feminist Art Program at the California Institute of the Arts and created, with Chicago and twenty-one women students, *Womanhouse* (1971–72). This collaborative installation piece profoundly affected Schapiro's life. It helped her to resolve, temporarily, her ambivalence about her femininity and made possible her artistic reentry into the home and into women's experience as a source for art. The Feminist Art Program and the friendships formed through it also provided Schapiro with her first female audience, who related to her work and understood it in ways it never had been before.[8] After *Womanhouse*, she knew for whom she was making her art: it was for the women whom she met in the course of teaching and lecturing and who were, for her, as real as her aunt Bessie, her grand-mother, and her mother. Her art became a celebration of that new awareness.

In 1972 Schapiro began to create her layered *femmages* (a term she invented), combining acrylic paint and pieces of fabric into a new kind of col-lage with a specific meaning for and about women.[9] The iconic images in these femmages—such as the cabinet, the apron, the kimono, the vesture, the heart, the house, and the fan—are both a celebration of women's creative endeavors within the confines of the house and symbols for their absence from histories. The *Anatomy of a Kimono* (1976), Schapiro's largest and most ambitious femmage, her "fifty-foot symphony in color," is an expression of that hopeful and optimistic decade.[10] The kimono was a robe for the new woman: its anatomy was analogous to the structure of quilts, and thus symbolized woman's creative work within the culturally imposed confines of the house. The piece became for her a means to link her formal concerns with her preoc-cupation with fabric in the seventies. In hindsight, however, even the work of this most optimistic period is part of a process of becoming, a quest for an identity, which, within the present cultural context, can only be partial and gendered. As Schapiro explained, she "wanted to explore and express a part of [her] life which [she] had always dismissed—[her] homemaking, [her] nesting."[11]

The pulls in opposing directions, the divide between inner and outer lives, continued to be present in Schapiro's life. The celebratory tone of her paintings of the seventies, which affirmed women's creativity, changed during

the conservative and regressive eighties. She reintroduced the human figure, absent from her work since the late fifties, and in the mid-eighties created a large autobiographical trilogy (1983–85), in which she presented a daughter's relationship to the maternal and paternal prototypes using dance and the proscenium stage as a setting. In *I'm Dancin' as Fast as I Can*, *Master of Ceremonies*, and *Moving Away*, Schapiro gives various shapes to the male and female aspects of her persona. By using the theater and dance, she also places the formation of gender within the context of performance and masquerade.[12] In *I'm Dancin' as Fast as I Can*, the central figure is tied to her mother by the umbilical cord, while the father walks off the stage. In spite of her intense desire, as expressed by her posture and movement, to follow the father into the public sphere of culture, the central female dancer remains tied to the mother, the elegant ballerina with a bouquet of flowers for a head. Simultaneously, the daughter also represents the cultural definition of femininity. In high heels and diaphanous stockings, she is already shaped "as the-other-from-man . . . site of sexuality and masculine desire."[13] These dancing figures enact visually Judith Butler's claim that gender is performative; it is an "identity tenuously constituted in time, instituted in an exterior space through a stylized repetition of acts."[14]

Throughout her oeuvre Schapiro has presented gendered identity as "tenuously constituted in time" by placing gendered figures within the context of movie stills, the theater, and dance and by frequently using masquerade and disguise. The image of dance, however, has a positive meaning for Schapiro. A metaphor for the creative act, it has meant the ability to "move through life effortlessly with elegance," thus creating memories of successful movements or moments. It is her hope that through creativity (the dance) and art (the bouquet of flowers) the woman artist might be able to claim "the shape of her being."

As much a stimulus for Schapiro's creative energies as the theme of dance has been the concept of "collaboration" with women artists, in which she expresses her search for artistic identity and ancestry and, therefore, a history. Very significant in the development of this theme were the groundbreaking exhibitions "Old Mistresses" at the Walters Art Gallery (1972) and "Women Artists 1550–1950" at the Los Angeles County Museum of Art (1976).[15] Of the Walters show, Schapiro recently said: "It meant everything to me to see women's art of the past honored at such an imposing museum. It created a goal—a vision for me—to be part of such a fantastic, yet unknown, tradition." The opening of the Los Angeles show, she recalled, was one of the greatest moments of her life "because we were codifying our own history."[16] Out of these experiences came Schapiro's first "Collaboration Series" with women artists of the past, her visual construction of "female genealogies."[17]

Schapiro created her earliest collaborations of the mid-seventies (e.g., *Collaboration Series: Mary Cassatt and Me*) with a sense of urgency to record her female artistic ancestors whose work had been completely absent from art history books. Small works on paper (primarily twenty by thirty inches), these pieces focused on the reproduction of paintings by Cassatt framed by a profu-

sion of decorative fabric borders, often arranged in quiltlike patterns. They were followed by "collaborations" with other artists and with the anonymous women who had created the aprons, handkerchiefs, quilt blocks, and needlework that Schapiro incorporated in her femmages of the late seventies and early eighties. Among her most complex "collaborations" is her 1988–93 "Collaboration Series: Frida Kahlo and Me." These paintings, in their symbolic and self-referential meanings, provide Schapiro's most introspective meditations in her search for personal and artistic identity. They were a means to pay homage to Kahlo (e.g., *Time, Conservatory, Agony in the Garden*), with whom Schapiro feels strong bonds as a woman and an artist who, in spite of painful obstacles in her life, spoke in a personally authentic voice. They raise several contemporary feminist critical issues such as a woman's loss of connection with her body and her severance from nature in order to become part of culture, her continuing wish to merge with the maternal body, and the sacrifice of aspects of her inner self in order to enter the intellectual world dominated by men and be recognized as an artist.

Many of these issues Schapiro further pursued in her most recent (1993–94) and most extensive collaboration, "Collaboration Series: Mother Russia," in which she identifies with the Modernist Russian women artists of the 1920s, including Sonia Delaunay, Natalia Goncharova, Liubov Popova, and Varvara Stepanova.[18] Her interest in these women was motivated by her own Russian ancestry (both sets of grandparents emigrated from Russia) and general parallels she saw between the revolutionary movement of which the Russian women were part and the feminist movement of the seventies. Equally significant was the importance these women gave to fabric in their work as part of an original and empowering formal vocabulary, validating Schapiro's own choices. Fabric has enabled Schapiro to create a language with which she can name her lived experiences and establish connections with the lives of women by reading, feeling, and touching their stories.

The "collaborations" are Schapiro's access to other women, her means to piece together their missing autobiographies and to insert their presence into the narratives of culture. They are her way of creating maternal genealogies as avenues to an individual self. In this manner her art parallels the position of those feminist critics who have argued for the potential access to an individual self and have proposed a space available to women in the psychoanalytic, symbolic, and historical contexts. A common project has been the retrieval of female genealogies and of aspects of the female body through a maternal prototype and the positing of maternal dimension in the symbolic order.[19] Luce Irigaray and other French feminist psychoanalytic theorists, such as Hélène Cixous and Julia Kristeva, have taken the lead in this search for a theoretical framework and have explored the influence of the mother's body on the pre-Oedipal child, an influence that continues even after the child enters the patriarchal order.[20] In this process they have sought alternatives to Lacan's identification of the phallus as a symbol with absolute power that does not belong to either men or women but is accessible to men only, and his claim

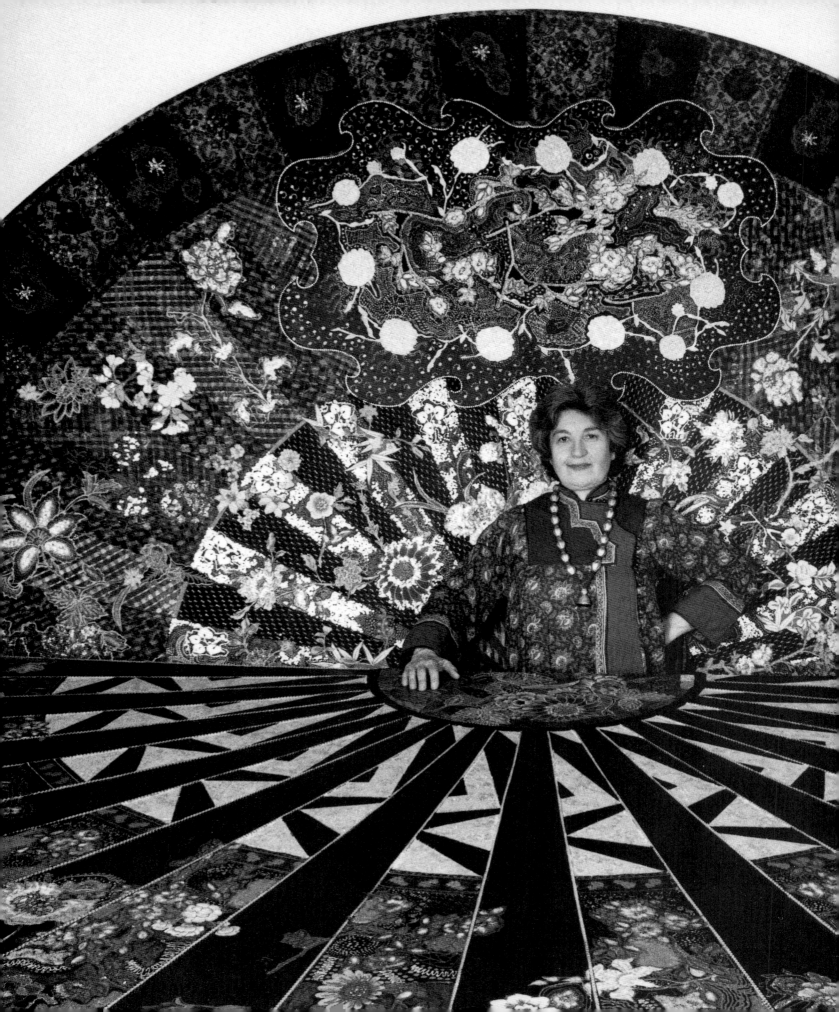

LIFE IN AND OUT OF THE STUDIO: A DIALOGUE WITH MIRIAM SCHAPIRO

What is a woman doing in the studio when everyone knows she should be in the kitchen?

Space, then, for the woman artist will reflect where she is at—in her life, in her dreams.
 —Miriam Schapiro, 1975

Miriam Schapiro's relationship to her studio and her home, the spaces in which she has lived and worked for more than forty-five years, has played a crucial role in her life. The separation and coexistence of these spaces, which changed as she moved from the Midwest, where she attended college, to New York (1952), to California (1967), and then back to New York (1975), express the intersections of her conflicting roles as artist and "homemaker." The studio became Schapiro's room of her own and, at moments of great personal conflict, the only connection with her creative self. It was a place away from the kitchen: "daily routine relieved with beauty." She held on to this space and made time to occupy it even though she, like other women artists, spent as much time away from her studio as she spent in it. In consistently creating a room of her own Schapiro enabled herself to continue being an artist. Her various studios, over the years, have reflected the changes in both the outer (social) and the inner (emotional and psychological) realities of her life. They also have become metaphors for her creative endeavor, and they have expressed her changing self-conceptions in accordance with or in antithesis to the social constructions of gender.

Schapiro was born in Toronto, Canada, where her mother, Fannie Cohen, had returned to be with her family at the birth of her child. Schapiro's father, Theodore Schapiro, an artist and an intellectual, was at the time in New York City studying at the National Academy of Design, the Cooper Union, and the Beaux-Arts Institute of Design. He later earned his living as an industrial designer and became Schapiro's mentor and role model, guiding her extracurricular studies of art while she attended Erasmus Hall High School in Brooklyn from 1937 to 1941. Her mother stayed home to care for her daughter, though during the Depression she worked in a department store. The young Schapiro was exceedingly conscious of her mother's circumscribed life and felt very ambivalent about her role as a housekeeper. Though she admired

her mother's striving to exceed these limitations, especially through reading avidly, Schapiro did consider her mother's view of the world not to be "a world view." Early on she developed "a perverse sense of the world as being a place where only a man could work."[1]

Aunt Bessie, Grandma, and Mama—those three women, plus Aunt Mollie, were my role models. They were not doers but dreamers. I'll call them beautiful Dreamers. My mother sang me a song when I was a child. Later, when I gave birth, it came back to haunt my days: "I have never been aboard a steamer, I have been content to be a dreamer." Sad what it is costing me not to just be a dreamer. [1974][2]

As a teenager, Schapiro attended Saturday classes at the Museum of Modern Art taught by Victor d'Amico, her first modernist teacher, and in the evenings she joined WPA classes for adults to study drawing from the nude model. In 1943 she entered Hunter College in New York City, but transferred to the University of Iowa at the end of that year. There she finally was on her own, away from her father's artistic influence, which had primarily consisted of a thorough grounding in the old masters.[3] At Iowa, Schapiro studied painting with Stuart Edie and James Lechay, art history with Lester Longman and Mary Holmes, and printmaking with the Argentine printmaker Mauricio Lasansky, whose first assistant she became. She exhibited paintings and prints and helped form the Iowa Print Group. At Iowa she also met fellow student Paul Brach, whom she married in 1946.

At Iowa I met two new men. One was my teacher, Mauricio Lasansky; the other, a fellow student, was to become my husband—Paul Brach. Both these men had enormous influence on my thinking—not necessarily on my art. My teacher was from Argentina and he brought the exotic flavor of hot-house art information from another country. I had never been close to any other than an American before. He reinforced my own energy and gave me his wisdom on space—which was a burning issue in those days. Paul taught me about the world in realistic terms. My parents were quiet, cloistered people, and I was unsophisticated when I met Paul. I knew a lot about the history of art but very little about anything else. Paul was gregarious and pulled me out of my shyness and we discussed all matters of the mind.

After Iowa, we went to Columbia, Missouri (1950), where Paul had a job teaching art at the University of Missouri and I worked for a rabbi. We had the first loft in that town and felt good about our chosen lifestyle— although everyone in the community thought we were nuts. Soon after this experience, we came to New York City. [1975]

In 1951 Schapiro and Brach moved to New York , living at 51 West 10th Street in a studio building with many artist-neighbors, among them Joan Mitchell and Philip Guston. While Brach taught at the New School for Social

Page 20:
Schapiro with two of her large fan paintings: in back, Black Bolero *(1980), and in front,* Azerbaijani Fan *(1980)*

Schapiro with Paul Brach in her attic studio in their house in East Hampton, New York, 1974

Research and served as a reviewer for *Arts*, Schapiro taught art to children, sold books at Brentano's, and performed secretarial duties in a real-estate office. The different job opportunities were symptomatic of the different public perceptions of male and female artists. In the beginning Schapiro and Brach lived and worked in the famous 10th Street studio building and shared a studio on 14th Street. In 1959, after Schapiro joined the newly established André Emmerich Gallery, they moved to a large seven-room apartment at 235 West 76th Street, where they each claimed one room in their home as a studio. Schapiro took over the dining room, through which one had to pass to reach the living room. Schapiro's choice of such a central space unnerved one male guest—a distinguished art historian —who confessed to his friend Brach: "It is embarrassing to walk through your wife's studio." Such a statement can only be understood in the context of the exclusively male New York art world of the fifties, in which women existed only as peripheral appendages, even if they belonged to a gallery and had their own studio. Brach's guest was thus embarrassed to acknowledge a woman's professional presence on his way to a more public social space.

The stripped-down dining room Schapiro used in 1959, containing her working table, pots of paint, brushes, stretchers, and paintings in various stages of completion, revealed a professionalism at a time when women artists were considered "hobbyists." Her studio belied such conceptions and questioned the gendered construction of women that was accepted as axiomatic at the time. In fact, Schapiro's studio conformed to the rules of what an artist's working space should be, laid down in the 1950s by tough-minded Abstract Expressionists at the Cedar Bar and the Club. For these men, as she has said, "the studio was the naked-lightbulb interior, a space that stood for poverty, dedication, and style."[4] It was a male concept that asserted the absence of woman from the creative order and of everything culturally attributed to her or associated with her.[5]

> *New York in the early fifties for artists revolved around the Club and the Cedar Bar. The Club was an outgrowth of a school that had been begun by Motherwell, Gottlieb, and Rothko—intermittently. Artists paid dues and met on 8th Street in a loft rented for that purpose. Every Friday the artists met and had a symposium or panel or a debate. The favorite topic was "Has the situation changed?" Harold Rosenberg, Philip Pavia, De Kooning, and Milton Resnick might be the panelists. What the question meant was "Is the avant-garde making any headway in the world."*
>
> *The Club afforded visibility, and Paul, who was extremely articulate, was soon identified as one of the new bright young men on the scene. I was shy and had no experience for speaking up. I also was concerned about people liking me and was afraid to speak up. I paid a great price for waiting and not acting. The other place to find artists was the Cedar Bar. In fact there was a style that artists adopted; they called it "hanging out." Sometimes I wondered when Kline painted. He would rise at 3:00 p.m., go to the Bar at 8:00 p.m., and leave at 2:00 or 3:00 a.m.*

*New York City was the most exciting place on earth for a painter to be.
. . . An exciting world ruled over by the patriarchal clan. In order to com-
pete with the clan at all, one had to have the serious trappings of art. A
high priority was placed on the size of one's studio. An even higher one
was the price one paid for it. That is to say—the cheaper the better. . . . The
studio had to have a "look." Milton Resnick had a rather superb model of
what was the going thing in real artist's studios. He was known as the
exponent of the naked-lightbulb school of Abstract Expressionism. Of
course, being an expert on plumbing and electricity and the raising of
walls he simply set the tone for it. I can remember him holding forth many
a night in the Cedar Bar on the subject of loft fixing. He and his cronies
had a lot to say. I, of course, felt extremely uncomfortable in these conver-
sations for two reasons: the underlying machismo that drove men on was
not my cup of tea; also, not being a sculptor, I didn't really enjoy wielding
hammers and tools and was deficient of the pride necessary to the
achievement of the perfect, pure, and naked loft. Joan Mitchell, on the
other hand, was quite a mensch in these affairs. She could raise walls
with the best of them. . . . She was one of the most respected painters in
New York City at the time. I have often thought that the price she paid for
her prestigious position cost more than the value received. . . . Many
women shared studios with their artist-husbands. I did. It wasn't until the
60s that I could afford a studio, alone. The stigma attached to sharing a
studio was mighty. One's outer-directed feelings caused great trauma if
the feedback was not right, on the subject of how you lived and how little
money you spent and how much time you spent at the Cedar Bar. . . . I can
remember many artists who wouldn't even walk into the Cedar Bar
because they felt they were being rated on a scale from one to ten as to
ability, lifestyle, success etc. [1975]*

In claiming as her own a central room in her house, Schapiro had both
asserted her centrality within the home, the space culturally assigned to women,
and incorporated within this traditionally feminine space the masculine-gendered
role of artist. Her relationship to these contradictory roles during her professional
life has been and continues to be complex. It has been related to the antitheti-
cal perceptions of herself as artist, wife, daughter, and mother and the contra-
dictions between the traditional and gendered constructs of woman and artist.
Having to share her life with family members for whom she felt responsible
pulled her away from what she has described as "the utter selfishness of being
an artist." Yet she preferred not to have a studio outside the house because, as
she commented recently, that would have denied her role in the family. For
example, in the barn that she and Brach acquired in East Hampton in 1955, she
transformed half of the attic into a makeshift studio (the other half was used by
Brach) in which she worked during the summers until 1979; and in the summer
house she rented in Provincetown, in 1962, her working and living spaces
again overlapped. Throughout her life Schapiro has wanted to make the anti-

thetical roles of homemaker and artist "seamless." But the transition between opposing gendered constructs is both painful and difficult. The crossing back and forth through their boundaries is fraught with tension and contradiction.[6]

Women had a problem in the forties and fifties, which is a historical and ongoing problem. When a woman emerged on the scene she was with a man, because it was not easy to arrive in the middle of an already-going establishment without the protection of a man. She was rated on her looks; if she was young and pretty, it was automatically assumed that she was sleeping with the artist she came with. Then he was rated as to his ability to pick 'em and con 'em. If she happened to be a young artist who came in from the West or Midwest and who wanted genuinely to make contact with artists working in New York or to be part of the talk and action of the art scene (a perfectly natural ambition) . . . the rules of the clan demanded paying [her] dues. What did it take? If you were a girl you had to hang around with a man. You could set foot into the Cedar Bar alone but you were their target for sexual advances. Under no circumstances were you to consider yourself a human being who arrived there for the same purpose that men did, namely to establish human relations. [1976]

The socially created and internalized conflict between needs imposed by family and the desire to be an artist came to a head for Schapiro in 1958–59, four years after her son's birth. When she was able to be by herself in her studio "those few hours a day," she found herself with a "work problem."[7] The pressures caused by the fragmentation and division of her private, social, and professional selves and her doubts about her "condition as a woman," as she has said, became so severe that she literally reached a point of "not knowing how to make a painting." She had lost "the ability to work." During the next year she gradually developed a ritual that allowed her to work again.

Miriam Schapiro and her son, Peter, in her summer studio in Provincetown, Massachusetts, 1962

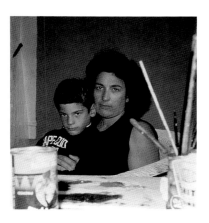

I talked to myself as if I were reborn, totally new on this earth. "You have to have turpentine. You have to have your paints laid out. You dip the brush in the turpentine. You mix the color you want. You start to draw." I repeated this litany, followed my own instructions. I began to work again.[8]

The studio empowered her. It gave her the possibility to regain her artistic creativity. To accomplish this, however, it became necessary to move her working space away from her home. She had to separate her artist self from the societal roles ascribed to women and from the daily realities of women's lives.

Before I gave birth to Peter, I was a dreamer . . . aspiring to a good life (pregnant with possibility). After birth postpartum depression set in and I was again reminded of my concrete self—this time wounded (as an animal gets wounded). I retreated to take care of myself, feeling sorry for my trauma and the trauma of the screaming child feeling hunger for the first time. What

has this got to do with painting? What indeed? I ask you the question.
Finally an image; the aerialist—a beautiful trapeze artist. Our lady of
the high wire—her parasol held steady—steady—one foot before the
other—poised, delicate, confident and high, high above the earth.
Supplicants below holding their breath in wonder—HOMAGE. [1975]

Miriam Schapiro's successive studios, after this period of crisis, became both
environments for and reflections of the changes in her life and art. Until 1976, these
studios remained separate from her home. In 1967 Schapiro and Brach moved
to California, where Brach became the first chairman of the art department at
the University of California, San Diego. Schapiro taught in the department as a
lecturer and later as an acting assistant professor, and painted in a studio on
campus. Responding to the scientific ambience of La Jolla, Schapiro created,
in collaboration with physicist David Nalibof and art student Jack Nance, a series
of computer drawings and paintings. Nalibof created a perspective program
for a "memory fact data computer" and fed Schapiro's drawings into it. With
this work Schapiro explored in an independent way three-dimensional space,
at a time when space as represented on canvas was a crucial formalist issue.
These large geometric paintings, in tune with the general trends of American
art during the sixties, suggest that Schapiro was creating a place for herself in
the male-dominated milieu of the California and New York art worlds. It was
during this period that Schapiro created one of her most important paintings of
the sixties, *OX*, a covert representation of woman, her body, and her aspirations.[9]

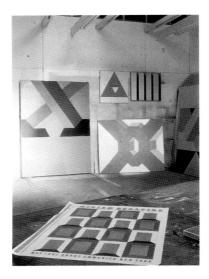

Schapiro's studio at the University
of California, San Diego, 1968–69

It seems now as if it were meant to happen—our coming to California. . . .
The studios came with the job, that was the deal! Nice for me, with no
sweat I have the best room to work in of my life. I like painting here. There
is nothing else to do . . . the phone never rings. . . . I'm in my new studio—
I'm trying to get to work. I have a student assistant. That will help begin.
Move paintings around—put desk in a different place. Stretch some canvas.
Get an idea? [1967]

1970 begins a new era. Technical change in working. 1. Changed enlarge-
ment of scale from hand work, i.e., mentally computing changes or mak-
ing blowups, to opaque projector. 2. Hiring full-time assistant. 3. Most work
sprayed. 4. Most work taped. 5. Shift to mylar series, taping lines and then
spraying with lacquer as opposed to acrylic. Finally: link up with David
Nalibof, computer expert at General Dynamics in La Jolla. . . . My concep-
tion: small cipher drawing, a letter from alphabet, Jack Nance structures;
drawing from computer, giving all paints on the drawing a name (number).
Computer is programmed by David Nalibof for a perspective program
which shoots all my ciphers into a wild 3-D. Drawings are produced by
computer. Drawings are projected onto canvas by opaque projector. Light
is held on canvas and traced in pencil. The pencil drawing is taped with
thin tape; then acrylic spray covers the canvas—tapes are removed. [1970]

The West Coast is a very busy place, these days. The Feminist Art Program at Cal Arts, under the direction of Miriam Schapiro and Judy Chicago, has begun work on the creation of a female environment in downtown L.A. Women have invested their creativity in rewarding their families with supportive environments for husbands and children. In Womanhouse *women will turn this creativity toward themselves allowing their fantasies to take over all rooms. No longer confined to enacting practical family needs. "House" will become the repository of female fantasy and womanly dreams. [1971]*

In 1970 Brach became dean of the new California Institute of the Arts in Valencia, and Schapiro became a member of the faculty. That same year she met Judy Chicago and visited her class for women artists at Fresno State College. Together, Schapiro and Chicago sought out women artists in Southern California and found them working not in studios but in dining rooms, kitchens, or any space they could claim as their own for a few hours a day. This revealing and inspirational experience prompted Schapiro to invite Chicago to team-teach a class for women artists at the California Institute of the Arts.[10] There, Schapiro, Chicago, and a group of twenty-one students created, in 1971, *Womanhouse*, a major feminist political statement and the *Gesamtkunstwerk* of the women's movement in California. Surprisingly, however, within this house about and by women, conceived and reconstructed by women artists, the artist's studio was conspicuously absent.[11] Whether intentional or not, this paradox reflected the realities of the lives of most contemporary American women artists at the time.

Significantly, Miriam Schapiro and Sherry Brody did introduce an artist's studio into *Womanhouse* as part of a small separate piece, the *Dollhouse* set into the wall of one of the rooms, known as the "Dollhouse Room." This six-room playhouse, constructed with wine-bottle crates and furnished with remnants from Schapiro's and Brody's personal treasure troves, combines reality with a world of female fantasy. It includes rooms such as the "Star's Bedroom," the "Nursery," and the "Seraglio," and also the "Artist's Studio." In the studio, on an easel, is a miniature replica of one of a series of paintings Schapiro did in the mid-sixties, entitled "Sixteen Windows,"[12] and, on a podium, a miniature soft sculpture of a standing nude male model (made by Brody). The studio's large window looks out on Kremlin Square and St. Basil's Cathedral. Few American women artists, in the fifties and sixties, had nude male models pose for them. In *Dollhouse* the male model, in cowboy boots and with an erect phallus, could become a threat to the woman artist even within her own domain, but instead is appropriated by her. Schapiro's own painting on the easel clearly attests to the reality of the woman artist's existence despite the political realities outside the studio/home. The *Dollhouse*, which might be seen as an incidental and playful endeavor, addresses a very real issue: the separateness of the spaces of femininity created and framed by the surrounding masculine world.[13]

In the early seventies, following her collaboration in *Womanhouse*, Schapiro made her first fabric collages in her storefront studio in Los Angeles, which looked much like a room in a house. The differences between her studios (the official academic space in San Diego and the more informal storefront) and the two bodies of work created in them are radical and profound. From the male technological world of computers Schapiro moved into a woman's decorated house. Through her involvement with the feminist movement she had finally developed what Bernice Steinbaum later called "a truly MIMI-ized style." Her studio, full of fabrics, comfortable furniture, and shelves for food and wine, reflected the home but remained spatially separate from it. In this homelike studio Schapiro celebrated and monumentalized her ever-present fabric cabinet and its significance for women, in a number of large femmages,[14] including *A Cabinet for All Seasons*, her poetic version of the cyclical changes and repetitions in women's bodies and lives.

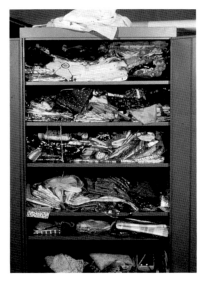

The artist's fabric cabinet

A woman artist experiences a contradiction in her life. She feels herself as subject in a world that treats her as object. Her work often becomes a symbolic arena in which she can firmly establish a sense of personal identity. She asks, "Who am I?" and proceeds to depict an image, central and clear, which proclaims to an unheeding world her information about who she is. Many women have done this but their images remain unseen and the information undigested by a society that insists on only one perspective. [1970]

I cannot emphasize enough the single unified point of view that permitted a refreshing answer to the problems of solving the question: What should the house [Womanhouse] be and how shall it reflect all of us? We became a mythic "One." A woman varied and intense. All of us were part of her. Delight in her facets spurred us on. It was a surprise. We revealed ourselves to the public. [1983]

I have always come away from the group meetings with a sense of happiness in seeing the women concentrate exclusively on their work. They come from homes and families and jobs where they "do their thing" after hours, into an atmosphere of art exclusively with no jeopardy from men, no criticism, no discomfort, only support. [1971]

Letter to a young woman artist: when a man is the model ½ of you is always missing and you are alienated and bereft in that place, as though a lobotomy had been performed and only one side of your brain cut out. If you complete the picture and have a model for each side—then you are Man and Woman together. If you are only identified with a male model one part of you will always have contempt for women. [1971]

On the making of quilts: the reason for putting years of productive hours into this patient task echoes a starvation for beauty and contact with

dreams and memories of the past—"I had to make the quilt to keep my family warm. I made it beautiful to keep my heart from breaking." [1974]

My own work is symbolic and I dovetail my feminism with decoration. Decoration pulls us all together and is nonelitist, nonsexist, nonracist. . . . The quality of self-analysis, probing deeply into one's historical resources—bringing to light repressed experience; learning the language of one's own unconscious—this is what leads an artist to a possible personal iconography. [1975]

The nest as a thing of beauty, as a positive embellishment of the healthy, strong, wife, mother. "The domestic engineer with a soul." The independent taste maker who furnishes her home. [1975]

To reach for a new form—a feminist form—one must reach against a male form. This is the logical place for anger. . . . Sentimentality is the new Frontier. Sentiment is a feeling. Sentimental lacks a framework for feeling and only deals with the outer edge or style of feeling, not with the dialogue between feeling and reason. [1978]

It was during this period, the mid- and late seventies, that Schapiro found a community that at last responded to so many of her needs. She also acquired a public voice, which, as she has said, enabled her "to feel much more comfortable with contradictory states of duty and selfishness." Seeing the exhibition "Women Artists 1550–1950," in 1976, at the Los Angeles County Museum, played a significant role in this. It was "the culmination of a dream."[15] It meant that henceforth "all young women who want to be artists can just walk into the museum and see they have a history, that someone came before them."[16] Between 1976 and 1980 Schapiro traveled throughout the country, from California and New York to Texas, North Carolina, Oregon, Arizona, and New England, lecturing to university audiences and art classes and also to women's groups. She spoke about her art, about feminism and art, and about the art of women past and present. She also did collaborative art projects, like her suite of etchings *Anonymous Was a Woman* (1977), which she produced with a group of nine women studio-art graduates of the University of Oregon. Each print is an impression made from an untransformed doily that was placed in soft ground on a zinc plate, then etched and printed. Schapiro washed out the original doilies and preserved them for her collection of women's needlework. These prints are thus double collaborations, with both the contemporary women artists and the anonymous women who made the doilies.

In the process of undertaking such projects (which continue to the present), Schapiro's studio expanded and became mobile, following her as she traveled. It was during the time of her Oregon collaborative project that Schapiro also created her first "Collaboration Series" with women artists of the past,

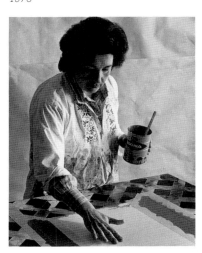

Schapiro in her New York studio, 1975

combining reproductions of the work of Mary Cassatt and Berthe Morisot with colorful and sensuous fabric borders in patterns inspired by quilts.[17] Her sense of newfound freedom and authority also made it possible to bring her studio back into the home. In 1975, when she returned to New York, she carved out a permanent working space in her new loft, in which she combined a large table, filing cabinets, and a desk with fabric cabinets, comfortable furniture, and personal mementos. In 1976, while creating the monumental *Anatomy of a Kimono*, her studio literally overflowed into her house.[18] This large femmage, composed of ten sections and dedicated to the new woman of the seventies, could not be contained within the studio and had to be partly constructed in the living room. The work itself temporarily obliterated the artificial boundaries between the realms of homemaker and artist.

> *I found myself in California, driving the most beautiful road in the world in La Jolla alongside the Pacific Ocean at high noon. The sun gleamed on the water and its reflection appeared as a silver lake—and I thought, "My God, I miss the subway." In the mean city streets, New York artists exchange ideas over the garbage, they bruise each other's egos and deflate each other's hopes. You return to your studio, sorry you bothered to go out to get the* New York Times—*and you suddenly find yourself inspired. Sweating, you make art. History is at stake. [1979]*

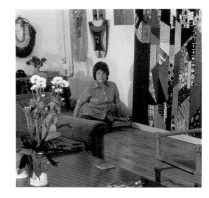

Schapiro in her living room with Anatomy of a Kimono, *1976*

After 1975 and her return to New York, Schapiro's creative space increasingly became what Teresa de Lauretis has described as "that elsewhere," which is not some mythic past, but "the elsewhere of discourse here and now, the spaces in the margins, social spaces carved in the chinks and cracks of the power-knowledge apparati."[19] When, in 1978, Schapiro conducted a workshop in her New York studio, the borderline between the woman's sphere within the home and the artist's creative space was obliterated. The materials for the workshop (buttons, thread, and pieces of fabric) could have been used for a sewing session. Schapiro had challenged her students in this workshop to "consciously try to construct, paint, draw, and collage a female art." These young women rose to the occasion and, in Schapiro's words, "made, sewed, and painted wonderful abstract objects which were indeed imagined from a woman's point of view."

Schapiro and her students were posing the terms for a different construction of gender, terms which, as de Lauretis has pointed out, can be posed in "the micropolitical practices of daily life," in daily resistances, and in the cultural productions of women and feminists, that is, "in the margins of hegemonic discourse."[20] Besides the fabric cabinet, Schapiro's studio walls were also decorated with costumes, handkerchiefs, needlework, and lace, as well as with her flowered hearts and heart-centered houses. Both her studio and her work played a central role in the mid-seventies redefinition of the decorative in art. Schapiro wished to celebrate women's lives and creative acts and to humanize the studio. The male myth of the lonely superman-genius in his bare-lightbulb

studio was restructured by the daily endeavors of women; by buttons and thread and pieces of fabric.

> *Sofonisba [Anguissola, 1535–1625], I dedicate my work to you, one of the most graceful and gifted artists of the past. Unknown, you are a mother to me. I am badly in need of one. I toast you. You are such a good, true, and strong woman to toast. [1975]*

> *Clothing is still a category not understood as the quintessential combination of structure and fancy. . . . Museum studies always make clothing to be like or "as important as" painting or sculpture. It is not—it is free of place and therefore can "hang on its own." [1975]*

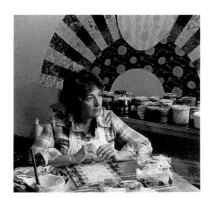

In the New York studio, 1978

> *The dress is the architectonic model of a tent, a shelter for the naked body [that] serves as a fundamental principle in women artists' work; often pattern is displayed on a simple structure or embroidery or special cloth. [1976]*

> *As a feminist I am concerned with the politics of aesthetics. As a feminist I question all assumptions about form and formal values, although the paradox remains that due to my background and formal training I often make art whose style seems to be at variance with content. My engagement with form continues as a challenge to me. [1976]*

> *Bruno Bischofberger came to the studio and bought large numbers of "Vestures" and "Fans." A team from Brussels—Alexandra Monet and Gierlandt, the director of the Brussels Palais—came to consult John Perreault on doing a "Pattern Painting" show. They chose seven artists and Anatomy of a Kimono to represent me. [1976]*

> *I felt great trauma at my first experience of real monetary success . . . I've dreamed about being there. But . . . the awful truth is that while I dreamed of success I was educated for failure—as a woman—as a member of society—as a mother. Nowhere in my background had any model been displayed for unimpeded, delightful success. [1978]*

> *[In Paris on her way to Brussels] "The Pattern and Decoration Exhibition" at the Palais des Beaux-Arts will open Thursday. Will it become "history"? [1979]*

Schapiro's consciousness of the absence of women from art history, and her driving desire to document them and bring them to the fore through her art, also made her more self-conscious about her own place in history. The "Pattern and Decoration Exhibition" in Brussels was the culminating event in a flurry of activity around the topic of decoration and the decorative impulse and their place in art and art history. Pattern painting or "P. and D." as it became known,

was an artist-generated movement of which Schapiro was a founding member. The group (Robert Zakanitch, Joyce Kozloff, Robert Kushner, Tony Robbins, Valerie Jaudon, and critic Amy Goldin) had begun meeting informally in 1976 to discuss the role of decoration in their art. It became clear to them that they were seeking to merge modernist art traditions with motifs from traditional women's crafts, folk art, and ethnic traditions "in order to express humanistic and decorative themes that had been excluded from the domain of modernism."[21] A substantial number of exhibitions followed: e.g., "Pattern Painting," at P.S. 1, curated by John Perreault (1977); and "The Decorative Impulse," at the Institute of Contemporary Art at the University of Pennsylvania, curated by Janet Kardon (1979). The formal and the critical issues pattern painting raised vis-à-vis modernism, humanism, and the avant-garde lost their appeal as topical subjects after 1980.[22] However, when Schapiro said in a lecture in Sacramento, in 1980, that P. and D. had lost its appeal, irate hands flew up: "not for us" the women asserted. For Schapiro herself, decoration had become an integral part of the structure of her art. In 1976, she described the ideology as "the wish to have the art speak as a woman speaks . . . to be sensitive to the material used as though there were a responsibility to history to repair the sense of omission and to have each substance in the collage be a reminder of a woman's dreams."[23] But for Schapiro, these dreams also included memories of the great master, Picasso, "the last superhero of the twentieth century," as she referred to him in 1980, in a response to the art editor of Soho *Weekly News*.[24]

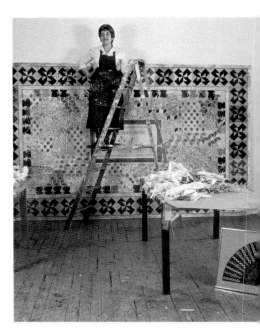

Schapiro in her New York studio working on Wonderland, *1983*

> *Picasso was the most documented artist of his time. As a young woman I studied every David Douglas Duncan photograph of him to learn as much as I could about the Artist's Lifestyle. He was the perfect star. . . . For my part I was dazzled by the pictures of the sun-drenched rooms in La Californie, his home in southern France. I loved the stacks of paintings in all the barren rooms, his beautiful garden filled with his own sculpture. I delighted in looking at his knickknacks, his masks, his paintbrushes and potbellied stoves. The general plethora of the great man's studio fascinated me. I dreamed about my own studio being photographed some day in the future. [1980]*[25]

After 1980 Schapiro had not only a room but a studio of her own, adjacent to her home in East Hampton, built with the money she earned from the sale of her P. and D. paintings. In addition to *Anatomy of a Kimono*, Bruno Bischofberger bought her whole production that year. Schapiro also sold paintings from a number of other shows in the United States and Europe and was able to finance her first trip to Europe. As she traveled and immersed herself in new projects, the objects, patterns, and motifs that decorated the walls of her studio changed. In 1987, for example, in preparation for her monumental painting of Frida Kahlo, one of her "Collaboration Series" with Kahlo,[26] entitled *Conservatory*, she surrounded herself, in her new East Hampton studio, with objects brought home from trips to Mexico. She began to see her

home as an extension of her studio. For her living room she created a decorative tile installation inspired by Kahlo's house. Decoration and "collaboration," two concepts central to Schapiro's art on conceptual, aesthetic, and political levels, play a significant role in both her house and her studio.

My art in its political context is "utopian." There will never be a time of parity between men and women. The battle between them has no name. . . . Is radicalization possible again? Can one recycle enthusiasm? Is the audience of women worth appealing to? Have we exhausted the house-nest as a locus for ideas, simply because others discuss it? . . . Can one renew interest in a room of one's own? Is Womanhouse passé? Are the ideas viable? If gender is no longer a factor then it is women who will dissolve into a man's world. [1983]

So much of what we did was motivated by guilt, particularly in the area of nurturance. . . . I regret those horrible, dark years when I was plagued by guilt and I kept impeding myself at every turn, because I thought I didn't have a right to success, but I don't think that goes on so much now. [1990]

All those years in the seventies, when I was living, acting, breathing, doing teaching, making art, making speeches, and organizing other women, I always had in my head the idea: "In what way am I plugged into the feminist structure?" What is the feminist structure? What is the feminist philosophy? I consider that makes me different from [women who] only adopted one aspect of feminism: "I'm going to get out there into the public arena, and I'm going to prove myself, and I'm going to have my own place in the spotlight." Which is fine. But what's the larger picture? The larger picture is we still are living in a patriarchal society and although we've come this far, it's all cosmetic. The basic issues have not changed. We don't even have the ERA. So who is kidding whom about what's going on? I, myself, have made peace with my own life. Sometimes it works; sometimes it doesn't, but it's where early on I said to myself: "Miriam, you must make your art for women, and when you make art for women, they'll get it." [1991]

In the New York studio, 1989

Over the years Miriam Schapiro's studios have become metaphors for creative endeavor, as well as spaces in which she could live her life and her dreams. Today her studio is both functional and decorated; from it she can move into her house and back. She has in her private life created unimpeded access between her professional space and her "nesting" space, overlapping her gendered roles in a society that has kept these roles separate. This patriarchal society had designated the artist as male and woman as the "other," through whose studio a distinguished male art historian could not, in the 1950s, move without embarrassment. Schapiro herself continues to be painfully aware of these separated and gendered realities.

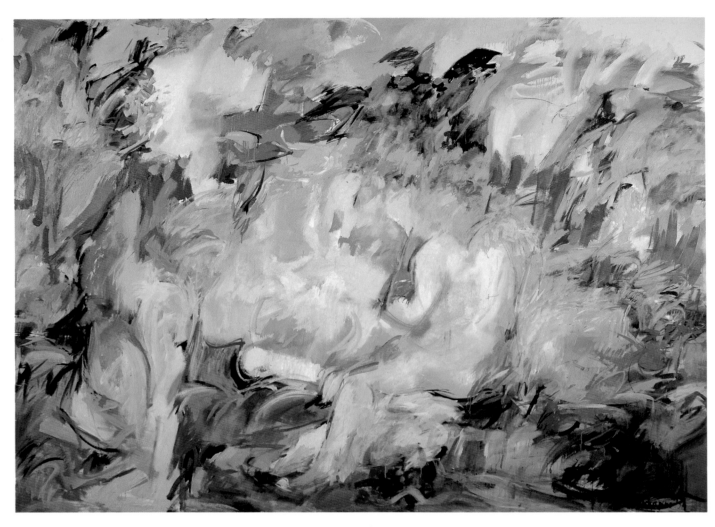

Fêtes Champêtres. *1954. Oil on canvas, 67 × 107"*

2.

COVERT FIGURES AND PERSONAL APPEARANCES

When I look back on the years of excessive self-doubt I wonder how I was able to make my paintings. In part I managed to paint because I had a desire, as strong as the desire for food or sex, to push through, to make an image that signified.

—Miriam Schapiro, 1977[1]

In December 1956 Miriam Schapiro wrote in her journal: "How good it would be for me to have some encouragement now, that is to say, some outside support. No one could be truer than Paul [her husband], but I must be patient." In March 1957 she drew in the margin of a page in her journal a house with a garden, with the words "the gate of world rejection" in the center of the fence and "the monster of self-hate" in front of the gate. Next to the gate an inscription reads "enter here to paint." The door of the house she described as "door to adventure." On that same page she wrote: "To err is human but apparently not aesthetic. But to err in painting is to hint at a search. But to search is to be alone." This drawing and statement of great self-doubt follow a comment on the paintings of Joan Mitchell, which to Schapiro seemed like those of Helen Frankenthaler, "full of talent and drive—articulate, as though they were ripe with intention to hold the sun in their orbit as long as possible." She would have liked to talk with these women openly, on a professional level, but that, in the art world of the fifties, was impossible. Writing in 1973, Schapiro recalled:

Joan Mitchell, Grace Hartigan, Jane Freilicher, Jane Wilson, Helen Frankenthaler and I were all friends and still are. We never discussed problems of ambition and ruthlessness. The spirit of the time did not permit such frankness—woman artist to woman artist. We identified and had camaraderie on the basis of being women rather than on the basis of being artists. Art was somewhat of a secret life when we were together. When Helen and I were together we would talk about problems with men; getting fat; whether to have a baby or not; the difficulty of moving; gossip of the art world; we would plan joint parties or remind each other when we were going to be on the beach. We never discussed our paintings. We were in the same gallery and didn't discuss our work.[2]

In spite of her excessive self-doubt, between 1953 and 1957 Miriam Schapiro completed a substantial body of work in which her primary concern was to create her personal version of the dominant style of the period, Abstract Expressionism. On stylistic grounds, these paintings of the mid-fifties (for example, *Fêtes Champêtre* (Homage to Giorgione), 1954; *Beast Land and Plenty*, 1957; *Fresh Air*, 1957) can be linked with the work of the second generation of Abstract Expressionists, who were primarily women; the men, considered to be the creators of the new style, were classified as the first generation.[3] Schapiro invented her own gestural language, drawing with a mixture of turpentine and paint, "painting thinly and wiping out," and letting the wiped area play as significant a role as the painted area. For her, painting was gesture and motion, "substitutes for the physical act of dancing." But many of these early gestural paintings, even some that appear to be totally abstract (e.g., *Beast Land and Plenty*), were based on primarily black-and-white illustrations of works by the "old masters" (in this case, Tintoretto) that she had cut out of magazines and pasted into scrapbooks, a practice she had begun very young, following her father's example.[4] The only formal language available to her at that time was the masculine construct of the "old masters," which she endeavored to make her own, thus inserting herself into the male-dominated art historical canon.

The formal challenge in these works was to fully integrate the spatial structure of her source with the surface of gestural brushstrokes. To achieve this she laid the color on the raw canvas in a patchwork system of lights and darks, as a "free-flowing grid," and divided the canvas into quarters with "strong S-curves bisecting in the center." She then repeated small shapes over the S-curves, working them into semiobjective areas that referred back to her source, re-creating it in terms of motion and gesture. She sought to keep the schema disguised in order to create a fluid and light painting. Many of these large abstract canvases also have landscape allusions, such as *Fêtes Champêtres* and *Fresh Air*, and Schapiro has described them as "inscapes," imaginary landscapes of the mind. She fused the imaginary landscape with what she described in her journal as "automatic stroking," which, following the Surrealists and Jackson Pollock, engaged her unconscious in the process of painting. She believed that this method denoted a lack of previous planning and retained the element of surprise in the completed painting.

On the abstract nature of her work of the mid-fifties, Schapiro has insisted: "There was no message. . . . They were honest works which began new with each painting, always asking the question 'What is painting? How do you make a painting?'" But in these same paintings there are also allusions to recognizable imagery, usually human figures, embedded in the abstract network of brushstrokes. Some of these figures are almost totally veiled (as in *Beast Land and Plenty*), while others are more clearly discernible, such as *Homage to Rubens* (1953). But, generally, in compositions based on the work of the old masters and those cast as homages to particular painters, the figures are mostly female nudes left visually coherent enough to be recognizable. In *Homage to*

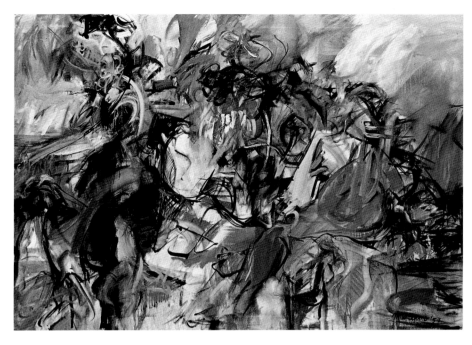

Fresh Air. *1957. Oil on canvas, 48 × 60½". Collection Pat and Paul Kaplan, New York*

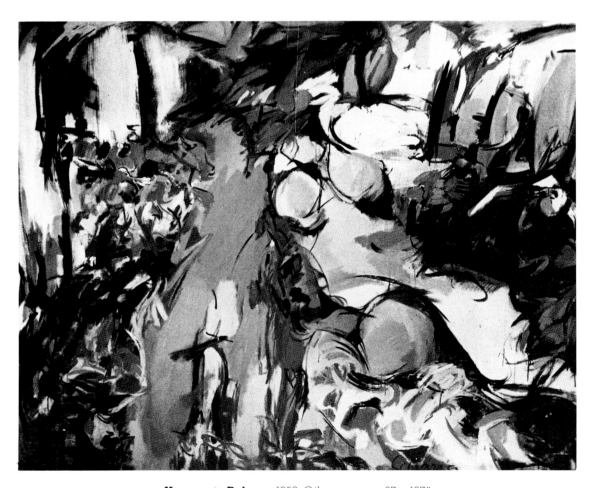

Homage to Rubens. *1953. Oil on canvas, 67 × 107"*

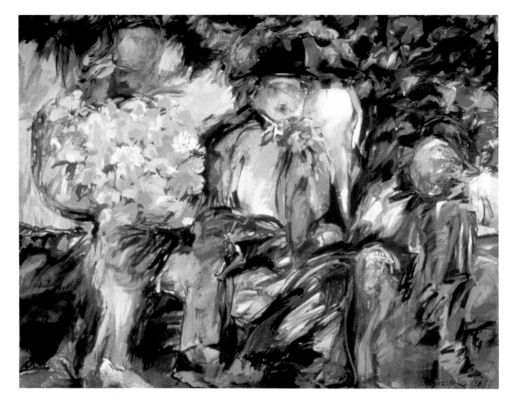

Idyll #1. *1956. Oil on canvas, 60 × 72". Williams College Collection, Williamstown, Massachusetts*

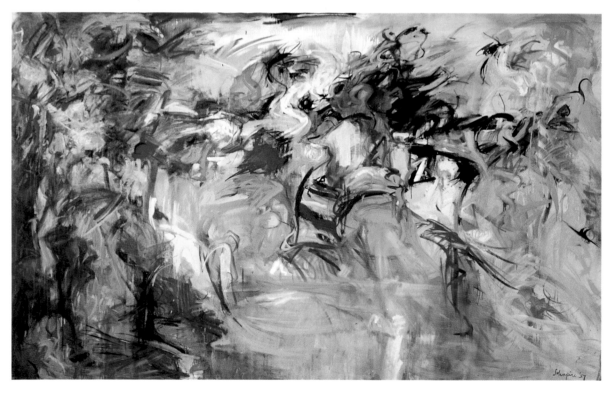

Beast Land and Plenty. *1957. Oil on canvas, 67 × 103¾". New York University Art Collection, Grey Art Gallery and Study Center. Gift of Mrs. Philip Lee*

Rubens, which is compositionally close to its source, Rubens's *Venus and Adonis*, the ample and dominant figure of Venus stands out. Eros, Adonis and his dogs, and the background elements dissolve into a fluid structure of abstracted shapes. *Fêtes Champêtres* (Homage to Giorgione), one of Schapiro's finest early paintings, is her translation into mural scale of Giorgione's mysterious *Concert Champêtres*. The composition of the painting is more open and atmospheric than *Homage to Rubens*, as Giorgione's modulated chiaroscuro dissolves into shimmering clouds of color. But here, too, the seated female nude (center right) is clearly identifiable and stands out from the colored atmospheric structure, into which the male figures and landscape have disintegrated.

In addition to the visual references to the female nudes present in her sources, Schapiro also added personal meanings. *Fêtes Champêtres*, for example, was for her "a far-off lyrical place, a gentle elegiac environment, woman's secret garden—a metaphorical combination of nature and human being." She added a very different covert meaning to *Beast Land and Plenty*, compositionally one of her most resolved abstract paintings of the mid-fifties, which is based on Tintoretto's *St. George and the Dragon*. The figure of St. George charging on his steed can be identified slightly off center to the right, moving inward in a swirl of brushstrokes. The rest of Tintoretto's composition is absorbed into gestural strokes. Schapiro has commented: "This was a time when Tintoretto and Pollock both spoke to me. Tintoretto was the dense, many layered stage with people advancing and receding. Pollock was the chance to move across this stage at my own speed." In discussing the presence of covert meaning in her early works, Schapiro has often related that while engaged in painting one of her abstract compositions she transformed, in her mind, St. George into "St. Georgina slaying the dragon." *Beast Land and Plenty* is the most likely candidate to have prompted these thoughts. In a painting in which the female figure is totally absent, and one which could compete with the work of contemporary male painters in its formal level of abstraction and large size (67 × 103"), Schapiro felt the need for some meaningful female allusion. However, in the context of accepted religious mythologies and accepted symbolic structures, St. Georgina does not exist. She existed only as a compensatory fantasy in Schapiro's mind—she had no cultural context. The artist commented on her fantasy of St. Georgina: "unknowingly I was taking myself through a process that later became very popular with women artists of the seventies. . . . In their search for power these women annexed the already existing power of men."

Fantasy was the dominant impetus in another group of Schapiro's paintings of the fifties, derived from photographs of movie stars (e.g., *Soft Shoe*). She remembered these, in 1970, as "typical little girl fantasies about Hollywood and movie stars," and was amazed at the incongruity of "a serious young woman artist in New York . . . having discussions in the Cedar Bar with de Kooning, Parker, Held, Guston, Pollock (real he-men) about the 'situation,'" and back in the studio "faking [her] life away on the canvas." She was engaged in painting a world where "Judy Garland and Betty Grable and Clark Gable and I lived side by side and spoke the same language." The illu-

sion and romance of the movies compensated for the loneliness and isolation she felt in the real world of art. One of her favorite still images was that of Charlie Chaplin, the flower girl, and the millionaire from *City Lights*, of which she painted three versions. In *Idyll #1*, painted in May 1956, Chaplin in his brown derby hat, the blind flower girl with her big bouquet, and the seated drunk millionaire (right), are quite recognizable, under a magnificent tree added by Schapiro. In *Idyll #2*, painted in November 1956, she returned to her abstract style of 1955. The three figures are barely suggested—forms open up and nature infuses the figures. In *Third Idyll* (1956) the origin of the image in the film still is completely lost, and one can only discern the rush of two figures moving toward each other. As the paintings became progressively more abstract, the viewer's perception of the image and the fantasy in the artist's mind completely diverged. The "Idyll" of the titles refers, most likely, to what Schapiro perceived as the idyllic relationship between the humble little tramp, searching for others less fortunate than himself, and the blind flower girl. Their relationship, as presented in the movie, is based on mutual need and unconditional support, the complete opposite of the gendered relationships of macho New York artists and their women. It was part of Schapiro's life of fantasy.

In December 1957 a significant event occurred in Schapiro's professional life: André Emmerich chose one of her paintings for the opening of his new gallery on 64th Street. "Painting is a joy this year—for the first time," she commented in her journal. "The wonder of belonging (in this case, merely having a dealer) leaves free space in the mind and heart for creation." That same year Schapiro posed with her "Imaginary Museum," photographs of works she would have liked to own, for an article on artists as collectors.[5] On a poster board she arranged portraits by Pollaiuolo, Corot, Degas, and Picasso; portraits of Toulouse-Lautrec and Charlie Chaplin; Picasso's and Duchamp's modernist masterpieces (the former's *Les Demoiselles d'Avignon* and *Gertrude Stein*, the latter's *Nude Descending a Staircase*); Brancusi's *Little French Girl*; a Mexican Jalisco sculpture; and a Henri Cartier-Bresson photograph of a fisherwoman. In the midst of this august assembly she placed a circa 1900 paperboard doll of a ballet dancer. This figure is flanked by a photograph of a nineteenth-century dollhouse with a standing Victorian doll in it. The most contemporary piece in Schapiro's wish collection was a painting by Gorky (bottom left). In the photograph, Schapiro holds up her "Imaginary Museum" while looking toward a series of studies of female dancers. She had made these drawings between 1953 and 1957, and was using them as reference points for a number of large abstract paintings of dancers she completed in 1958–59 (for example, *Fanfare*, 1958; *Soft Shoe*, 1958).

The choice of works in Schapiro's "Imaginary Museum" exemplifies her interest in the masters, old and modern, and her abiding concern with figuration at a time when she had just completed a group of large paintings in her

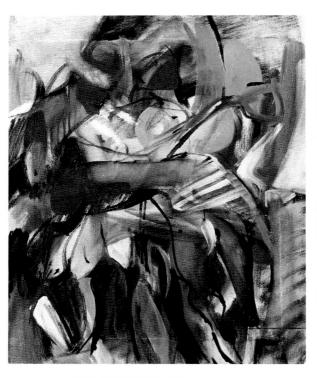

Third Idyll. *1956. Oil on canvas, 60 × 48". Collection Mr. and Mrs. Guy Weil, New York*

Opposite: Schapiro with her "Imaginary Museum," 1957

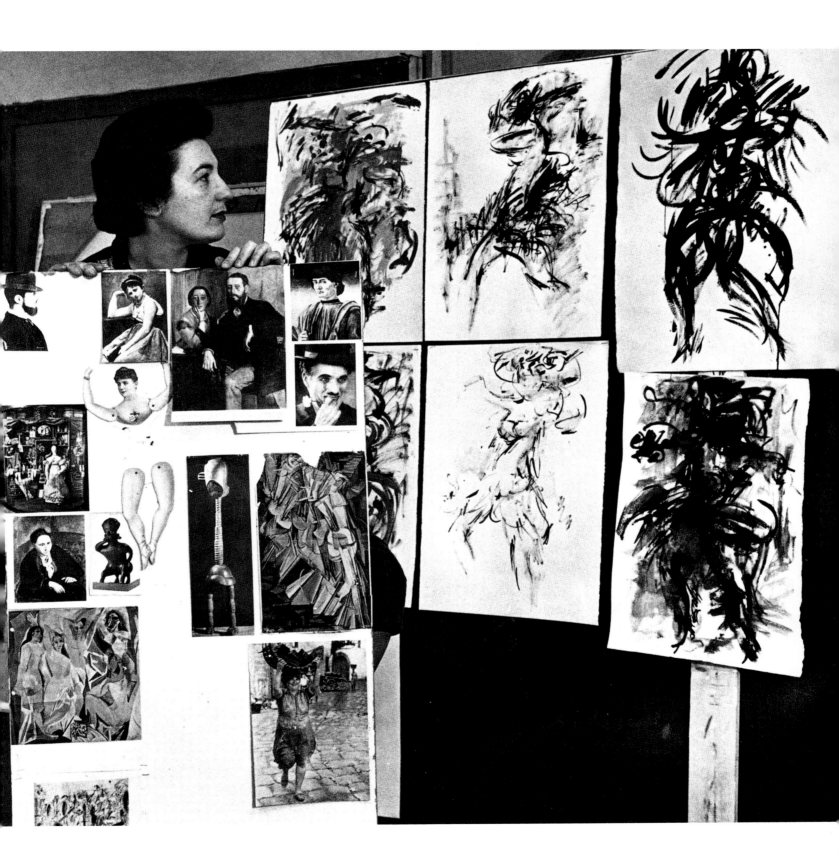

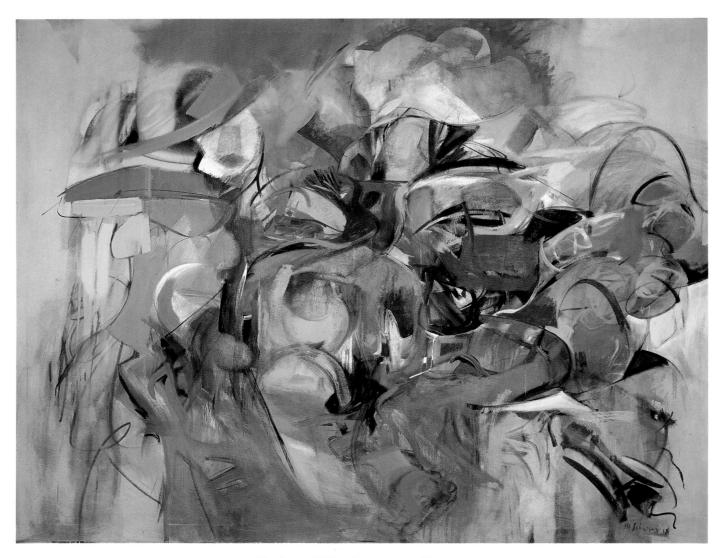

Fanfare. *1958. Oil on canvas, 60 × 105"*

Garland. *1954. Oil on canvas.*
Destroyed by fire

Soft Shoe. *1958. Oil on canvas,*
80 × 72"

gestural style (including *Fresh Air*, *Sur l'Herbe*, *Night Wood*, and *Third Idyll*), some of which she showed in April 1958, in her first solo show at the André Emmerich Gallery. Figuration, both overtly and covertly, had been significant in her work since her years as a graduate student at the University of Iowa. Her thesis project, completed in 1948, had been a series of figurative pieces that culminated in a self-portrait and a portrait of her husband, Paul Brach.[6] In a journal entry in 1957 she states that she was moving between "more or less automatic paintings and thematic paintings." She preferred the latter, and evolving a clarity of subject matter and form became very important to her. She no longer identified "painting itself, the struggle of painting a picture" as "the End"; but she was very conscious that "the meaning of an image, like the moment of truth, is revealed only when the technique is perfect." In moving away from Abstract Expressionism toward a more explicitly figurative and personal style with a specific theme, she felt the need to develop the appropriate form and technique.

The photograph of Schapiro with her wish collection sets up a dialogue between her art and the art of the past. She looks away from the masters whom she admires, and toward her own mobile and assertive drawings of female dancers. In these drawings she has transformed the paper-board ballerina, which forms the centerpiece of her collection, into an activated and dynamic female figure. The flying brushstrokes, which translate into both visual and emotional fury, contrast with the inactivity of the seated women in Corot's and Degas's paintings and the inertness of the paper doll. Together with Brancusi's *Little French Girl*, these static images are flanked by the formally active but emotionally negative presences of the nude women in Picasso's *Les Demoiselles d'Avignon* and Duchamp's *Nude Descending a Staircase*. Only the image of the formidable Gertrude Stein, one of Schapiro's favorite paintings, which she has described as "a magnificent analysis of an intense and powerful woman," introduces woman as a thinking (although masklike) being.

Most likely Schapiro had not, in 1957, fully articulated these issues in her mind. Nevertheless, in the photograph, perhaps through fortuitous accident, she poses the question she would articulate in her journal in 1970: "Where is the mirror in the world to reveal who I am?" As she turns away from the images in her wish collection and looks at her own creations of dancing figures, she suggests that the mirror is her own work. In fact, several of the subjects and themes that she would use in the course of the next decades appear in her "Imaginary Museum" of 1957: the dance, the doll, the dollhouse, the Mexican ritual figurine. Of these, the dance is directly associated with Schapiro's own life, for as a child she had taken dance lessons and from the beginning dance was for her identical with artistic creativity: the painter/dancer moves within the stage of her canvas, creating a dance of color and form. She commented in 1966: "In the fifties, when I was conducting my art education in public, the canvas was a stage. Painting was gesture and motion, even speed, substitutes for the physical act of dancing." In *Fanfare*, originally entitled *Dancescape*, and *Soft Shoe* gesture and speed are combined with the subject of dance. The agitated and fragmented figures in *Fanfare* are engaged in an

intense *pas de deux*. A broad and expansive dancer, painted primarily in brilliant reds and oranges, moves from right to left toward a quieter, more restrained, and cooler figure, painted primarily in light blues and wearing a blue hat. The compositional layout is repeated in *Soft Shoe*, which is based on a photograph of Fred Astaire and Ginger Rogers dancing, suggesting that *Fanfare* may derive from the same source. In *Soft Shoe*, both the articulation of the figures and their gendered identity are more explicit than in *Fanfare*. The dynamic figure on the right is clearly identified as male by a number of phallic projections and contrasts with the quieter, broader, and more static female figure with large breasts. In this painting Schapiro also moves toward a more vertical composition, both figures being framed by vertical lines. The central theme of these two paintings, combining dance and performance with gender identity and sexual relationships, is one to which Schapiro would return in her dance trilogy of the mid-eighties.[7]

In searching for meaningful female imagery in her world of movie fantasy, Schapiro turned to photographs of movie stars standing in front of their public. Two of these paintings, *Garland* and *Personal Appearance*, both dating from 1954 and representing Judy Garland holding a bouquet of flowers, deal with a subject that was to become a leitmotiv in Schapiro's art: the creative woman— whether artist, dancer, or actress, who for Schapiro are one and the same— coming out of her isolation and loneliness and facing her public and, potentially, her adoring audience. In both paintings, however, the woman's body is camouflaged by the bouquet and a network of abstract brushstrokes, and her face, masklike and featureless, is hardly discernible. These faceless women making their public appearance are Schapiro's visual comment on a woman's inability to face her public in a culture in which she hardly exists as a public person, a theme to which she would return in a series of autobiographical paintings of the mid-eighties.[8] As Hélène Cixous has argued, for women in patriarchal society "decapitation rather than castration is at stake."[9] Both decapitation and facelessness and their implicit muting express women's lack of voice. The woman appears but does not speak; her presence is masked and camouflaged. Schapiro's paintings of female movie stars, in fact, raise the issue of the illusory nature of femaleness, its cultural construction and its transformation into a form of masquerade, a camouflage behind which women hide their intelligence and creativity.[10] These paintings contain the germ of Schapiro's later use of masquerade and performance as part of her visual investigation of femininity and gender identity. She has reminisced about her actress and dancer paintings of the fifties:

> *I made some really bizarre portraits of movie stars that contained a lot of female identification—much more explicit work. Jackson Pollock came in my studio one day while I was working on a painting of Judy Garland (an abstract painting where her clown's costume was transformed into flowers . . .) and said "the trouble with you painters of the younger generation is that you don't know who you are—you don't know what sex you are painting."*[11]

The Great Master, the macho artist par excellence, had sensed the camouflaged gendered identity in Schapiro's painting. These were not male figures, but they were not typically female either.

By 1958, Schapiro extended the female allusions in her work to include those based on photographs of friends, such as Helen Frankenthaler (*By the Sea*, 1958), and of celebrities, such as Gloria Swanson and the Lindberghs (*Interview*, 1958).[12] *Interview* is based on a newspaper clipping showing Lindbergh in the center, with his wife sitting slightly behind him on the right and Swanson sitting by herself on the left, looking away. The painting is important in Schapiro's oeuvre of the late fifties, both because of its subject matter contrasting an independent woman (Swanson) with a married woman (Lindbergh's wife) and because, with its more explicit figuration than the earlier dance paintings and its broader simplified shapes, it signifies a stylistic change. Schapiro was moving to simplified forms with an underlying geometric structure and a symbolic meaning. She said, "I wanted to become stylistically clearer, to put new order in my work." This wish for a new formal order coincided with one of the most conflicted periods in Schapiro's life, when her artistic identity was severely threatened by all the other roles she had to fulfill.

She had had ambiguous feelings about pure abstraction even while she was engaged in it, in the mid-fifties. She commented in 1966:

> Since the style of the day scalped thought, there was really nothing else to do but to abandon yourself to the liquid reality of paint and shmear yourself around the painting, imagining yourself really free, like Isadora Duncan.
>
> That was no freedom because there was no responsibility. Except that I cheated and I can think of a few of my contemporaries who did the same thing. We would spellbind ourselves before we began, dreaming of nature, or imagining rites of other peoples, or, in my case, selecting some marvelous Tintoretto painting and re-creating the structure in terms of motion and gesture.

Both the work of Tintoretto and Abstract Expressionism were part of an artistic tradition, historical and contemporary, that in Schapiro's mind had completely excluded her as an artist. She wanted to articulate in her paintings a personally relevant content that would speak to the realities of her life. This is evident in a number of paintings dating from 1959, all of them dealing with family relationships, especially that of mother and child. Schapiro was experiencing this relationship both as the mother of a son and as a grown daughter intensely longing for her mother's care.[13] In 1975, she described her painful and ambivalent feelings about the mother/child relationship:

> When a girl is old enough to separate from her mother, she then is old enough to receive instruction on how to be a mother. The daughter in the process of separation finds the umbilical cord snapped, and freedom means serving others. The boy child separates gently. The cord is never snapped,

as it is not necessary for him to be a mirror image of his mother. He receives nourishment from his mother until the next woman is there to take over.

A woman never gets another mother. She remains secretly faithful to her own image as a child. She likes security, tender things, and loves cuddling.

In her own terms Schapiro was articulating Freud's psychoanalytic position that a woman is programmed to become like her mother, whom she, therefore, both imitates and loses.[14] *Pandora, Mother and Child,* and *Autobiography,* all painted in 1959, deal with the mother-and-child relationship and its psychological complexities. In *Pandora,* the figures of the flesh-colored protective mother, with outstretched arms, and the young child are quite coherent. The closeness of the two figures and the child's placement next to the mother's abdomen also suggest birth. *Autobiography* is both more abstract and more complex. Here the rectangular aperture and the ovoid shape are introduced as separate motifs. The flesh-colored mother figure, shown to the waist (left), has next to her abdomen a rectangular aperture painted sky blue. This window, with its underlying geometric form, can also be read as a threshold leading to/through the maternal body. The bending child (bottom right), entwined by flesh-colored ribbonlike forms suggesting umbilical cords, also looks like a nest, its simplified ovoid head becoming an egg in the nest. This painting thus contains in embryonic form the aperture/window and the egg, which would become the central symbolic devices of Schapiro's work during the next six years. It also introduces the theme of the bond of mother and child, tied by the umbilical cord, which here appears to be severed, a significant theme in Schapiro's autobiographical figurative trilogy of the mid-eighties.[15] The gender of the child in these three paintings from 1959 is not specified, but the severing of the symbolic child/egg from the mother figure in *Autobiography* suggests that Schapiro was referring to the relationship of the female child to her mother. The autobiographical symbolism, alluding to maternity and the maternal body, coalesces in *House of the Artists.* Initially entitled *Couple* and then *Home,* the painting depicts two figures with an azure blue window between them, holding a nestlike form with two eggs. But the central shape and flesh-colored area below the window can also be seen as a reclining female body with breasts, a navel, and a womb (a red splash of color in the bottom center of the painting). With its simplified shapes, vertical alignment, and central window, this painting prefigures the "tower/house" compositions and *Shrines*

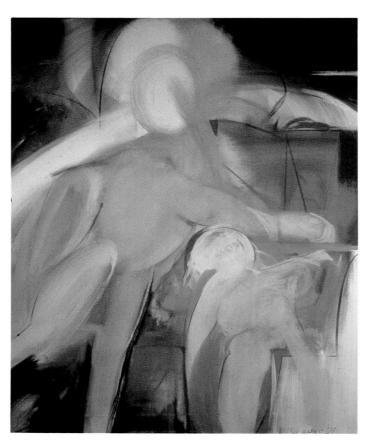

Pandora. *1959. Oil on canvas, 38 × 32". Private collection*

of the sixties. This autobiographical body of work explores the symbolism of the maternal body and the womb as sources of early childhood memories and feelings.

In the four paintings of 1959 Schapiro abandoned her world of fantasy to delve into the psychological and existential realities of her own life. The various apertures she introduced are passages or thresholds to childhood memories and represent bonds to the maternal aspect. Having opened Pandora's box, Schapiro then transferred her complex memories and feelings to the proscenium stage, where these realities acquired a grander scale and public visibility but also became more illusory and ambiguous. *Facade*, originally entitled *Orpheum*, the largest painting of 1959, is the first of Schapiro's paintings to be set in the theater. It also is the most formally coherent example of her "ordered" style, its structure consisting of figural geometricized fragments and interlocking shapes. She had returned to the simultaneously interlocking and overlaying forms of Cubism that she had studied extensively in her twenties.[16] The triad of the family (either Schapiro and her parents or Schapiro, Brach, and their son) has been set "on the front of the stage close to the footlights." The three vertically shaped figures are: a toreador in the center and a jockey at the right, identifiable by their hats, and a headless female figure with exposed legs and a small crimson heart in her chest at the left. A tubelike umbilical cord connects the female figure with the figure of the toreador, whose abdominal area is the aperture or window, associated with the mother in the other paintings. These symbolic allusions suggest that this painting too explores the relationship of the female-child or woman (the left figure) to the maternal figure in the center, here cast in disguise as a toreador. The rather ambiguous figures in this painting seem to be composed of separate and interchangeable parts, and the borderlines of gender appear flexible. The title of the painting suggests that Schapiro may have been referring to gendered appearance as a facade assumed by people onstage. The artifice of the stage allowed Schapiro to cross the boundaries of gendered categories. She commented in 1990: "The theater is a metaphor for life—my life. It will always work most successfully for me in my art when it directly refers to my life." With this group of paintings of 1959, which culminated in her first theater painting, Schapiro looked inward and directly referred to her life. They are expressions of her strong desire to "make an image that signifies."

In her work of the fifties Miriam Schapiro moved from gestural paintings based on photographs of works of the old masters, movie stills, and photographs of movie stars facing their public to more fully internalized compositions with a clearly articulated formal structure that reveal fragments of her inner life and personal desires. Self-allusive titles such as *Autobiography* and *House of the Artists* and the personal symbolism that informs these paintings point to the direction that Schapiro's art would take in the next decades, as it became increasingly autobiographical. In moving toward autobiography, Schapiro entered an unmapped terrain in which she invented the images of what had not been articulated or recorded.

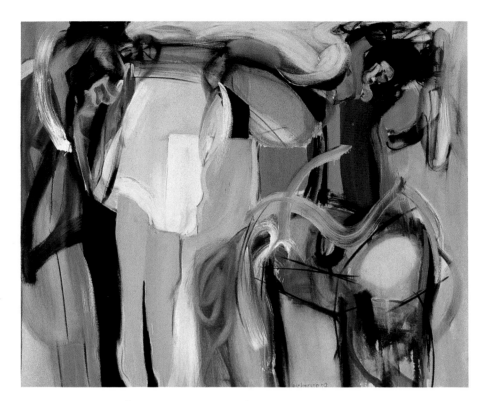

Autobiography. *1959. Oil on canvas, 54 × 64"*

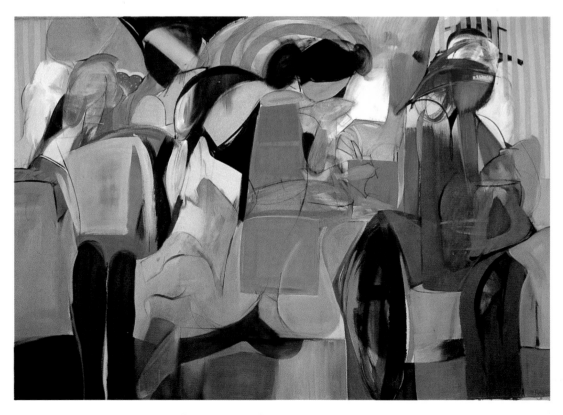

Facade. *1959. Oil on canvas, 69½ × 95"*

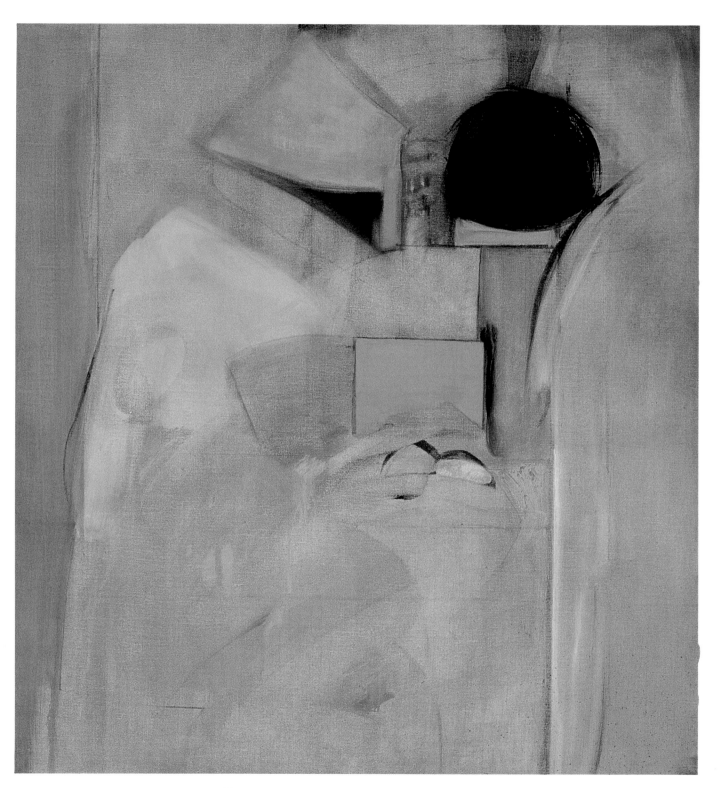

House of the Artists. *1959. Oil on canvas, 60 × 50″*

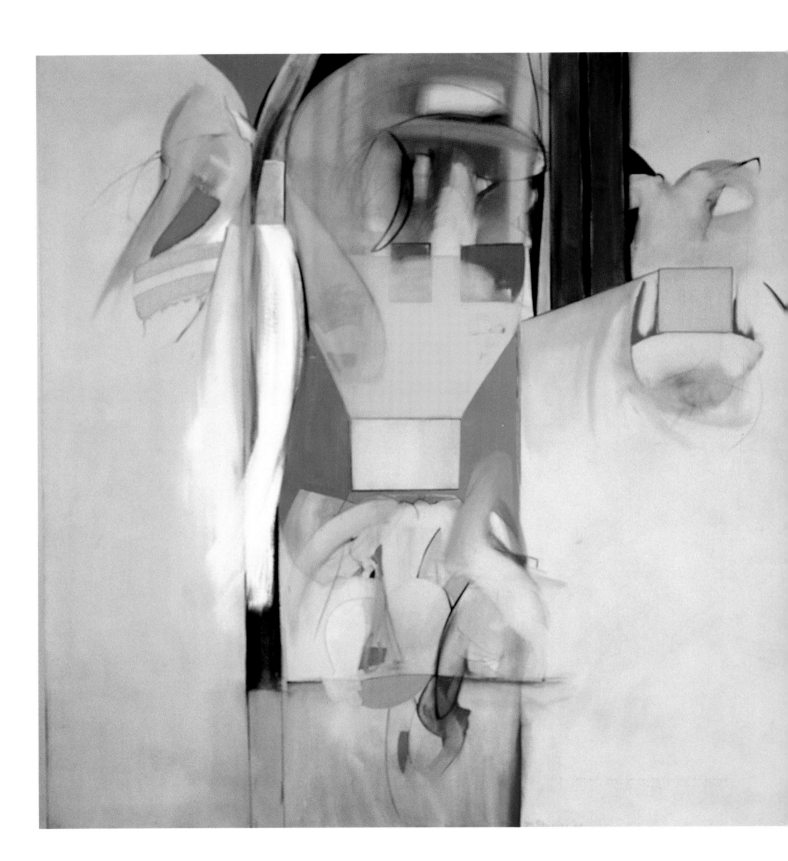

3.

MIRROR, WINDOW, AND MATRIX

Where is the mirror in the world to reveal who I am?
—Miriam Schapiro, 1970

The absence and muting of women artists as professionals, in both the history of art and the contemporary New York art scene, profoundly affected Schapiro. By the late 1950s, after the birth of her son, her situation reached a crisis. She could no longer paint. It was as if everything she knew "had been washed out of [her] brains." Circumscribed by the symbolically contradictory spaces of her house and of the studio she had created in it, she found neither literal nor symbolic support for her ambition and creativity. Like the professional women studied by Joan Rivière in the 1920s, she felt diminished by her social and cultural identification as mother, wife, and daughter. Pressured to adopt the masquerade of femininity she, like Rivière's patients, suffered symptoms of psychic pain.[1] She has described her ambiguous status and the role of the woman artist as that of an outsider in the art community (1971): neither "like the male artist nor like the artist's wife or girlfriend," but rather existing "in a kind of netherland of isolation, in which she must continually assert her lone voice against the culture's perception of women." In the public arena, the desire for creativity became for Schapiro a source of anxiety and fear of retribution from the men, whose "raw ambition" dominated her professional life. She has alluded to her fear of the desire to be creative ("the utter selfishness of being an artist") as "running into too much un-love," the punishment for assuming what has been defined as a purely masculine prerogative.

Of the state of her work in 1958 and her feelings about it, she has written:

> After having painted lyrical, abstract, expressionist paintings since graduate school, I felt a change coming on. I was increasingly unhappy with my painting and my work was moving slowly. . . . I did not know what I wanted.
> I was a relatively young painter and could not profit from my own experience. Questions like "Who are you?" "What do you like?" were impossible for me to answer. . . . I became despondent. I felt the void inside as powerfully as if my heart had cancer. . . . I wondered if being a woman had any bearing on my problem."[2]

The Game. *1960. Oil on canvas, 81 × 90½"*

Following this period of profound conflict, Schapiro created, in 1960–61, a series of very original compositions in which emerge a number of recurring

symbolic shapes: the vertically shaped tower/house and the recessed rectangular aperture, which she has referred to at various times as window, box, and house. On a symbolic level these containers also appear to be allusions to the female/maternal body. Within their apertures they usually contain abstracted, biomorphic figures, which in several cases appear to be struggling. Toward the end of this series Schapiro introduced another symbolic image, the egg, which she has identified as the fertile, procreative, and creative woman, a metaphor for herself, and which replaced the abstracted figures in the tower/house.

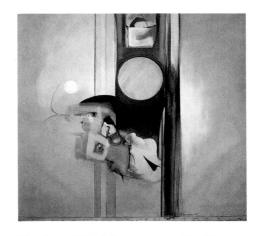

The Law. *1961. Oil on canvas, 81 × 90½"*

In these paintings Schapiro achieved two goals: greater clarity of form, by introducing geometric structures and confining the Abstract Expressionist brushstrokes within them, and greater clarity of meaning, by introducing symbolic and allusive imagery. The tower/house series became her visual response to the questions that she could not answer verbally. In 1966 she commented briefly on the meaning and development of her work from the tower/house series to the *Shrines*:

> *I wanted desperately to make my images clearer. It all began by changing an S-curve into a straight line. That was impossible for me to do all at once. All I could do was to juxtapose them side by side. In 1960 I made a picture called* The Game. *"The Game" is the game of making a real world on canvas. "The Game" is also the game of knowing that the made world can never be wholly real. The Game was the first painting to use the box as a symbol. The box became a house. I could no longer live in the jungle. I built the house out of all the things I was unsure of and certain about. I called it a "Shrine."*

In *The Game* (1960) and the other two largest and most visually impressive works in the series, *The Law* (1961) and *Treasury* (1961), the abstractly structured biomorphic figures are quite dominant. Some appear to be reclining, held in place by rectangles and oppressive shadows (*The Law*); others, entwined under the window, appear engaged in what Schapiro has described as the game of "making out" (*The Game*). Bright circular shapes/cavities are repeated inside and outside the tower/house and contrast with shadowy masses (*The Law*). In *Treasury* the central box is echoed in a smaller box outside and the abstract S-shaped brushstrokes are confined within the dominant vertical parameters of the tower. In these three works and those that followed, Schapiro was experimenting with new formal and thematic possibilities, and it would seem that these paintings are directly related to her own conflicts about domestic entrapment and the freedom to be creative.

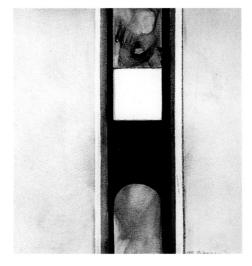

The Tower. *1961. Oil on canvas, 20 × 18"*

The autobiographical interpretation proposed here for the tower/house series is supported by both Schapiro's 1966 statement and a number of smaller works she had completed in 1959–60 (see previous chapter), bearing such titles as *Autobiography* and *Pandora* and representing abstracted but clearly identifiable variations on the mother-and-child theme. Among these is *House of*

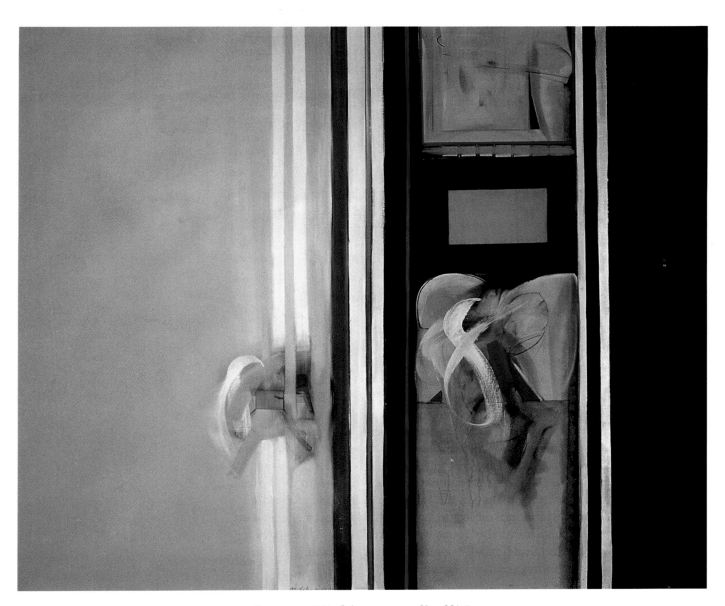

Treasury. *1961. Oil on canvas, 81 × 90½"*

the Artists showing two abstracted figures wearing hats, flanking a house or nestlike structure, which can also be read as the body of a reclining woman with breasts, a navel, and a womb.[3] In this painting the aperture or window functions as a threshold to the symbolic maternal realm, which forms the foundation for the artist's house. In this and the other works of 1959–60, Schapiro was dealing metaphorically with her perceptions of the female body, which she described in 1971 as "formed around a central core" and having "a secret place which can be entered and a passageway from which life emerges."[4] The vertical structures, with windows, gates, and enclosed figures, are allusions to both the house and the female body, both potential sources of entrapment for the woman artist. They also have covert but explicit sexual connotations as dominant phallic forms encompassing or controlling female cavities.

The tower/house/body metaphor and the creative woman's struggle with her body is reiterated in *The Tower* (1961), which features a quiet and abstracted human form within the vertical frame penetrated by a gray phallic shape. In three subsequent works in this series, *The House, Dialogue,* and *Once Upon a Time,* the female presence is introduced as the symbolic egg. In *The House,* which includes a clearly defined vertical tower, window, and gabled roof, an immense egg either enters the structure or is being expelled by it. Too large to be contained within the house, the powerful and very strongly modeled egg is both ready to rupture the confines of the rigid vertical borders and to exit from them. This relationship can also be seen as an image of birth. The confrontation between woman and house takes a different shape in *Dialogue,* in which the egg appears both inside and outside the house. Here, aspects of the fertile woman entrapped within the tower and appended outside it coexist, engaged in a dialogue.[5] The original title of the painting, *The Game Is Yours,* more specifically contrasts it to *The Game* and its flailing, sexually engaged figures. On the contrary, the interaction between the two eggs in the later painting suggests a measured and rational dialogue, a peaceful relationship between two aspects of woman: one within the house (the procreative mother) and another (the creative artist) that has left to enter the outside world. The relationship of the two eggs manifests the possibility of a multiplicity that exists alongside the unitary oneness of the phallically shaped tower. But the tension of the relationship also suggests passages between interiority and exteriority and between the real and the imaginary. The smaller egg within the tower and cavity, more fully and clearly defined, implies that the entrapped procreative woman is more fixed than the much larger and freer egg outside, whose shape is incomplete. The issue here, as in so many of Schapiro's subsequent paintings, appears to be the creative woman's relationship to herself.

Schapiro continued to experiment with the relationship of the egg to its container and its formal and symbolic possibilities in a series of egg drawings and a number of paintings in 1961–62. In *Once Upon a Time,* the large and darkly colored egg, set in a nestlike structure, has taken over the tower/house, whose central rectangular aperture it occupies with great ease.[6] The painting suggests a temporary reconciliation of the fertile creative woman with the

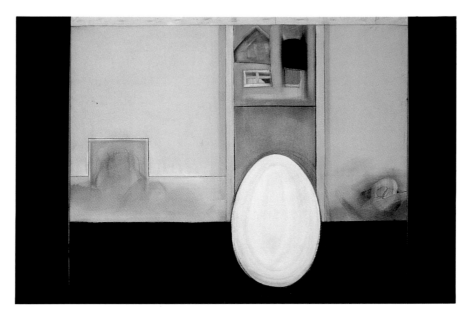

The House. *1961. Oil on canvas, 35 × 40"*

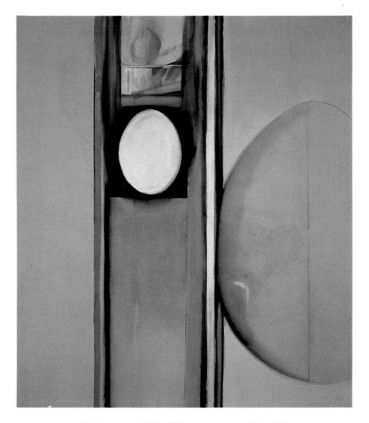

Dialogue. *1961. Oil on canvas, 40 × 35"*

house and her own body. In another canvas a single large white egg floats against a dark ground (*Egg*, 1961), while in another a beautifully formed white egg nests within a rather fragile tower (*Untitled*, 1962). In these works the egg is progressively less confined by the tower/house. In a painting of 1961, also entitled *Egg*, it becomes both egg and womb. Here the flesh-colored egg, overpainted with black shadows, has a rectangle in its center. Within this rectangle one can discern a faint ovoid shape—an allusion, it would seem, to the embryo in utero. The egg as a metaphor for herself became a significant element in Schapiro's *Shrines* series of 1961–63.

The *Shrines* were Schapiro's earliest group of fully realized autobiographical paintings. In them she defined the iconic forms she had used in the tower/house series—the window and the egg—and added the mirror. She placed these within the allusive geometric structure of the shrine, which replaced the house. The *Shrines* provided both a new thematic context and the formal order she had been searching for. In these paintings she created a new and original artistic vocabulary that allowed her—albeit covertly—to name the unspoken, the story of her life. The *Shrines* were symbolic of Schapiro's body and soul, each compartment containing an aspect of the creative woman artist. As identified by Schapiro in 1977, the uppermost space, arched and painted gold, is a symbol for aspiration; the second compartment contains an image quoted from the history of art; the third holds the egg, "the woman, the creative person, I, Myself"; and the fourth, painted silver, is the mirror where she looked into herself "to find images for the future."[7] In a more tentative journal entry of 1966, however, Schapiro added, "I looked back at the past, and at my future, and then over and over, into the mirror to ask what the painting is about. It was impossible for me to paint this picture any other way than using symbols." The metaphorical contents of the apertures/windows and the mirrors in the *Shrines* became means to visualize fragments and contradictions of desires and lived experiences.

The *Shrines*, with their personal imagery, reveal the artist's deeply felt need to place herself within a context, both symbolic and historical. A form of self-analysis, the *Shrines* enabled Schapiro to discover the multiple and fragmented aspects of herself, or, in the terminology of recent feminist theorists, the *matrixial* aspect of the self. The *matrix*, defined in the dictionary as "that which gives origin of form, . . . or serves to enclose, . . . the womb,"[8] has been proposed by Bracha Lichtenberg Ettinger as the experience of the prenatal and pre-Oedipal that corresponds to a plural or fragmented subjectivity.[9] She conceives of it as existing not "against but alongside a relativized concept of the Phallus in a universe which is plural" and partial.[10] The matrix and the matrixial, therefore, become alternatives to the exclusive use of the phallus as a symbol, as articulated by Jacques Lacan.[11] The *Shrines* and the tower/houses that preceded them, as Schapiro later came to understand, are about the "compartmentalization of women," or how "women see themselves in fragments, in parts . . . not only mind-body, but also parts of the body." They allowed Schapiro to openly bring together her male and female personas,

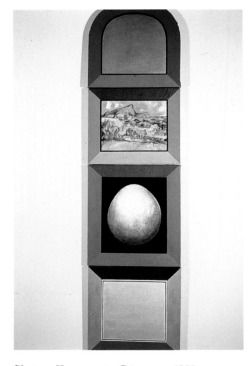

Shrine: Homage to Cézanne. *1963. Magna on canvas, 56 × 16" (four parts). Collection Walter Munk, La Jolla, California*

Detail of **Shrine: Homage to Cézanne**

which until then she had perceived as being separate. The fragments of feminine subjectivity, which Schapiro described as "contained within a sheltered space of the soul," were visually circumscribed by the oneness of the phallically shaped shrine, which, however, was also a symbolic image of Schapiro herself. Thus, these fragments remained confined within the symbolic oneness of the phallus, defined by Lacan as the symbol of power to which only men have access. With these images Schapiro was, in the early fifties, articulating complex feminist psychoanalytic ideas that did not become current until twenty years later.

The shrine/house/body, both phallic and matrixial in shape, and representative of a new self-image that is subdivided into multiple units, shows Schapiro in contact with both her masculine and feminine selves. Compartmentalized and additive, the geometrically structured and brilliantly colored *Shrines* transform the Lacanian "One" through female "multiplicity and plurality."[12] The perfectly shaped and dominant egg, often shrouded in mysterious shadows, and the mirror, which reflected both into the past and future, are Schapiro's personal symbols of access to fantasies and desires that traditional patriarchal psychoanalytic theory foreclosed.[13] In placing her work in a symbolic and personal context, Schapiro held a unique position among modernist painters, countering the major postwar tendencies of formalism and Minimalism in the United States.

Gatelike, towerlike, cabinetlike, compartmentalized, human in scale, and symbolic in content—the *Shrines* were briefly able to contain Schapiro's multiple identities and aspirations. But the connection of the woman artist with the tradition of art remained unclear. The images in the compartment with the fragment referring to art, placed immediately below her golden aspiration, vary significantly. Cézanne's *Mont Sainte-Victoire*, in *Shrine: Homage to Cézanne* (1963), is one of the few complete art historical references. An allusion to Leonardo Da Vinci takes the form of a delicate ghostlike rendering of the Mona Lisa's smile floating over a Leonardesque dream landscape; significantly, this *Shrine* is entitled *Homage to M. L.* (1963), paying homage not to Leonardo but to the mysteriously smiling female image he created. In many of the other *Shrines* this compartment contains references to Schapiro's personal history or studio fragments, such as two paint tubes (*Shrine for Two Paint Tubes*, 1962), jewelry and personal objects strung on trees in a surrealistic landscape (*Shrine: Dream Landscape V*, 1963), and, in *Shrine: Gemini (a pair)* (1963), drawings of her open palms, the fourth finger of her left hand marked by a wedding band. In two of the *Shrines*, therefore, the artist's hands and materials, part of her creative agency, replace the art historical fragment. In *Gemini*, Schapiro also records her socially constructed identity as a married woman, which has become part of her artist's hand. In this group of works the layered relationships between the real, the imaginary, and the symbolic create a network of overlapping meanings, an attempt to access that unmapped terrain of her autobiography.

Throughout her life Schapiro has longed for a creative maternal role

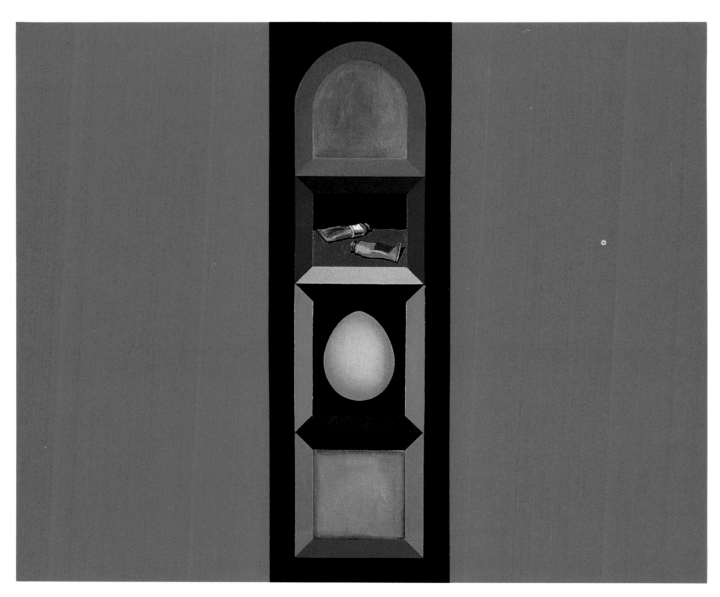

Shrine for Two Paint Tubes. *1962. Magna on canvas, 50 × 60"*

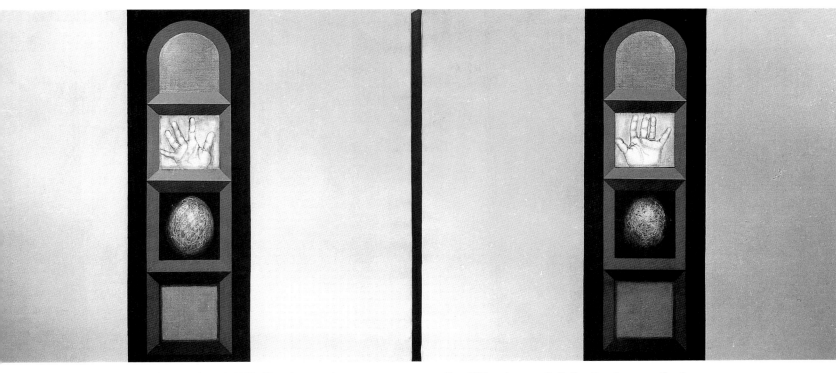

Shrine: Gemini (pair). *1963. Graphite and magna on canvas, 40 × 48"(each panel). Collection Jacques Kaplan*

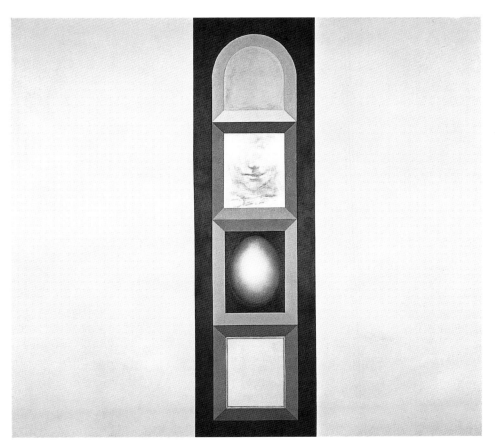

Shrine: Homage to M. L. *1963. Magna on canvas, 72 × 80"*

model to nurture and inspire her, and to counterbalance the paternal figure—principally her artist father and the great masters, especially Matisse, who dominated her creative persona. Her perception of her mother as "a dreamer without a world view," who "lived inside, at home," exacerbated her sense of woman as absence. This perception was intensified by her belief that once the daughter separates from the mother "the umbilical cord is snapped and freedom means serving others" (1975). "A woman never gets another mother." This loss motivated her search for a maternal symbol. Over the years she introduced symbols of the maternal body in a variety of guises, first the egg, box, mirror, and shrine, and later the luminous cavity, kimono, and heart. Yet none of the guises showed her own image, specifically her face. It took Schapiro more than four decades to gain the confidence to include "her shape" as a recognizable adult in her work ("Collaboration Series: Mother Russia," 1994). But even there she presents herself in a nineteenth-century costume and veil, introducing an element of masquerade that continued to question the presence of her autobiography as a creative artist in the texts of culture.[14]

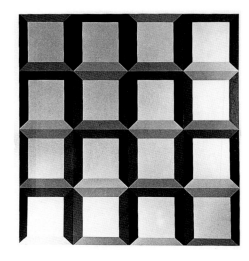

Empire. *1965. Acrylic on canvas, 80 × 72".*
Permanent loan to the U.N., New York

When she was forty-three years old, in 1966, Schapiro read Doris Lessing's *The Golden Notebook* (1962). As it affected so many other women at that time, it seemed to change her life. She identified with Lessing's protagonist, Anna, a writer who finds herself no longer able to write and whose life is sharply divided between her political activities and her roles as mother, lover, and friend. Anna records herself in different notebooks and then finally produces a fourth notebook—the golden notebook—which symbolizes her aspiration toward a greater unity of her identities. These notebooks, as Moira Roth has suggested, constitute "a final formal expression of the discord of the selves."[15] Schapiro's *Shrines* likewise presented a formal record of the artist's different selves, as well as her aspirations—symbolized in the arched gold segment of the house/shrine—to integrate them. But the most important message of *The Golden Notebook* for Schapiro was the possibility that Lessing's novel might be autobiographical—that Lessing's experiences as an artist and woman might be as complex and conflicted as her own. Perhaps, she thought, she was not alone.

The *Shrines*, which briefly answered Schapiro's deep-felt need for a unified self, appeared in a solo show at the André Emmerich Gallery and were included in the 1963 exhibition "Towards a New Abstraction" at the Jewish Museum. The "Sixteen Windows" series that followed took the form of highly ordered grids that repeated the mirror, the lowest compartment of the *Shrines*, sixteen times. The compartments in this series, however, were divested of any reference to a recognizable private world of fantasy and desire. Appropriately, the subtitles of some of the paintings in this series allude to public places and their vast anonymous spaces, such as *St. Peter's* and *Empire* (1965), and, with a subversively bizarre streak, *Kingdom of Pink*. The matrixial cavities, emptied of symbolism, become mirrors that only reflect woman's absence, echoing Lacan's statement that, in the symbolic realm, woman "does not exist and signifies nothing"[16] and recalling Schapiro's own question: "Where is the mirror in the world to reveal who I am?" In 1963–65, in spite of her professional success,

Miriam Schapiro could neither see herself reflected in the mirrors of her art nor access her autobiography. Her old fears would rise up: "Work belonged to men; could *I*, could a woman be an artist?"[17] But the canvas/mirror, as a reflective surface, still held out hope for the future: the hope that by looking over and over into the mirror she might be able to find "what the painting was all about" and, therefore, uncover her story.

The transition from the *Shrines* to the *Sixteen Windows* was more circuitous than it appears, as Schapiro's journal entry for September 1965 reveals. It began in the spring of 1965 with an experimental painting, "a very complex box painting with 12 little paintings in it—collections of abstract paintings done in the manner of the '50s," but "other styles crept in—one seemed like a Francis Bacon." These insets were "true unconscious abstract impulses," and a number of them seem to allude to surrealist paintings. Four compartments in the center are empty and flesh-colored, and behind them hovers a large egg. The multi-colored mitered frame of the painting expresses Schapiro's "strong need to arbitrarily control the surface with the frame or grid imposition." The frame provided the order, and the colors were intended to achieve strident and bizarre effects that would "demand equal time." After the painting was completed, she began to make collages, out of which "came two collages with 16 boxes and silent inserts" controlled by a superimposed grid. After much reflection and anguish she "decided less is more" and started her new series of paintings. In this process she silenced her impulses and disconnected her art from her unconscious. With the decision that "less is more," she brought her painting in line with the large, hard-edged, and minimal abstractions of her male peers.

After the "Sixteen Windows" series Schapiro created a series of large, geometrically structured, and intensely colored canvases devoid of recognizable symbolic or self-referential content. Works such as *Byzantium* (1967) and *Painting City* (1966) received consistent and positive critical attention and were included in a number of important group shows.[18] In spite of their abstractness, they suggest a breaking up of the rigid structure of the grid and a possibility of outward motion. This new group of works coincides with Schapiro's and Brach's move to California in 1967, where he became the first chairman of the art department at the University of California, San Diego. Schapiro taught in the department as a lecturer, and for one year as an acting assistant professor, and painted in a studio on campus. Responding to the scientific ambience of La Jolla, Schapiro created, in collaboration with physicist David Nalibof and artist Jack Nance, a series of computer drawings and paintings. These large, formalist, and geometric paintings, in tune with the general trends of American art during the sixties, suggest that Schapiro was creating for herself a place in the masculine milieu of the New York and California art worlds.

During this period Schapiro made one of her most significant paintings, *OX* (1967). In 1974 she described it as her "explicit cunt painting," noting its "tender shades of pink," its invitational and seductive nature, and its great assertiveness in both color (red-orange, pink, and silver) and form.[19] More recently Schapiro has stated "in fact, cunt imagery was . . . a real cry in the

Painting City. *1966.*
Acrylic on canvas,
80 × 72". Hirshhorn
Museum and Sculpture
Garden, Washington, D.C.

Byzantium. *1967.*
Acrylic on canvas,
108 × 72". Barbara
Kafka Foundation

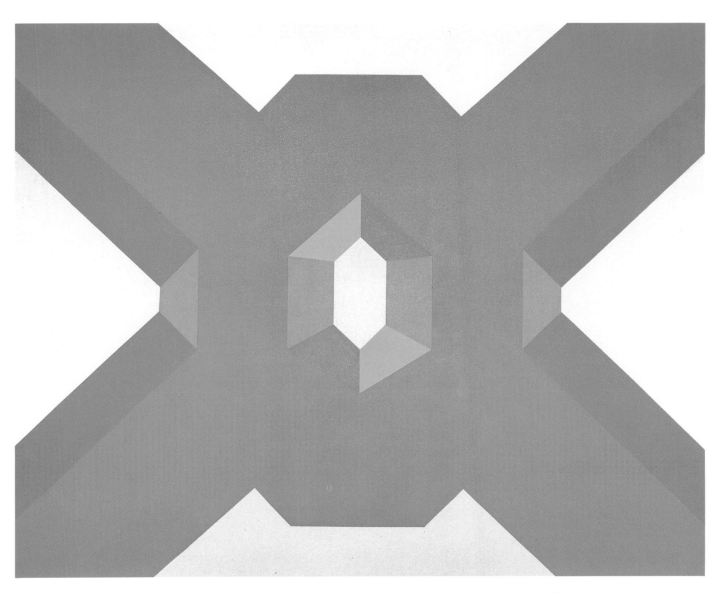

OX. *1967. Acrylic on canvas, 90 × 108". Museum of Contemporary Art, San Diego, California*

darkness . . . for something besides the symbol of the phallus."[20] Clearly the painting tapped into parts of her subconscious that she had not reached before. *OX* is a metaphor for the female body and for female desires. As a shape, it refers back to the *Shrines*, with their open passages and ovoid shapes. The "O," the nucleus of the composition, is the egg transformed into an octagonal aperture, a window or passage into the maternal body. No longer contained within a compartment or a tower, the maternal body exposes its passageway and dynamically extends outward in the outstretched limbs of the "X." Neither fragmented nor compartmentalized, the painting was a new stage in Schapiro's continuing quest for a unified identity.

It was difficult in 1968 to speak out about the true meaning of the painting. Schapiro's first public statement about *OX*, in 1969, was guarded and veiled. She explained that she was inspired "by the thought of a large, imposing sense of landscape coming toward the viewer and inviting him to become part of it." She wanted it "to look terribly real and present" and wanted "the spectator to stop and think, 'Here I am, and who are you?'" The only way she could do this "was to reproduce the experience that ordinarily stops a person every day of his life—namely, the stop-sign." For her, "orange is a stop color," so she painted *OX* orange. In order to give the spectator the feeling of "being able to tunnel right into" the painting, she strengthened the illusionism through sensual and inviting colors, using the most intimate color, that of flesh. She then set the structure into an inclusive silver space "with a refractive and inspiring light."[21] In her artist's statement for an exhibition at the University of California at San Diego, in 1970, she was even less explicit, describing the origin of the form of *OX* as simply the superimposition of the letter O on the letter X. "The first image is a frontal one (my Egyptian period). The second version shows *OX* from a different station point—there are two drawings for this work which is called '*Side OX*.'"

In 1974, she explained the meaning of the painting in a public lecture at the National Gallery, in Washington, D.C., clarifying that it was a metaphor for her own body. Her explicit "cunt painting" revealed that a woman could have "strong, male-assertive, logical, measured, and reasonable thoughts in a female body." Finally, in 1992, she placed *OX* and "cunt art" within the context of the revolutionary seventies and their aftermath.

> *This work, the early work of cunt art, and various ways that women show themselves holding a mirror to themselves contributed to the changing ideas of modernism. It was radical, as radical as Cubism, but not touted in the same way. Not written about in the same way, not exposed in the same way. It continues to be underground art, even though I have that painting hanging in a major museum in the West. It makes no difference. It is my bottle, with a little note inside. My note, a note that can be read only by women.*[22]

OX and its variants (e.g., *Side OX*, *Fallen OX*), which were inspired on a formal level by two letters of the alphabet and could pass as the epitomy of

Again Sixteen Windows. *1973.*
Enamel spray, watercolor, and
fabric on paper, 30½ × 22½".
Private collection

large, powerful, aggressive, and virile paintings, are, in fact, statements by a woman about her desires, aspirations, and conflicted feelings. At a time when there was as yet no formal language to speak about women's fantasies and desires or to articulate issues of gender construction, Schapiro invented an iconic emblem. Transforming the letters on which it was based, she gave them a new meaning, yet one that remained private since the symbols for feminine otherness as seen by a woman do not exist in patriarchal culture.

Schapiro returned to the grid of sixteen apertures twice in subsequent decades. Both paintings illustrate the profound changes in her work after 1971 as a result of her involvement in the feminist movement. *Again Sixteen Windows* (1973) is a much smaller and more intimate work than the earlier series. Here the mitered window frames are constructed of checkered and calico-patterned cloth, and the apertures are filled with segments of floral cloth and embroidery. The matrixial openings lead back to childhood memories of home and kitchen, to woman's accepted social domain. Acknowledging its special meaning, Schapiro made a gift of the piece to her mother, establishing a new relationship with the maternal and accepting that the maternal and the creative are not incompatible. The matrixial apertures/mirrors/windows in this work are no longer empty, nor are they circumscribed by the symbolic phallus, as they had been in the *Shrines*. The grid, formally both modernist and traditional, is a multivalent framework that refers to both quilts and modern abstractions, and is also another definition of *matrix*.[23] Schapiro created a network of childhood memories of the mother, whom she feared she had lost.

In her recent "Collaboration Series: Mother Russia" (1993–94), Schapiro, for the first time, explicitly combined the grid with her genealogy of artistic female ancestors (her mothers). She also introduced the word *matrix* in the title. In *Russian Matrix* (1994) she acknowledges the possibility of a female meaning for the word *matrix*, "the womb, that which gives origin of form." She incorporates in it the human image in order to deal more directly with the lives and images of women. In this and other recent works she both celebrates historical women as creative artists and confronts woman's assumption of "the masquerade of femininity."[24] Each of fifteen of the sixteen apertures or windows has a floral or abstract fabric ground, surrounded by an individual recessed frame, and is occupied by the portrait of a modernist Russian woman artist.[25] In the remaining window is a portrait of Schapiro herself, in disguise, wearing a veil and hat (right side, second from top). Through the repetition of the artists' faces and the inclusion of her own, she strives to make herself and the Russian women artists visible, thus counteracting, in Lacanian terms, the nonexistence of woman within the context of the symbolic and, by extension, the creative.[26] The reflections of faces in the mirrors of the grid are partial and multiple answers to her question, "Where is the mirror in the world to reveal who I am?"

By using screenprinting in the painting (the first time she had done so), she simplified the portraits of the Russian women. She emphasized their plainness and directness, the absence of cosmetic femininity, with a lack of

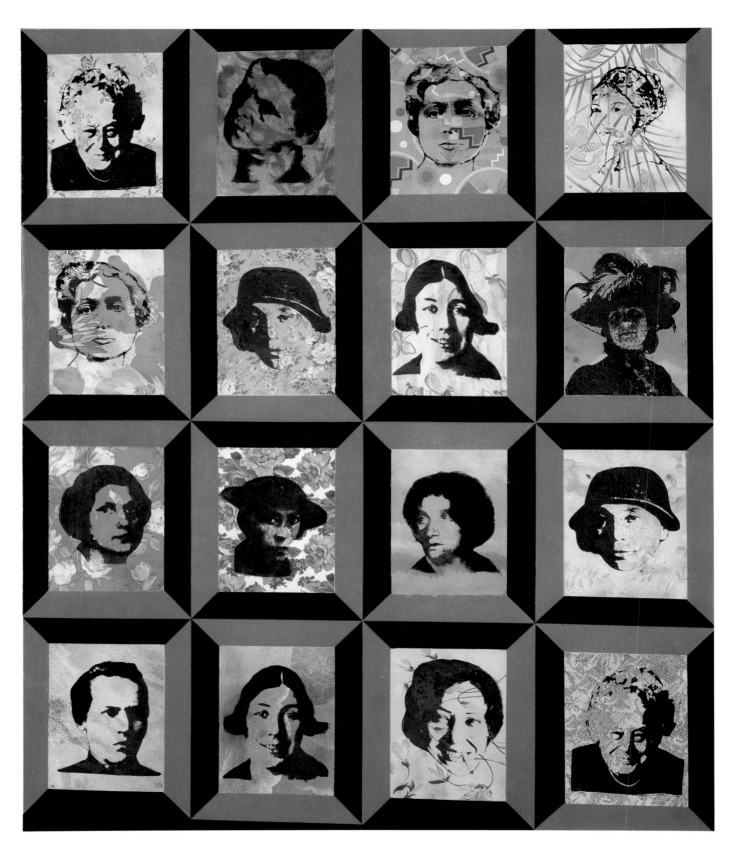

Russian Matrix. *1994. Silkscreen on fabric and acrylic on canvas, 60 × 50". Collection Catherine Muther, San Francisco*

painterly embellishment. In representing herself, however, she used masquerade and disguise, and therefore distinguished herself from her genealogy of women. Wearing an elaborate nineteenth-century plumed hat, her face covered by a veil, she claims her place within the matrix, a universe that is plural, partial, and composed of units that can be added to each other. Since she is in masquerade, presenting stereotypical femininity as a disguise, we are uncertain of her true identity; her self-portrait seems to be at odds with the straightforward portraits of the Russian women modernists. Significantly, this self-portrait is based on a photograph that Schapiro had used on the cover of the modest catalogue of her retrospective exhibition after *Womanhouse*, in 1975, which included some of her *Shrines*, computer paintings, and femmages.[27]

In her self-portrait Schapiro appears to be taking on womanliness as both masquerade and performative act. Her image suggests that gender is, in Judith Butler's terms, a "corporeal style," an "act that is both intentional and performative," and that the woman artist can only exist in disguise.[28] However, Schapiro uses the image three times in "Collaboration Series: Mother Russia," and it thereby transcends disguise to become an emblematic device. Her repeated portrait, in fact, functions like a signature asserting authorship. The portrait also has a special meaning for Schapiro, for the costume was given to her by her students in the Feminist Art Program and the initial photograph was taken by them. As the oldest member of the group she became "the consummate nineteenth-century person—complete with fan." The playful nature of the photograph questions the validity of feminine disguise as anything more than a game or fleeting illusion. Behind the veil is the face for which Schapiro had been looking all her life and which, as the emblem evolved, became increasingly more visible.[29]

As she further explored issues of gender formation in the context of costume and disguise in her autobiographical work of the eighties, Schapiro gave different answers to the question of what lies behind the masquerade.[30] Like herself, her images of women are in the process of becoming. As she looked into the mirror, the window, and the matrix of her creative and procreative self, she found multiple symbols, fragments, and apparitions that raised the conflicting issues surrounding the gendered constructions of femininity, masculinity, creativity, and identity politics. The reflections in the mirrors and apertures of her "tower/houses," *Shrines*, and grids are part of her attempt to make "a real world on canvas," knowing full well "that the made world can never be wholly real," as she observed in 1966 about her intent in painting *The Game* (1960). *The Game* of sexual encounter was a fragment of her life, part of the autobiography that she had to invent, as she went along, through the story of the other, the story painted, drawn, and inscribed on the blank canvas. The search for the mirror in the world is part of Schapiro's search for her autobiography, which is still missing because, like her painting *OX*, it has not radically affected the broader cultural context in its beliefs about femininity, creativity, power, and the female body. It is, as she said in 1992, her "bottle with a little note inside."

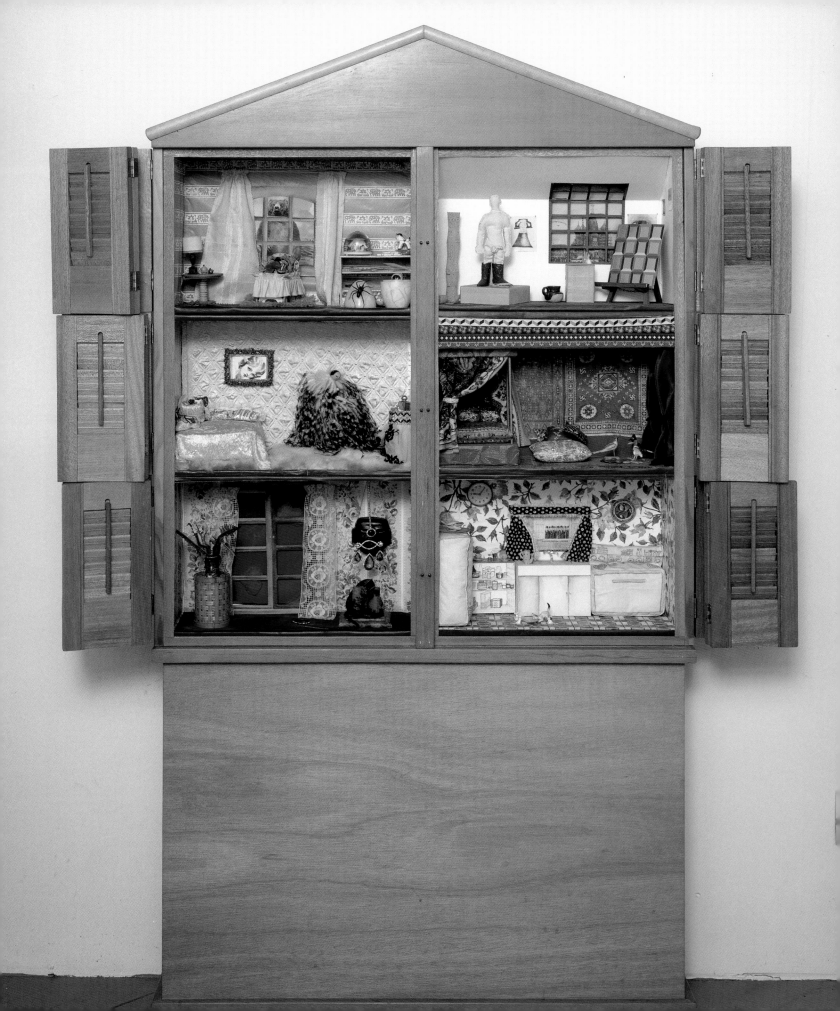

4.

FEMMAGE: FABRIC, ORNAMENT, AND SENTIMENT

For me the fabric of my art and the fabric of my life equate each other.
 —Miriam Schapiro, 1976

The seventies were a period of profound and radical transformation in Miriam Schapiro's life and art. She discovered that she could construct a genealogy of women artists and, for that inspirational decade, was able to distance herself from the thought that had plagued her since high school: "that she was in a woman's body with a man's concerns." After fourteen months of teaching in the Feminist Art Program and not doing any work of her own (except for the collaborative project *Dollhouse*) she returned to her studio and began "making art out of women's lives." Using fabric and acrylic paint she invented "femmage," which, in both form and content, expressed the creativity of women within the confines of traditional domesticity.[1] This body of work, which encompassed Schapiro's politics and identified the canvas as a site for political exploration, became central to the feminist art movement of the seventies. It differed profoundly from the large geometric abstractions and computer paintings she had been doing in 1970–71.

In 1970, after joining the faculty of the new California Institute of the Arts in Valencia, Schapiro met Judy Chicago. Having visited her class for women artists at Fresno State College and having met women artists in Southern California, she was exposed to profoundly different contexts from the professional New York art world. The women were not working in studios, but in dining rooms, kitchens, or whatever space they could find in their homes. This experience prompted Schapiro to invite Chicago to team-teach a class for women artists. In 1971 they founded the Feminist Art Program as part of the California Institute of the Arts, the first art program of its kind, to encourage women to make art out of their own lives and fantasies. The program radically questioned the approach, content, and methods of art-making as taught in graduate and undergraduate art programs at the time.

Out of the Feminist Art Program came *Womanhouse*, the epoch-making feminist political statement of the early seventies. Schapiro and Chicago and twenty-one women students transformed an abandoned Hollywood mansion, slated for demolition and owned by an elderly eccentric woman who made it available to the program, into an environmental piece by, for, and about

Dollhouse (with Sherry Brody). *1972. Made for* Womanhouse. *Three-dimensional construction, mixed media, 84 × 40 × 9".* *National Museum of American Art, Smithsonian Institution, Washington, D.C.*

women. *Womanhouse* transcended in every way the models, norms, and standards accepted by the art establishment. In celebrating the domestic lives of women the artists gave the abandoned home new life and meaning. Traditional women's arts and crafts, painting, collage, assemblage, weaving, needlework, and sculpture, as well as performance pieces were combined into an all-encompassing environment. The site-specific piece about women in the home became a legend in Southern California. As soon as *Womanhouse* was completed in December 1971, reporters from *Time* and *Life* and representatives of *Encyclopedia Britannica* and public television arrived at its door, and for three months thousands of people, predominantly women, streamed through its rooms. The women of the program had achieved their goal: out of their lives, fantasies, and politics they had shaped a new aesthetic sensibility that questioned the status quo.[2]

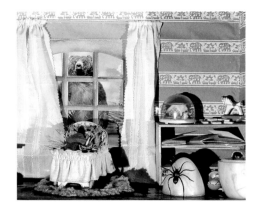

For *Womanhouse* Schapiro created *Dollhouse* (1972), in collaboration with Sherry Brody. They returned to the theme of the house/shrine Schapiro had used earlier and transformed it into a three-dimensional structure, using wooden wine cases and small objects from their private storerooms. The four windows of the *Shrines* became six and were filled with miniature rooms. The rooms suggested very specific images that had little to do with official or sanctioned art: a parlor and a kitchen (first floor), a star's bedroom and a seraglio (second floor), a nursery and an artist's studio (top floor). All this was created from the two women's hidden treasures—discarded small objects, personal mementos, and bits of fabric —things traditionally collected by women but never used or exhibited in public.

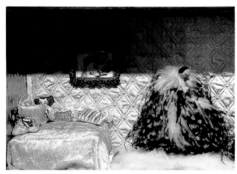

Details of **Dollhouse**

Originally the six rooms of *Dollhouse* were set against the wall in a special room in *Womanhouse* (the "Dollhouse Room"), creating a second illusory reality also focused on women's lives. After *Womanhouse* was dismantled, Schapiro took *Dollhouse* to her own house, had it reconstructed into three floors, and capped it with a pediment. She placed it on a tall podium and framed it with functional shutters, making it look like an ancient temple or treasury. It became both house and shrine, a miniaturized and dreamlike vision of women's lives that could be kept private when the shutters were closed or made public when, on special occasions, the gates were open. Combining playfulness and irony, *Dollhouse* refers to a female reality that in both scale and content is unreal. The rooms refer to women's lives combined with dreams and nightmares. What woman has a seraglio, or wants to live in one, and how many women inhabit a star's bedroom? Softly upholstered, carpeted, and windowless enclosures, these two rooms suggest either the comforting and protective space of the womb or prison cells from which there is no exit. However different, both allusions speak of confinement. When *Dollhouse* was finished Schapiro realized its pivotal significance. It made her see art-making from another perspective—from "the eyes of a woman." *Dollhouse*, to some a "frivolous" work, released Schapiro from the previous imperatives to create mainstream art. Through her collaborations in *Womanhouse* and *Dollhouse*, Schapiro was able to integrate the formal box, the geometric grid, her painted and collaged surfaces, and the stuff of her everyday life. She transformed her private life

Curtains. *1972. Acrylic and fabric on canvas, 60 × 50"*

into a public act, validating the traditional activities of women, which she had, until then, dismissed.[3] She returned to her studio, and work, as she said, "just poured out of her."

In discovering the means to access the stories of other women and her own autobiography, Schapiro began to fulfill her longing for a maternal prototype. She embarked upon a series of works that establish her connections with women as creative beings—women artists of the past, living women artists, women friends, and anonymous women past and present who managed to create beauty within the confines of their lives in the home. Her layered femmages of the seventies and eighties are among the most significant works in her quest to invent a form that could become "a container for her feelings." The iconic images in Schapiro's femmages—the cabinet, the apron, the kimono, the vesture, the heart, the house, and the fan—are metaphors for women and for Schapiro herself. They pronounce the absence of women from official histories as they establish women's presence on the margins. Throughout the seventies and early eighties, Schapiro's awareness of women's marginalization motivated her choice of subjects, materials, motifs, and themes. Every artistic choice she made had a political dimension. By describing the daily ways of her life, she was redressing "the trivialization of women's experience."[4]

In using crunched handkerchiefs, fabric, and Valentine's hearts, Schapiro also questioned the negative implications ascribed to both sentiment and women's handicrafts, officially excluded from the realm of serious art. As Arthur Danto observed, Schapiro's art "presenting itself as high art . . . calls into question the distinction between 'high art' and the art women unassumingly contrive without thinking themselves as artists."[5]

But the switch from hard-edged, abstract, geometric paintings to collages incorporating fabric was extremely difficult for her, as is clear in her recollection about creating *Curtains* (1972), her very first painting with fabric:

> No sooner had I finished this painting . . . [when] the moment of crisis arrived and I was panicked. I was in a real panic and I sort of knew what the panic was about, it was about having put the fabric on the canvas, having glued it on. I had never done that before, and I was frightened. I was frightened of having done something wrong, and again it came to my mind that when we were doing Womanhouse there was no man there standing over us. But here in my studio where I was all alone with my canvas he appeared, the invisible man, the man of my entire life, the man whose critical judgings were correct. And that man lived within me, and I was the one who was being critical about the painting.[6]

Made of paint, organdy, and trimmings, the rectangular composition of *Curtains* is divided into two sections by strips of eyelet that appear to be pulling open. Schapiro was about to unveil her whole female side. To decide as an established forty-nine-year-old artist to unveil a side of herself that was culturally identified as trivial, unimportant, and unartistic took a special kind

of courage. Among other things, she had to confront her own masculinist artistic training—"the man that lived within her"—before she could begin collaging her story, which she had yet to own.

Masculinity and femininity and past, present, and future meet in *Lady Gengi's Maze*, Schapiro's first large work of 1972. In a roomlike enclosure framed at the bottom by a wall or fence, with steps leading up to a door, three carpet or quilt shapes, two covered with rich floral patterns in fabric and one painted, seem about to float out of the confines of the architectural setting and of the canvas. The lower structure, with its rigid geometry and linear drawing, recalls her computer-generated work. Schapiro has described it as an empty garden. But the ordered geometry does not inhibit the freedom of the flying carpet-quilts that almost totally fill the room. Implications of palace and maze are combined with allusions to Eastern splendor. But the sheltered female existence acquires new assertiveness and freedom in the images of the carpet-quilts, one of which has a central aperture or cavity, Schapiro's familiar reference to the body of the procreative woman. The idea of a house or palace as a confining space is clear both in the title of the painting and in its spatial and architectural setting; the black steps lead to a gray door that is shut. But unlike in the *Shrines*, the creative woman can no longer be contained in geometric structures; she rises out of them.

Schapiro further explored this newly found freedom in a group of paintings of the early seventies. Three of these, *Explode*, *Mimi's Flying Patches*, and *Window on Montana*, allude to the house, or female habitat, and the window, which represents the passage to the maternal body. On a formal level, Schapiro was experimenting with what she described as "the explosion of forms against the grid or rectangle." Out of a central rectangle, a luminous or diaphanous cavity, float bits of exuberant and freely structured fabric, embroidery, and lace. The contrasting aspects of the geometric grid and the splintering shapes, which Schapiro associated with modernism and postmodernism, respectively, represent the artist's aesthetic and political orientation: the formal box, "the symbol of where [she] had come from" and the flying fabrics, a metaphor for "anarchical action." The femmages are created from the fabric of women's lives, and Schapiro saw herself as part of the fabric. The autobiographical nature of these works is particularly apparent in *Personal Appearance* (1973). Here fabrics fly out of or are given birth by a shrinelike body with a floral basket as a head. Reaching outward in multiple directions the fabric fragments are reminiscent of the outstretched limbs of *OX*. In this case, however, they clearly allude to the shared experiences of women: their memories and fantasies, freedoms and constraints, sorrows and joys.

Constructed out of multiple pieces of cloth that create a weblike structure, Schapiro's femmages can also be read, on a psychoanalytic level, as providing routes of passage between the artist-subject and the women who inspired the works. These interconnecting subjects, which include the artist herself, can be seen as a symbolic web of prenatal memories of the maternal body. Her matrixial passages, apertures with blurred borders partly screened by fragments of cloth, give access to that which Ettinger has identified as "another kind of sense-

Computer Image (Cage). *1969. Enamel on magna on canvas, 40 × 50"*

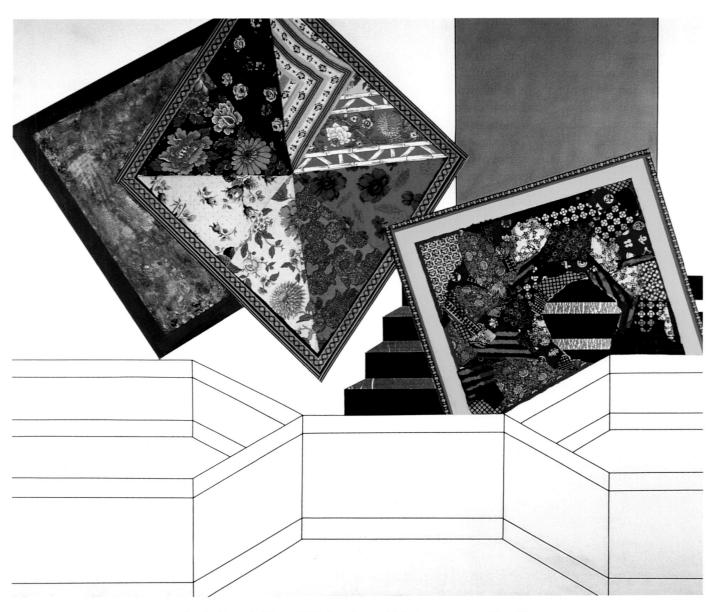

Lady Gengi's Maze. *1972. Acrylic and fabric on canvas, 72 × 80"*

making and a route for the feminine to filter into the symbolic, into meaning."[7]

These works of the early seventies visually articulate the question Schapiro asked in 1970: "What does it feel like to be a woman; to be formed around a central core and to have a secret place which can be entered and a passageway from which life emerges?" The central aperture in these collages emanates light, drips paint, or "gives birth" to pieces of fabric. *OX* had been her first explicit central-core painting, though the egg and the apertures in the *Shrines* of the early sixties certainly had alluded to it. Throughout the seventies, when the gender implications of central-core painting became hotly debated, Schapiro held on to the central aperture as a reference to the womb. She placed it under aprons and handkerchiefs, and in the center of vestures, houses, and hearts. It became an expression for the necessary condition of her own identity and an essential part of her retrieval of women's history.[8]

Schapiro's new style reached a critical point of resolution in *Cabinet for All Seasons* (1974). Here abstraction, decorative pattern, and feminist imagery are combined with the architectural framework of four arched, gatelike shapes with a human scale that incorporate elements from earlier work—the grid, the window, and the shrine. Posed midway between dream and reality the four units have as their center a cabinet, three shelves within a dark recess, a symbol of the dark and mysterious female space and a passage to her inner being. Covered with a pattern of floating flowers and floral bouquets, each of the four units has a dominant color scheme evocative of a particular season—red for fall, white for winter, yellow for spring, and green for summer. The scale, order, and monumental rhythm of this work, with its shifting color harmonies, validates its feminine subject matter, materials, and decorativeness. Like doors, the four units invite the onlooker into the house and, therefore, into a woman's inner being and its changing moods.

Much as the themes of the maternal procreative body and the fabric of women's lives released Schapiro's creative energies, so too did her "collaboration" with other women artists. She first used this theme, expressing her search for female artistic ancestry within the history of art, in a series of "collaborations" with Mary Cassatt. Through these works Schapiro established a female/maternal genealogy as a model and organizing image for her own artistic endeavors. Stimulated by the exhibitions "Old Mistresses" at the Walters Art Gallery and "Women Artists 1550–1950" at the Los Angeles County Museum, Schapiro created these small collages on paper, twenty by thirty inches, with a sense of urgency to record the existence of her female artistic ancestors whose work had been completely absent from history books.[9]

Each of the "collaborations" focuses on a cutout reproduction of a painting by a woman artist of the past, who was at least known by name, such as Mary Cassatt or Berthe Morisot. The reproductions depict the kind of daily tasks and incidental events that Cassatt and Morisot favored—a mother bathing her child, a woman reclining on a sofa, a woman gazing in a mirror—and are often flanked by photographs of rooms in Schapiro's house, her garden, the seashore, or her friends. The central images are framed by an exuberant

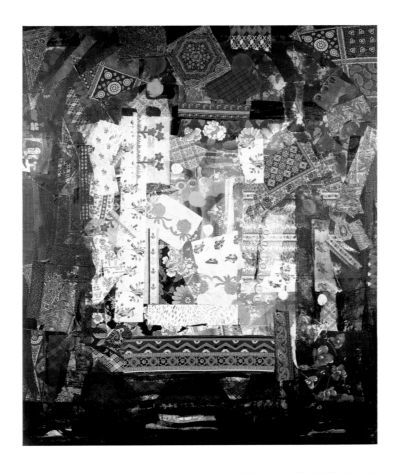

Window on Montana. *1972. Acrylic and fabric on canvas, 70 × 60". Collection Bruno Bischofberger, Zurich*

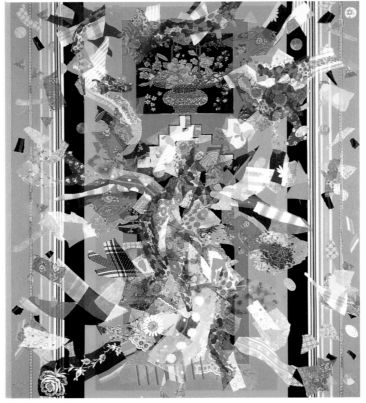

Personal Appearance #3. *1973. Acrylic and fabric on canvas, 60 × 50". Collection Marilyn Stokstad, Lawrence, Kansas*

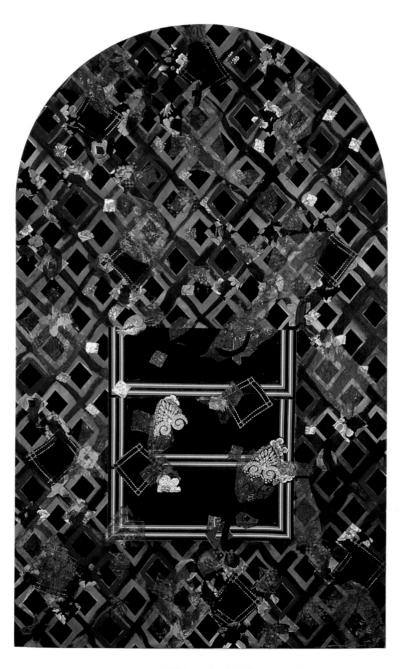 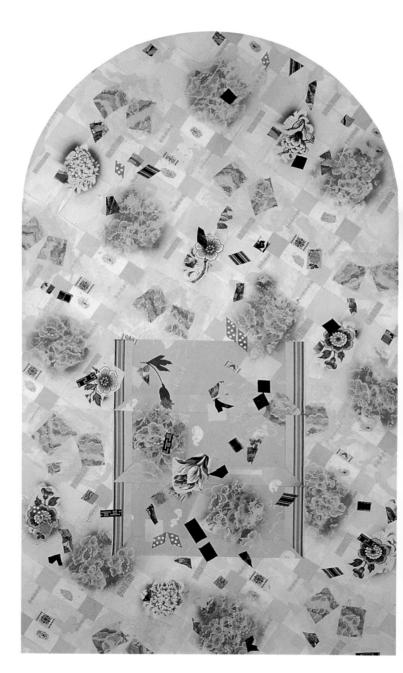

Cabinet for All Seasons *(four panels). 1974. Acrylic and fabric on canvas, each unit 70 × 40"*

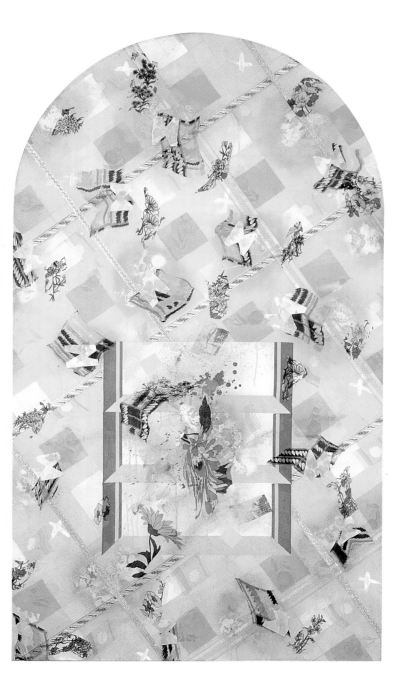

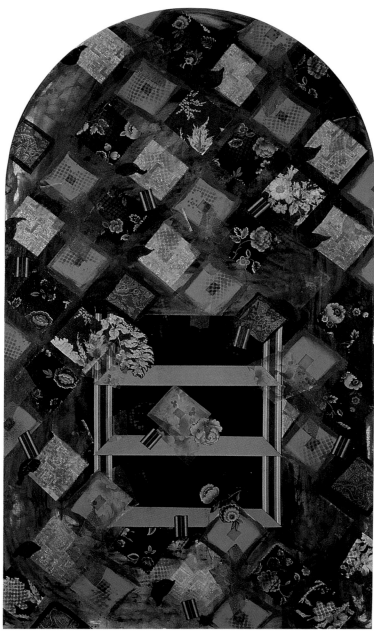

patchwork border of fabric squares and rectangles with floral and geometric motifs organized in clear patterns, which emphasizes the flat picture plane. As a result, the central sections with their receding space read like windows through which we can view and enjoy a private moment. The colorful borders, in referring to women's handicrafts, further extend this experiential aspect. In these "collaborations" the woman artist and the art-historical reference are no longer compartmental- ized, as they had been in the *Shrines*. Instead, these works emphasize the woman artist's view of women's private lives.[10]

One of the most sensuous and beautiful pieces in this series, *Collaboration Series: Mary Cassatt and Me* (1976), includes a reproduction of Cassatt's painting *Mother Reading Le Figaro*. In addition to the rich quiltlike border, the reproduc- tion in the composition's central field is encompassed by a live- ly pattern of floral bouquets interspersed with bits of floating fabric. Here Schapiro overlapped her own mental image of her mother with Cassatt's maternal ideal—her mother, an indepen- dent, intelligent woman, reading a serious newspaper within the context of the home. In both cases the image of the mother expressed the daughter's desires for access to the mother as an intellectual being. In Schapiro's mind, the Cassatt painting and her "collaboration" are as much about an ideal concept as they are about reality.[11]

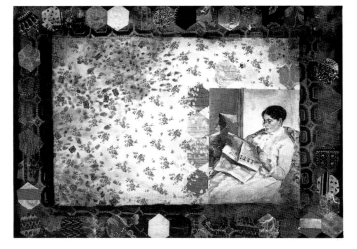

Collaboration Series: Mary Cassatt and Me. *1976. Watercolor and collage on paper, 30 × 22" (includes Cassatt's portrait of her mother)*

Schapiro also did a number of "collaborations" with male artists, includ- ing Delacroix, Gauguin, Courbet, and Gericault.[12] In these pieces the men's faces, often self-portraits, are partially concealed with lace, for example, in *Courbet and Me*—the woman's art layering and obscuring the memory of the male master. In *Collaboration Series: Delacroix and Me* (1975), one of Delacroix's Orientalizing watercolors, showing a reclining soldier and a woman in harem dress, is placed below the hem of a stately floral robe—the powerful female presence rising above, enveloping, and partially veiling the male artist's image of the gendered relationship between a man and a woman. The spirit of Schapiro's "collaborations" with men is profoundly differ- ent from her concurrent "collaborations" with women, expressing a different intent: a celebration of the newly found maternal genealogy versus a partial veiling or overlaying of the male tradition of art, which until then had domi- nated Schapiro's artistic life. As she commented recently: "I can never forget that my male instructors in art wished to neuter me. I was to make art as it had been made before me by men."[13] In several of these works the art by the men is incorporated within a female matrix. This is especially evident in *Paul Gauguin and Me* (1975), in which Gauguin's early self-portrait and an image of one of the Polynesian women he so often painted are enfolded within a rich kimono. The pensive Gauguin is set within the dark central cavity of Schapiro's composition, which flows from the body of Gauguin's female image.

Capturing the essence of women's personal, intimate, and everyday expe- riences reached an extreme in Schapiro's work when she began collaborating

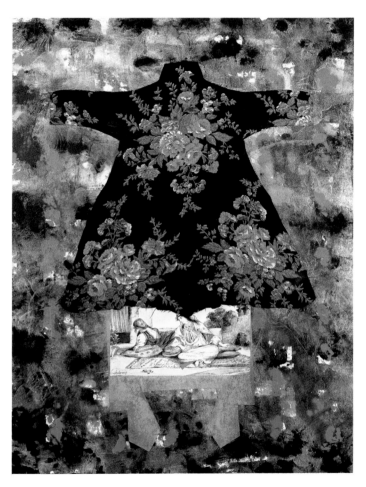

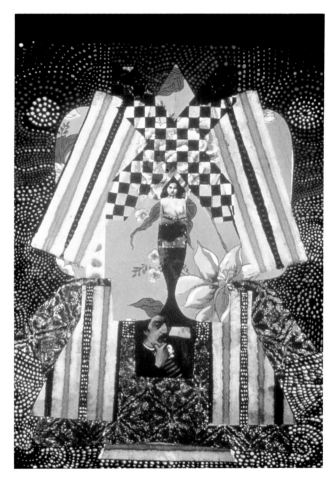

Collaboration Series: Delacroix and Me. *1975. Watercolor, paper, and fabric on paper, 30 × 22"*

Collaboration Series: Paul Gauguin and Me. *1975. Watercolor, paper, and fabric on paper, 30 × 22"*

with anonymous women and introduced actual handkerchiefs, aprons, doilies, napkins, and tablecloths into her femmages. The expressive, moving, and poetic titles of these pieces were hand-embroidered by the women: *My Nosegays Are for Captives, She Sweeps with Many Colored Brooms* (1976), *Water Is Taught by Thirst* (titles derived from Emily Dickinson) and, more simply, *Patience* (1977) and *Souvenirs*. The period when these collaborations were made was very important for Schapiro. She had begun traveling and lecturing throughout the country and meeting the many women who were part of her new audience. She asked them for souvenirs—a handkerchief, a bit of lace, an apron, a tea towel—some object from their past that they would be willing to have "recycled" in her paintings. Having reached this extreme stage of interpersonal intimacy in her work Schapiro, characteristically, began to monumentalize her newfound sense of communion and transform it into a more public statement. In *The Architectural Basis* (1978), she created an imposing handkerchief femmage, composed of handkerchiefs formally placed around an elegant but small tablecloth that once belonged to art collector Ima Hogg of Texas.

> *Alice Simkins, her relative, gave it to me because she believed in my sense of carrying history with me in my paintings. Ms. Hogg was a great civil servant in the State of Texas and the cloth is her memento. When you look at this painting I want you to think about the ordinariness of handkerchiefs, how women used them to soak up their tears. Some of them are flattened out on the surface on the canvas and some are crunched up. They appear to fly and move and rush like Alice, down the rabbit's hole. The grid is there in my painting so you can think about form, the handkerchiefs so you can cry.*[14]

The flattened and floating handkerchiefs, with their rich embroidery and lace, suffuse the severe geometry of the work's underlying formal structure. They embody the physical realities of women, their bodily liquids, their tears, and sweat. These are bittersweet works that deal with unresolved conflicts.

When Schapiro exhibited her handkerchief paintings and other femmages in a solo show at her New York gallery in 1976, her dealer, André Emmerich, was aghast. Nor could he understand why she would want to include in her artist's statement expressions of gratitude to over forty women, including:

> *Adele Blumberg for her beautiful embroidery in the paintings* Veil of Tears *and* Souvenirs; *Enriqueta Pena who sewed the words "SHE SWEEPS WITH MANY COLORED BROOMS" and "MY NOSEGAYS ARE FOR CAPTIVES"; Mimi Roberts who assisted me with the painting* Anatomy of a Kimono; *Carole Fisher for finding the tablecloth I used in WATER IS TAUGHT BY THIRST and for sending so many handkerchiefs she found in Minnesota and Wisconsin thrift shops.*[15]

Schapiro's art had become the bond for a reading of the story of the Other, and the gratitude she felt toward these women for their "symbols of connection"

was profound. Her dealer claimed the handkerchiefs had nothing to do with art. For Schapiro, however, these mementos were at the core of her art. Believing that the medium is the message, she did not wish to deal with domesticity "minimally," but with Victorian abundance of both sentiment and ornament. This was Schapiro's last exhibition with the André Emmerich Gallery. Her professional life was moving in new directions.

One of the most significant events for Schapiro during this period was her return to New York City, where, in 1975, her husband had accepted a position at Fordham University. Announcing her arrival, she created a monumental femmage, *Anatomy of a Kimono* (1976). Composed of ten sections and dedicated to the new women of the seventies, the painting was intended, with its scale and formal structure, to establish her artistic authority among her group of peers, the tough professional New York artists around whom she had felt so uncomfortable in the fifties and early sixties. But she also wished to clarify how her creative process related to the daily acts of women. The motifs in this landmark are the kimono, the obi sash, and a shape Schapiro described as "the kick," all

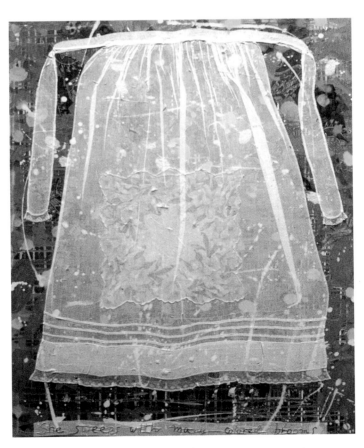

She Sweeps with Many Colored Brooms. *1976.*
Acrylic and fabric on canvas, 40 × 32"

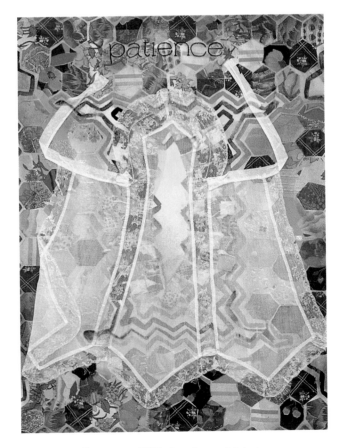

Patience. *1977. Acrylic and fabric*
collage on canvas, 30 × 22"

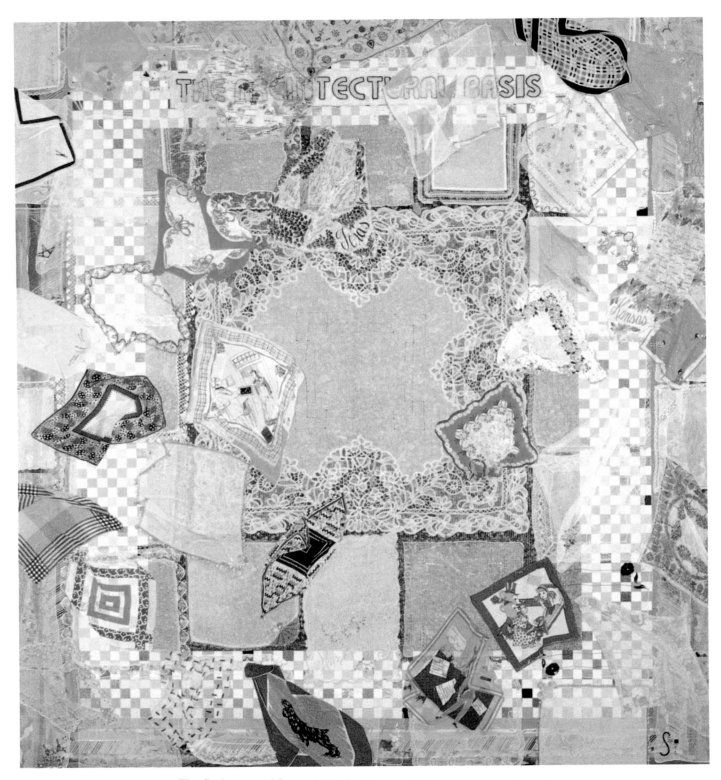

The Architectural Basis. *1978. Acrylic and fabric on canvas, 80 × 78"*

taken from a book on Japanese kimonos sent to her by Sherry Brody. To these she added fragments of cloth structured in the manner of quilts, which formed the skeleton, or anatomy, for each unit. In the successive sections, ranging from light lavender to medium blue, dark blue, and crimson, the repeated shape of the kimono, normally associated with the secluded and oppressive life of women in the Orient, was transformed into a "ceremonial robe for the new woman." Within this symphony of colors and shapes are incorporated embroidered fragments, one of which states "Sew a while and be in style." For Schapiro the kimono in this monumental work was the robe for the new woman. When she later remembered that men also wore kimonos, she felt that the piece potentially had an androgynous quality and responded, "Nice. The painting gave me a gift."[16]

As Schapiro developed and applied her new repertory of decorative motifs, many of which were derived from her study of quilts, she became one of the founding members of a group of artists (both women and men) who used ornament and pattern as the basis of their work. The group (Robert Zakanitch, Joyce Kozloff, Robert Kushner, Tony Robbins, Valerie Jaudon, and critic Amy Goldin) sought to merge modernist art traditions with motifs from women's crafts, folk art, and ethnic arts in order to "express," according to John Perreault, "humanistic and decorative themes that had been excluded from the domain of modernism."[17] In using such decorative motifs they questioned the hierarchies of high art and craft. The artist-generated movement became known as Pattern Painting or P. and D. (Pattern and Decoration), and it received much critical attention in the mid- and late seventies (see pages 31–32).[18] With the money earned from the sales of her P. and D. paintings Schapiro was able to build a new studio in East Hampton, thus acquiring a new kind of independence and professional validation.[19]

It was during this period that Schapiro acquired a public voice that enabled her "to feel much more comfortable with contradictory states of duty and selfishness." Between 1973 and 1980 Schapiro traveled throughout the country, from California and New York to Texas, North Carolina, Oregon, Arizona, and New England, lecturing to university audiences, art classes, and women's groups. She spoke about her art, about feminism and art, and about the art of women past and present. She also did collaborative art projects, like her suite of etchings *Anonymous Was a Woman* (1977; see pages 92–93) that she produced with a group of nine women art majors at the University of Oregon. Each print in the suite is an impression made from an untransformed doily that was placed in soft ground on a zinc plate, then etched and printed. Schapiro washed out the original doilies and preserved them for her collection of women's needlework. The prints therefore can be seen as double collaborations, with both the women art students and with the anonymous women who made the doilies. As much as any of Schapiro's work since 1972, these prints question the concept of the male master.

Between 1976 and 1979 Schapiro created variants of the ceremonial costume in her "Kimono," "Vesture," and "Robe" series. These works offered her the

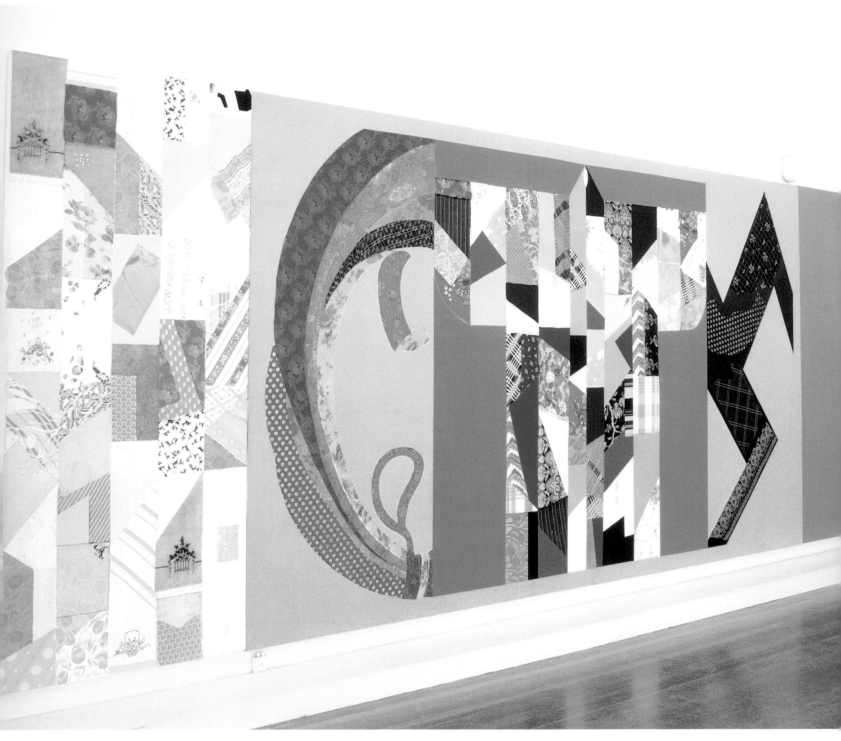

Anatomy of a Kimono. *1976. Acrylic and fabric on canvas, ten panels, 6'8" × 52'2½".*
Installation, André Emmerich Gallery, 1976. Collection Bruno Bischofberger, Zurich

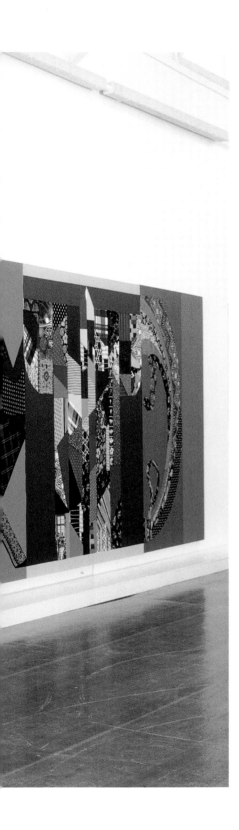

opportunity to indulge her love of costume. She remembered how as a young child she waited for her parents to return from performances of the "Chauve Souris," a Russian cabaret group that performed in New York City, with the illustrated programs that she "was allowed to study." In the mid-fifties this love was manifest in her use of beautiful dancers and movie stars, such as Ginger Rogers, as sources for her paintings.[20] By the early seventies, she had started thinking about the role of costume in art and in different cultures in a more serious and systematic way. Her journals from this period (1972–76) are full of notes and comments about the meaning and significance of dress and costume. In 1972 she bought a book on the small German town of Banat. Though she could not read the German text, she carefully studied the photographs of townspeople in various settings wearing costumes. She concluded that the costumes were "realer than reality" to her and made a catalogue in her journal of all the costumes and their various parts, itemizing everything in great detail. She wanted "to break the code," in order to get to the emotional and intellectual message of the costumes. She especially described the images of women: working, sitting out of doors, carding and sorting hemp and wool, wearing long cotton dresses and exquisite crowns on their heads. "There were young girls dressed all in white with grand white ribbons from waist to opposite shoulder, with ruffs and crowns around their necks, and floral crowns on their heads." They reminded her of Velázquez's painting of the young Infanta and her attendants. In both the painting and the Banat photographs the elaborate costumes suggested that something special was about to happen—"the aura of expectancy enhanced by special dress."

During the seventies, in her Kimono and Vesture series, dress became for Schapiro a major art form, independent from both painting and sculpture (e.g., *Vesture Series #2* [1976], *The Golden Robe* [1979], and *Paris Vesture Series #2* [1979]). Combined with her newly discovered love of fabric and quilts, dress offered possibilities for endless variations of form and meaning that she would continue to explore throughout the eighties and nineties.[21] In a journal entry of 1976 she describes dress as "the architectonic model of a tent" and "a shelter for the naked body." Her costumes, however, are empty; therefore, they conjure both an absence and a presence. They are iconic images of the women who have made them and worn them but who have been excluded from official culture, their presence ignored or even denied. The *Anatomy of a Kimono*, unlike the other robes and vestures, is enlivened by the suggestion of human action. It looks to the past—the Edo kimono and traditional women's art, in the kimono and anatomy sections—and toward the future as the "kick" (repeated four times), a traditional Japanese motif to which Schapiro gave a new name and meaning, suggests a figure walking into the world of the future. Schapiro's other kimonos, vestures, and stately robes are immobile. They allude to real presences but have no heads or hands; a cross between reality and illusion, they are in Schapiro's words "the quintessential combination of structure and fantasy." But, as she added, they also are "women without faces, hands, or legs—no women."

The concept of the dress as an architectonic model, as a shelter, led

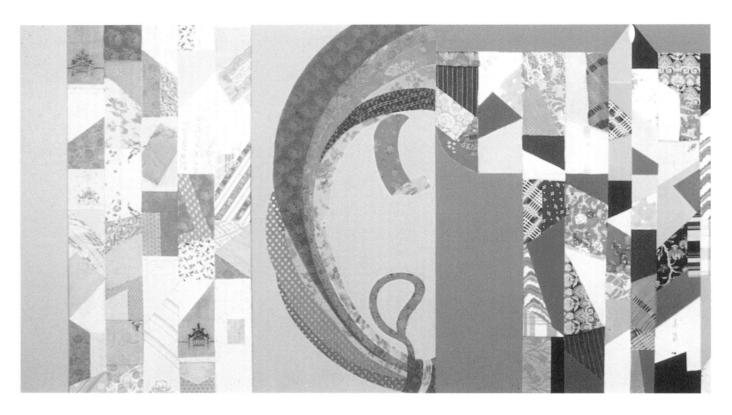

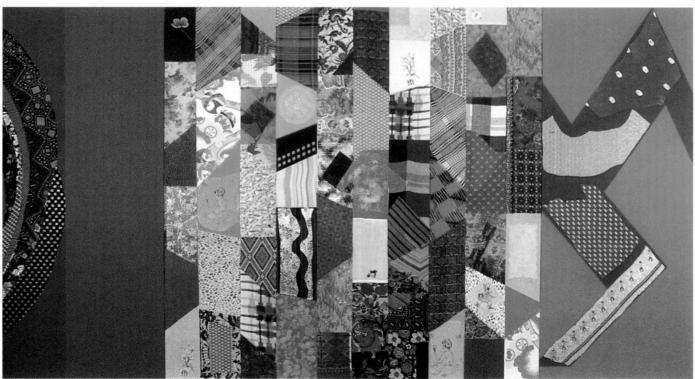

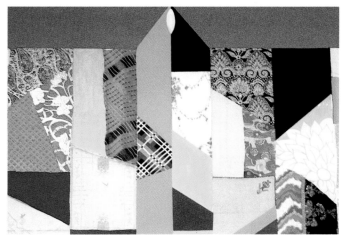

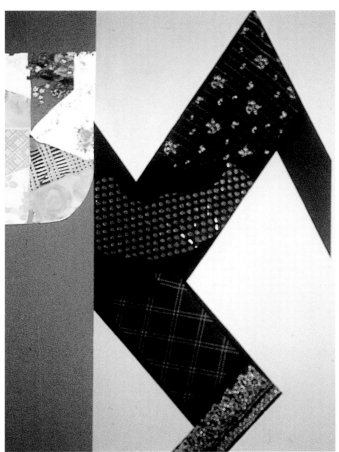

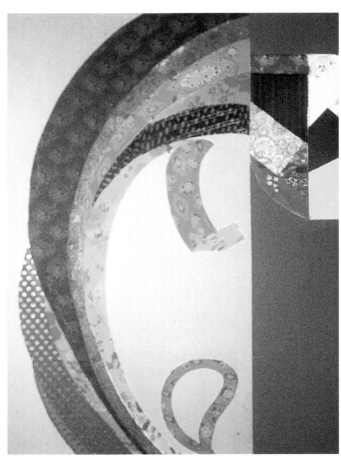

Opposite and above: details of **Anatomy of a Kimono**

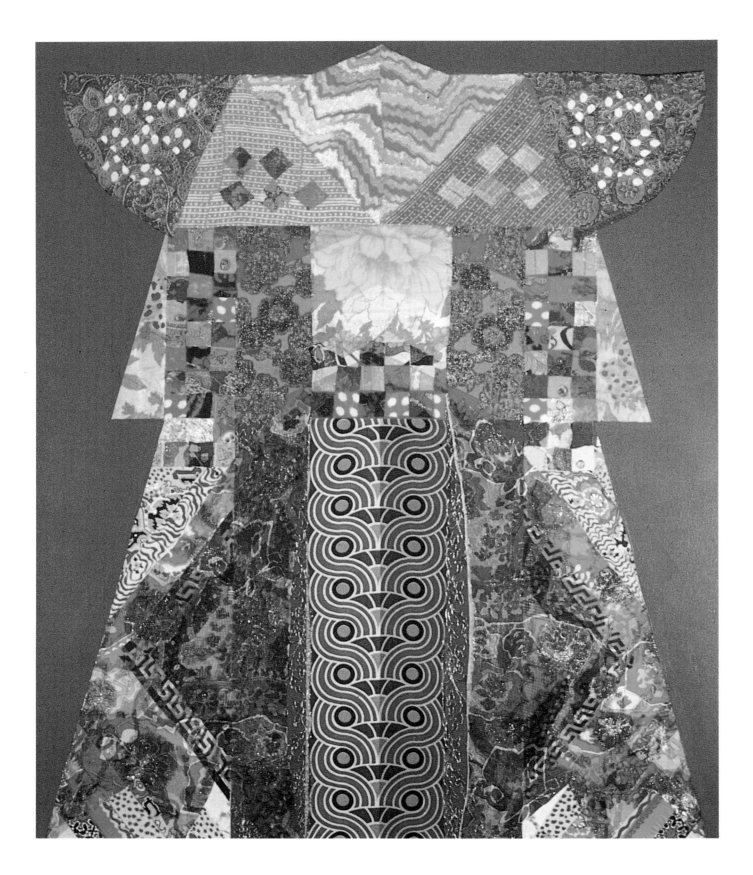

Vesture Series #2. *1976. Acrylic and fabric on canvas, 60 × 50"*

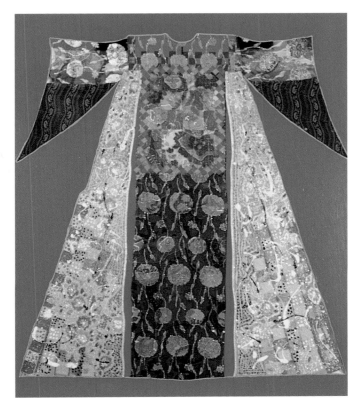

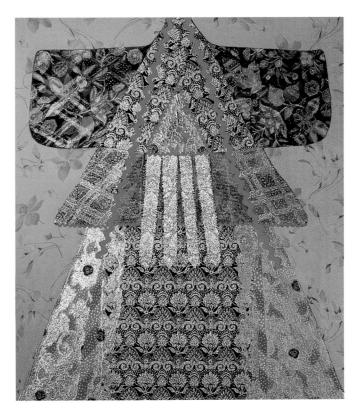

Paris Vesture Series #2. *1979. Acrylic and fabric on canvas, 60 × 50". Collection Barbara Gladstone, New York*

The Golden Robe. *1979. Acrylic and fabric on canvas, 60 × 50". Private collection*

Schapiro to reintroduce into her work the theme of the house/shrine. The house-shaped femmages she completed in 1979, for example, *Dormer*, *New Harmony "B"* (1980), *Heartfelt*, are related to the *Cabinet for All Seasons*, *Dollhouse*, and the *Shrines* in their allusion to women's lives and spaces, both psychic and physical. With their floral decorations, streamers of color, and geometric patterns these later works project an air of joyous self-confidence and celebration. Unlike the earlier houses and *Shrines*, they are not about fragmentation, confinement, and enclosure. They are fully occupied by the female presence, which is complex and ambiguous. In the case of each painting, we are not sure whether we are in front of the house, facing its cental gate through which we might enter, or looking out through the central portal into a dreamlike garden. Like the earlier femmages of 1972, they have luminous centers; in *Heartfelt*, this center takes the form a large heart that encloses a portal or small house. Womb, matrix, container, and heart are here overlapped.

Analogous to the egg in Schapiro's *Shrines*, the heart provided a new metaphor.[22] Schapiro's use of it harked back to its appearance in eighteenth-century textiles, specifically on items of special meaning in the home. Her houses and hearts are aspirational and poetic statements about being a woman and an artist and being alive. Their joyous colors, profusions of flowers, and luminous atmosphere transcend and transform the realities of life. Indicative

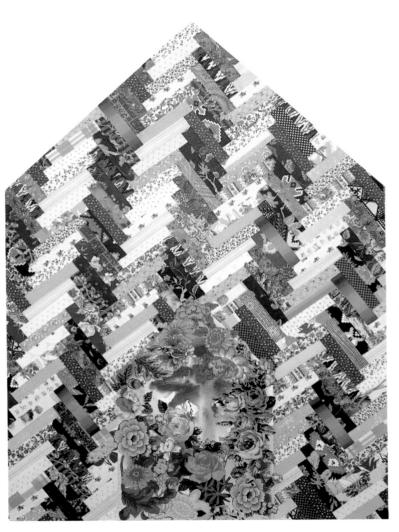

New Harmony "B". *1980. Acrylic and fabric on canvas, 59 × 50". Private collection*

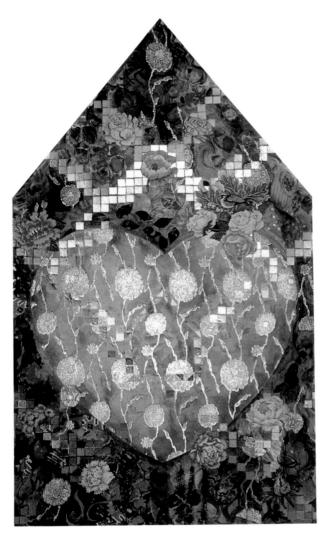

Heartfelt. *1979. Acrylic and fabric on canvas, 70 × 40". Morton G. Neuman Family Collection, New York*

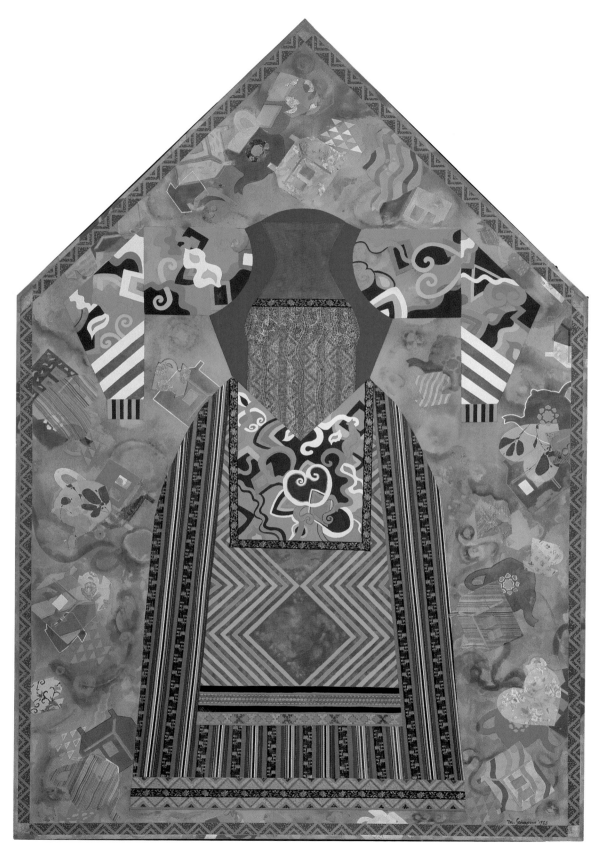

The Poet. *1983. Acrylic and fabric on canvas, 106 × 72". Courtesy Steinbaum Krauss Gallery, New York*

Anonymous Was a Woman. *1977. Suite of ten etchings, each 18 × 24". National Gallery of Art, Washington, D.C.*

of Schapiro's artistic credo, they risk being dismissed as sentimental, corny, overly rich, and too effusive. These images represent Schapiro's passages to the symbolic maternal presence for, as she has explained, the house is her mother's house, the heart (the large throbbing heart) is her mother's heart, and the little house in the heart is her own.

In 1978, Schapiro introduced a new motif into her work, the fan.[23] One of the most popular objects and images in the Orient and a frequent motif in Western painting from the eighteenth century onward, the fan was also used by women for both practical and flirtatious purposes. The series of fans, which began as 22 × 30-inch collages on paper (*Fan #1*, 1978), were followed by 6 × 12-foot semicircular canvases (*The First Fan*, 1978; *Geometry and Flowers*, 1978; *Barcelona Fan*, 1979). The fan-shaped canvas, a powerful icon, gave Schapiro the opportunity to experiment with combining fabric patterns with painted passages in a formal system, composed of twenty-four radial spokes subdivided by a number of smaller concentric semicircles. By transforming an object that has been considered feminine and trivial, she created an ordered and monumental visual structure. She also allowed herself to explore the varieties of printing on fabric and the possibilities of gluing a transparent, tissue-thin floral fabric onto flat paint. Out of this emerged a surface of textured coloristic complexity and opulence that formed the basis of her new personal style. The kimonos, fans, houses, and hearts were the form into which she repeatedly poured her feelings and desires, her anxieties and hopes.

The optimism and hope expressed in her work of the seventies and early eighties did not cancel out Schapiro's doubts about the cultural status of the "entity—WOMAN ARTIST." With the new conservatism of the eighties, the splintering of the women's movement, and the emergence of a second generation of feminists that rejected the solidarity and positivist thinking of the first generation, Schapiro's ambivalence and questioning resurfaced overtly in her art. In *The Poet* (1983) she combined two images that she had previously treated separately—the robe and the house. A colorful female peasant costume occupies the full space of the house-shaped canvas. Headless, frontal, and immobile, the poet stands in her house among floating teapots, flowers, and small images of houses. The monumental figure of the creative woman—the poet—

occupies her assigned domain, the house, and remains silent, unable to enter the linguistic and symbolic structures of patriarchy. An empty dress, she is a decapitated image, a "silenced" creative woman, in Schapiro's words "a woman without hands or a head . . . no woman." *The Poet* exemplifies the paradox of a woman's relation to herself—her absence, her decapitation—within intellectual culture.[24] Like the kimono and the vesture, the peasant dress in *The Poet* conjures both absence and presence—the absence of the corporeal body and the presence of the memory of those who have yet to be officially recorded.

Similar, opposite, and even contradictory messages are expressed in *Wonderland* (1983), one of Schapiro's most exuberant femmages. In this large work, she created a rich tapestry of quilt blocks, crocheted aprons, teapots, teacups, houses, hearts, and flowers—the domestic manifestation of women's creativity. Effusive and opulent, the work is to a large degree unreal, a household of fantasy set on an operatic stage. The central rectangle, where most of the action takes place, is supported by a geometric structure similar to that of *OX*, the painting in which she had, fifteen years before, expressed for the first time her conflicted feelings about being in a woman's body, about being strong and ambitious, and about being an artist. In the midst of this grand performance and assertive composition stands the small apologetic housewife, part of an embroidered tablecloth, discreetly bowing and welcoming us to her home, in which she is still confined.

In *Welcome to Our Home* (1983), Schapiro presents a different version of the theme of the creative woman within the house. As in *The Poet*, a woman's costume is surrounded by teapots, houses, hearts, and flowers, but this time it appears pregnant. The fetus, inscribed in an egglike shape, occupies the center of the apron. The dress, therefore, has acquired a partial bodily reality, almost becoming a female figure that represents the maternal. The environment is disturbed by jagged lines like rods of lightning, which emanate from the costume and lead to the borders of the canvas. The jumble of familiar household motifs and their disorder proclaim, in Schapiro's words, that "domesticity is also chaos." The painting suggests that the woman intends to keep this chaos at bay. Her outstretched arm seems to suggest that she will take charge of her

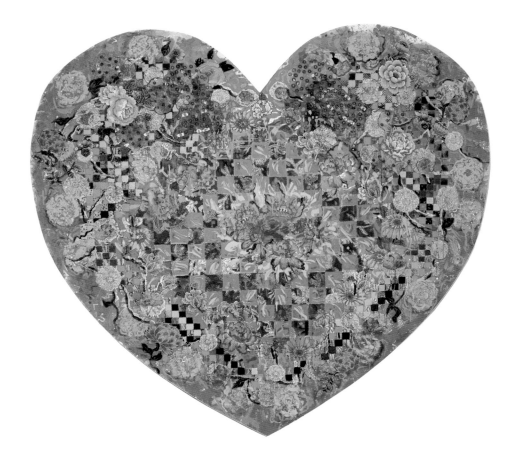

Atrium of Flowers. *1980. Acrylic and fabric on canvas, 64 × 60". Collection Norma and William Roth*

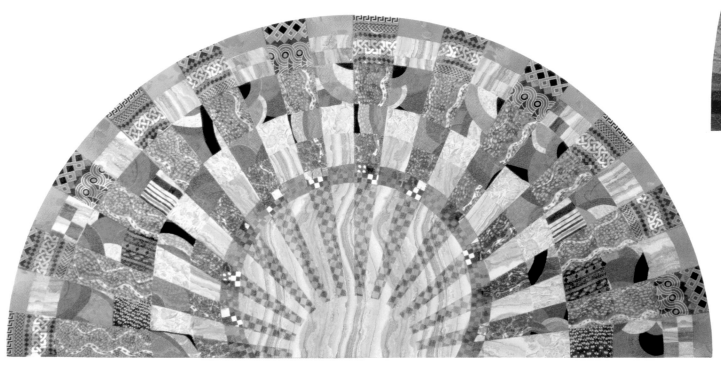

The First Fan. *1978. Acrylic and fabric on canvas, 72 × 148". Collection Bruno Bischofberger, Zurich*

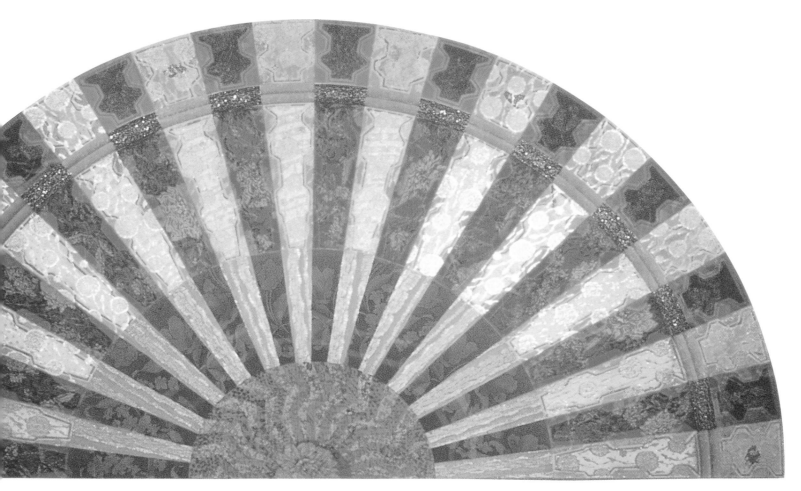

Barcelona Fan. *1979. Acrylic and fabric on canvas, 72 × 144".*
On permanent loan to The Metropolitan Museum of Art, New York

space and transform it. But she still is headless and without a voice. The large inscription "Welcome to Our Home" fills the space above the costume. This very complex painting summarizes many of the concerns about the lack of female identity that had preoccupied Schapiro for years, but it is also hopeful. Having established friendships and professional relationships with contemporary women artists, as well as having witnessed the avalanche of books and exhibitions on past women artists during the previous decade, Schapiro took comfort in the knowledge that her search for a genealogy of women was finally bearing fruit.[25]

One of Schapiro's projects has been to make art and art-making more democratic, to bring into the pantheon of art "those who didn't quite make it." Her art of femmage, incorporating fabric, ornament, and sentiment, was intended as a critique of masculinist representation. Whether egg, kimono, fan, vesture,

Wonderland. *1983. Acrylic and fabric collage on canvas, 90 × 144". National Museum of American Art, Smithsonian Institution, Washington, D.C.*

or heart, her central images in the seventies and early eighties had been about women whose histories she wanted to recover, whose culture she extolled, and whose traditional images she transformed. After 1970 it became imperative for her to turn the world around "to make a place for ourselves as thinking, dreaming, yearning people." The sensuousness, colorfulness, and beauty of her work, its decorativeness and formal rigor, are visual extensions of theoretical and political positions. They are intended to question the heroic image of art and its overtones of power and mastery.[26] The connections with other women, both well known and anonymous, the bonds Schapiro established through reading, hearing, seeing, and touching their stories and then in turn telling these stories to other women, gave her an access to her own autobiography, which, like that of other women, was still absent in the broader cultural context.[27]

Welcome to Our Home. *1983.*
Acrylic and fabric on canvas,
90 × 144". Museum of Fine Arts,
Boston

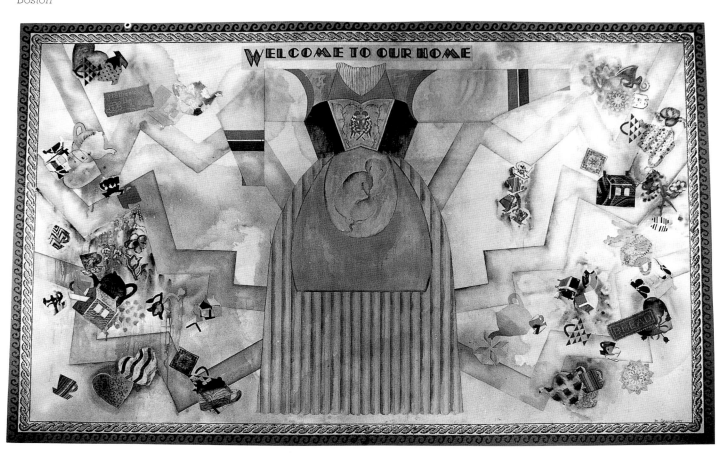

5.

AUTOBIOGRAPHY: DANCE, PERFORMANCE, AND MASQUERADE

All of these works are autobiographical. They are about the desires and yearnings of a woman who decided a long time ago to be a painter. What does that decision cost a woman? Who are the characters in her story? How does she create her own persona?

What does she look like? I have asked that question for years.

—Miriam Schapiro, 1985[1]

In a letter of 1986, Schapiro reminisced about the day when her former dealer (a woman), while talking with a handsome young man in blue jeans and boots, with dark brown curly hair and fiery eyes, turned to her and said, "doesn't he look the quintessential artist?" Schapiro wrote: "mustering all my courage I answered 'no, I do,' knowing full well that according to female stereotyping in our culture I looked like a middle-aged school teacher with something a little wrong around the edges." At that time she had just completed a major series of works, focusing on the formation of female identity within the illusory context of the theater and dance hall.

Dance has been an important theme in Schapiro's oeuvre, both as a metaphor for the creative act and as an expression of the celebration of life and of the ability to move through life effortlessly and beautifully. The theater has been equally important as a stage on which life, and more specifically her own life, is enacted. She commented in 1990, "The theater is a metaphor for life and it will always work most successfully for me in my art when it directly refers to my life." In 1985, she brought the two themes of dance and theater together in a trilogy of large autobiographical paintings that deal with a young woman's relationship to her maternal and paternal role models: *I'm Dancin' as Fast as I Can, Master of Ceremonies,* and *Moving Away.* It appears that as Schapiro's parents were getting older and weaker (both were in their nineties) and the artist herself was looking more intensely at old age, she felt the need—and gave herself the license—to deal in her art with issues that had been with her since childhood.

She first used the motifs of dance and theater as expressions of sexual and familial relationships in early paintings such as *Soft Shoe* (1958) and *Facade* (1959). She returned to the subject of the theater in 1975 in a large femmage entitled *Phoenix: Theater Piece,* in which a dark and mysterious central stage, a

Anna and David. *1987. Cor-ten steel and aluminum, height: 35'. Rosslyn, Virginia*

womblike cavity that holds the phoenix, is surrounded by a colorful proscenium arch in bright and scintillating patterns of cloth. But the stage remains empty. Almost ten years passed before Schapiro was ready to introduce recognizable human images and openly declare the autobiographical nature of her theaters.

In 1979 the theater became part of a series of small collages on paper, as an alternate to the house and shrine image (e.g., *The First Theater, Shrine for the Egg*).[2] These works, which depict arched or gabled roofs and proscenium arches, often combine the house, shrine, and theater and eliminate the boundary between private and public domains. In most, the stage is empty; but in some a small, immobile, and vulnerable egg, Schapiro's familiar metaphor for herself, first used in her "tower/house" and *Shrine* series of 1961–63, occupies a podium in the center of the stage. That same year (1979) she introduced a female figure within an arched stagelike frame in two small watercolors entitled *Homage to Goncharova* (see page 103), inspired by an exhibition of Natalia Goncharova's theater and costume designs, which she had seen in Paris. Frontal, immobile, and iconic, these figures and their brightly painted backdrops combine elements of folk art, Russian icons, and early-twentieth-century

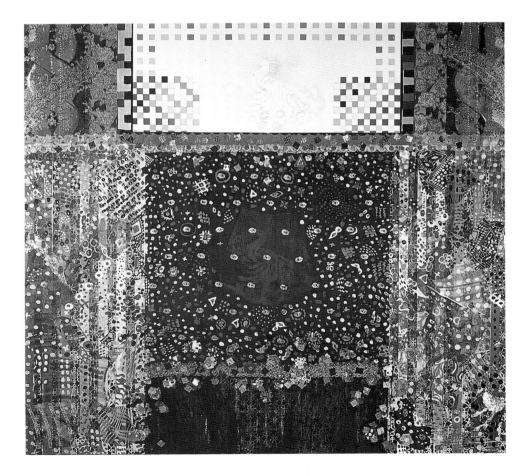

Phoenix: Theater Piece. *1975. Acrylic and fabric on canvas, 72 × 80". Private collection*

ornamentalism, as did Goncharova's own work. Schapiro had entered the proscenium arch in a carefully chosen masquerade.

Three years later, in 1982, Schapiro for the first time combined the metaphors of the theater and dance and the woman artist/dancer in one work, the large *Presentation*.[3] In this painting, also an homage to Goncharova, a large abstract figure with multiple limbs and a dark central cavity is set within a proscenium stage—a decorative rectangular frame painted with stripes and overlaid with a fabric of gold flowers. In the center of her chest is a bouquet of flowers, and her featureless face seems to be looking inward. The energetic, vital, and mobile figure fills the whole proscenium space and merges with the surrounding patterns of painting and cloth.

Schapiro's woman in *Presentation* (see page 106) is unfixed and mobile and contrasts strongly with another image of a woman Schapiro created that same year. In *The Poet*, a colorful and stately female peasant costume occupies the full space of a house-shaped canvas. Headless, frontal, and immobile, the poet stands in her house among floating teapots, flowers, and small images of houses. She is in many ways an enlargement of the images in *Homage to*

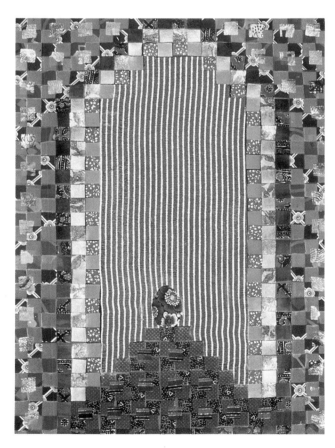

The First Theater. *1979. Acrylic and fabric on paper, 30 × 22". Private collection*

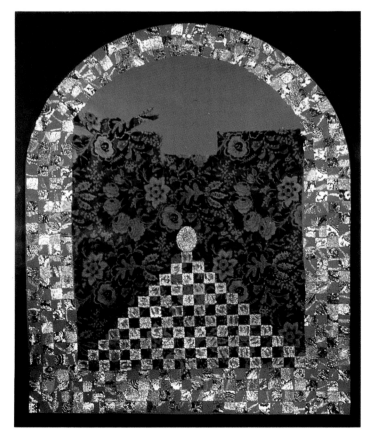

Shrine for the Egg. *1979. Acrylic and fabric on paper, 40 × 30". Private collection*

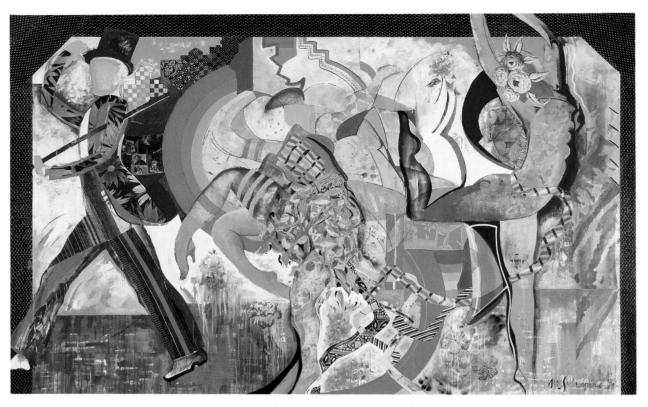

I'm Dancin' as Fast as I Can. *1984. Acrylic and fabric on canvas, 90 × 144". Collection Bernice and Harold Steinbaum, New York*

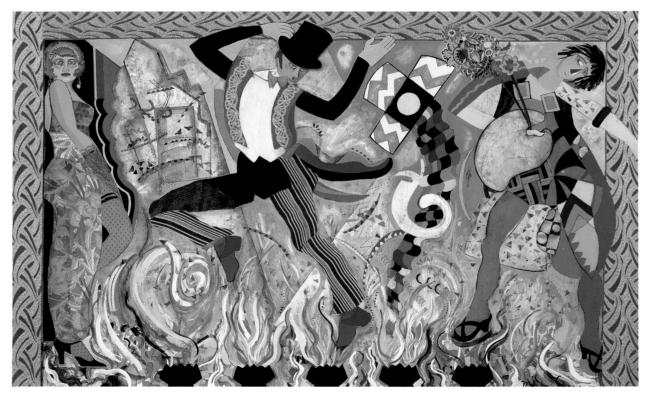

Master of Ceremonies. *1985. Acrylic and fabric on canvas, 90 × 144". Collection Elaine and Stephen Wynn, Las Vegas, Nevada*

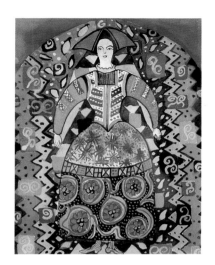

Homage to Goncharova. *1979.*
Watercolor on paper, 11½ × 8½".
Collection Thalia Gouma-Peterson
and Carl A. Peterson, Oberlin, Ohio

Goncharova, but unlike those images, she has no head. In contrast to the figure in *Presentation*, she is identified as specifically female and static and confined within the fabric of the house. A powerful symbolic presence, she is, however, only a costume, a bodiless and faceless sign. In *Presentation* and *The Poet*, Schapiro gave visual structure to the unfixed and fixed aspects of womanhood, respectively. She brought together these two aspects in her monumental trilogy.

Schapiro had begun thinking seriously about doing a dance series in March 1980, after seeing a biography of Fred Astaire on television. The memories of Astaire and Rogers dancing came back.[4] She commented in her journal about seeing a sequence of ten stills of Astaire that showed him relaxed and "less aestheticized, less rigorous," as Rogers "became more rigorous, . . . slender but chunky"; "the seduction dances are their best." She remembered how in her late twenties and early thirties she had painted Ginger Rogers the star, Charlie Chaplin, dancers—"an ephemeral world" beyond her reach. "A world of movement and style." She began thinking that she might like to do "dancers—men and women—who exchange qualities." She also raised the possibility that she might just do costumes: "The beautiful moving chiffon dance dress. The top hat and tails. Perhaps paper cutouts—pale against the pale background—maybe not a screen, maybe a triptych." These ideas and images germinated in her mind for several years before she combined them with the theater. It is typical of Schapiro's creative process to think and talk about her ideas for paintings for several years before actually beginning. Some never get done and others become radically transformed after the initial stages of conception. In the process of transformation, the Fred Astaire and Ginger Rogers paintings became the dance trilogy.

These canvases, *I'm Dancin' as Fast as I Can*, *Master of Ceremonies*, and *Moving Away*, give visual form to the artist's attempts to shape herself and deal with the male and female aspects of her persona. Using the theater and dance, they also place gender formation within the context of performance and masquerade.[5] In all three paintings the artist/dancer is trying to form her identity and is struggling with her male and female prototypes. In two of these the male/father figure remains consistent as the dominant dancer in tails and top hat, while the older woman, the mother-figure, is variously cast as ballerina (*I'm Dancin' as Fast as I Can*), vamp (*Master of Ceremonies*), and fashionable woman (*Moving Away*).[6] The nascent woman/artist is shown in different stages of development. In the first painting, she is frantically resisting her induction into the masquerade of femininity, while at the same time being drawn into it.[7] In *Moving Away* she is literally moving away from the socially constructed female prototype to enter the world in some other, not as yet clearly defined form. In *Master of Ceremonies* she has given herself a novel and unexpected appearance, that of a Raggedy Ann doll. In these shifting, layered, fragmented, and autobiographical images, Schapiro both confronts the formation of woman as the other and stages the self through a series of masquerades.

Detail of **Master of Ceremonies**

In *I'm Dancin' as Fast as I Can*, the first painting in the group, a frantically dancing female figure, her body and limbs breaking up into fragments of painting and cloth, is positioned between the female and male dancers, acting out their roles on a large proscenium stage. The elegant ballerina, to whom the woman is connected by a long strip of cloth tied around her waist, an allusion to the umbilical cord, is frozen in an upward aspiring motion, while the father figure, in top hat and tails, confidently strides off stage. As he does so he pulls the tradition of Western art behind him: a patch of cloth (one of the remnants that Schapiro purchased at various fabric shops) printed with self-portraits of Rembrandt, Goya, and Cézanne, and signatures of Van Gogh and Picasso. The dancing woman, who does not know who she is or what she wants, is pulled between the male and female signs of sexual difference and almost aimlessly spins in place.

This central figure, shown in the process of becoming, also brings to mind a fetus *in utero*, as her unformed white head and the umbilicus suggest. The fetal woman is already shaped by feminizing and fetishistic trappings of male desire, as indicated by her multiple legs sensuously encased in pink, floral, and glittering stockings (one with three garters) and red high-heeled and pointed shoes. Her multiple legs and arms in uncontrolled motion express chaos and a sense of desperate striving. Two sets of colorful arcs, which allude to paintings by Sonia Delaunay (Schapiro's artistic ancestor), frame and stabilize her.[8] The figure is connected to these cultural allusions, which attest to her creative potential, through repeated shapes and overlapping segments of cloth. The visual connections to the paternal prototype include motifs derived from male artists, such as the Klee-like shapes in the background, covered by floral and checkerboard femmage that extends even to his formal coat.

In Freudian and Lacanian terms the painting could be interpreted as showing the girl-child at the moment of the Oedipal crisis—that is, as she is about to move out of the pre-Oedipal stage, when the child believes itself to be part of the mother, into the order of the father, which, in psychoanalytic terms, splits up the "Dyadic unity between mother and child and forbids the child further access to the mother's body."[9] But for the girl, since she too must become the object of desire, the spatial proximity and ties to the mother, as Michelle Montrelay has argued, remain present; therefore, she cannot displace the first object of desire.[10] In her journal, Schapiro offered a variant on the interpretation of this relationship: "When a girl is old enough to separate from her mother, she is old enough to receive instruction on how to be a mother." In the process of separation she finds the umbilical cord cut and "freedom means serving others. . . . A woman never gets another mother. She remains secretly faithful to her own image as a child."[11] In Schapiro's assessment of the mother–daughter relationship, the girl does not get another mother because she herself has become the mother; in other words, the ties to the mother remain in spite of the loss. The painting then can be read as representing the nascent woman's struggle to both hold on to memories of the maternal and to resist the masquerade of "womanliness."[12] The complexity of her situation is

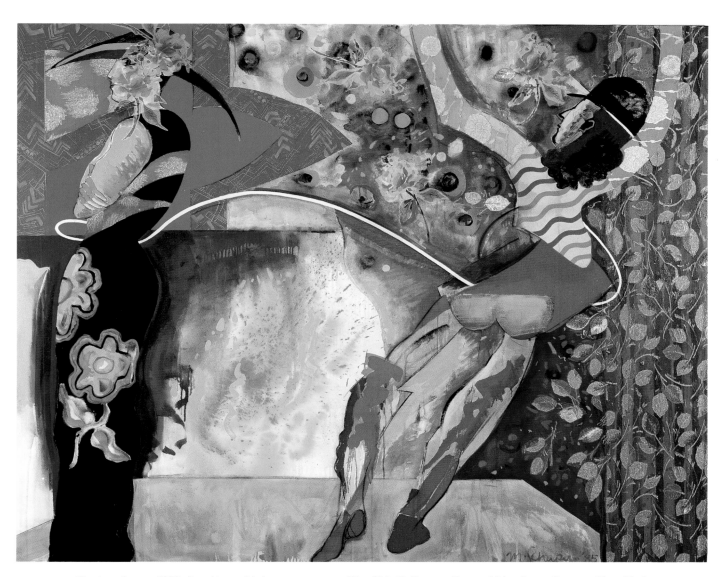

Moving Away. *1985. Acrylic and fabric on canvas, 72 × 90". Collection Dr. and Mrs. Leon Oxman, New York*

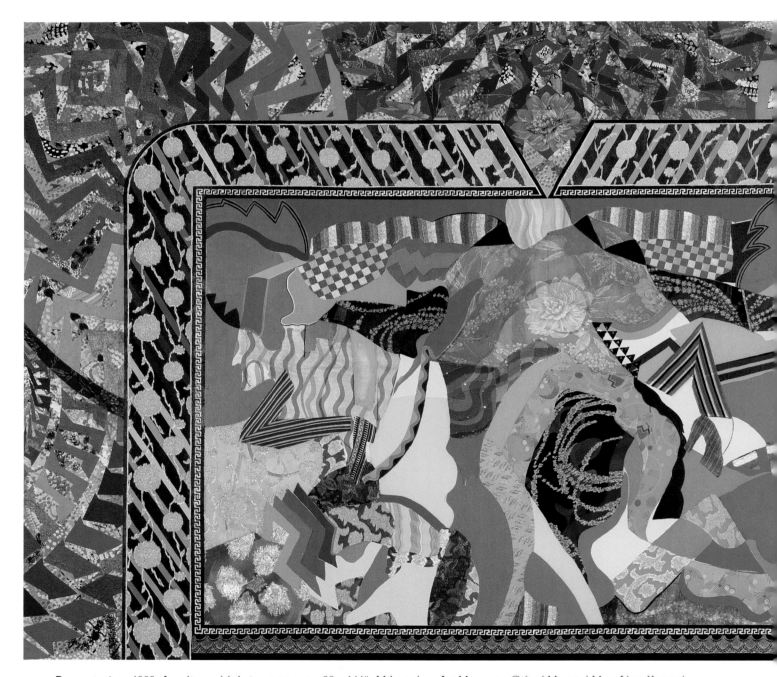

Presentation. *1982. Acrylic and fabric on canvas, 90 × 144". Milwaukee Art Museum, Gift of Mr. and Mrs. Alan Koppel*

clear in the predicament of the central figure. Before even being fully formed, and while still tied to her mother by the umbilicus, she is already shaped "as the-other-from-man,"[13] in high heels and diaphanous stockings, while the father walks off stage. The separateness of the maternal and paternal spheres, placed at opposite sides of the stage, emphasizes the conflicted state of the central figure.

In spite of her intense desire to follow the father figure, as expressed by her posture and movement, the central dancer remains tied to the prenatal (pre-Oedipal) maternal figure. She is part of the cultural definition of femininity represented by the faceless ballerina, whose vestigial head is obscured by a bouquet of flowers. The decapitated, silenced mother remains a potent force in the daughter's formation through the connection of their bodies, which are culturally constructed and feminine. The daughter herself has a putative head but no face and, therefore, is literally unable to face the public. The relationship of the women in this painting again recalls the paradox of woman's relation to herself within modern intellectual culture, which is premised on "the mother's expropriation, her own decapitation,"[14] or, in Schapiro's terms, the daughter's permanent loss of the mother. The memory of the maternal, however, continues to be powerful, as the strong athletic body of the mother/ballerina suggests. Her torso is covered by floral ornaments that take the form of multiple breasts, reminiscent of the statues of Artemis of Ephesos, the ancient goddess of fertility and power. The painting presents a complex image of the cultural construction of gender and of the daughter's bonds to the maternal body. It also initiates a body of work in which Schapiro most explicitly deals with the concept of femaleness as masquerade—that is, of the intellectual creative woman hiding behind an assumed identity of femininity in order to avoid the retribution of masculinist culture.[15]

The paradox of woman's relation to herself is restated even more clearly in *Moving Away*. This painting focuses on the dyad of mother and daughter. The mother figure is inscribed in the masquerade of womanliness. The young woman appears to have made the conscious decision to move away, turning her back to the mother figure. "She is moving away from the need to please in a stereotypical way" and is about to step out on the stage of culture. She approaches the light at the other side of the stage. The raised floral curtain indicates that the background may be the front of the stage in the glare of the footlights. A burst of bright yellow light, with crimson and purple brushstrokes, occupies the space between the two women and, in terms of Schapiro's iconography, alludes to the female cavity of light that frequently forms the center of her femmages. This aperture, therefore, can also be read as a passage to the maternal body. The ambiguous spatial relationship between the two figures suggests a kind of dream space or a fantasy that exists in the young woman's mind. She moves out "territorially and psychologically."[16]

The young woman, with her long dark curly hair and jockey hat (also worn by one of the figures in Schapiro's first theater piece, *Facade*, discussed in Chapter 2), throws her flowering arms up in an exultant gesture. Her slender

form and ruptured abdominal cavity visually express her wish to reject the resemblance to the maternal body. Both her attenuated aspirational form and her ambiguous relationship to the actual and implied space of the painting suggest the struggle of transition. We can see her profile as she is about to face the public. The darkly elegant, fashionable woman, the mother figure, is shown as an object of desire, closed within herself, and contrasts with the loosely structured, outwardly reaching, and still unformed young woman. Erect and immobile, she is framed by passages of abstract painting partly overlaid with fabric. The shapes immediately behind her torso can also be read as two large breasts reinforcing her femaleness. The older woman looks away to the left, her profile camouflaged by flowers. The daughter also turns away, but still looks toward the mother figure as she is about to face the audience. However, the strong bond between the two women is visually expressed by the white line (the umbilicus) that extends from the older woman's abdomen and penetrates the young woman's body. The memory of the mother, the competition with her, and the desire for her approval are significant aspects of the daughter's relationship to herself.[17]

In *Master of Ceremonies* (1985) the characters have been realigned and the rupture of the relationship between mother and daughter is complete. The woman artist, dressed in a Sonia Delaunay–inspired costume and holding a palette and flowering brushes, describes herself: "Her painting/clothes become her persona." She hardly looks at the male dancer, center stage, and at the immobile female stereotype, the seductive vamp, who could also be a movie star playing the role (e.g., Marlene Dietrich), confined to a narrow space on the left. In her completely unconventional and atypical form, the woman artist is not stereotypically female. Dressed in her own art, she has invented her costume and does not conform to culturally accepted notions of "genuine womanliness."[18] Hesitant and anxious, but strong and active as she steps over the flaming footlights to move into her space, the woman artist in her quest for self-definition is assisted by a genealogy of creative women, here metaphorically conjured by a kite that evokes the work of Sonia Delaunay. The illusory nature of all three figures is emphasized by the setting: the theater in which they act out their assumed roles. This painting, like the two others in the trilogy, represents one act in an ongoing performance.

The three parts of the trilogy, as Schapiro has stated, are autobiographical. The figure of the young woman, shown in each canvas in the process of defining herself, is a self-portrait. In *Master of Ceremonies* the self-portrait has acquired a face for the first time in Schapiro's oeuvre since 1949.[19] But, to our discomfort and, perhaps, even dismay, her face is that of an anxious Raggedy Ann doll. Part woman, part child/doll, the strong figure of the artist recalls Schapiro's statement that "a woman never gets another mother" and "remains secretly faithful to her own image as a child." In other words, to find a face the woman artist has returned to her childhood; she is a girl growing up. Alone, separated from the woman as other (the alluring vamp) by the figure of the dancing master, the woman artist is holding on to her public arena. The flaming lights engulf that space in threatening orange, red, and yellow

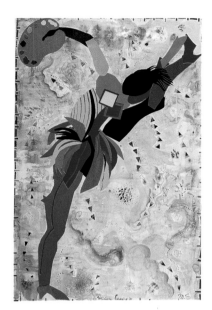

High Steppin' Strutter 1. *1985. Paper and acrylic on paper, 80 × 54½". Private collection*

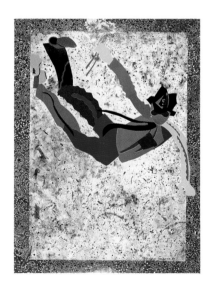

Free Fall. *1985. Paper and acrylic on paper, 90 × 64". Collection Elise and Lee Sachs, Illinois*

swirls. Holding a large palette, which is still empty, she is taking the risk of her commitment and steps with her right foot on one of the lights, usurping some of the power of the master of ceremonies. Her female counterpart, the vamp, remains impassive and immobile behind the lights, as if pinned in place by a series of firm color outlines and by the thrusting phallic leg of the dancing master, who confidently occupies the center stage. Nimbly dancing over the flames, he dominates the two women, who could be read as vying for his attention—that is, attempting to gain access to patriarchal culture and the masculine order.

But the two female images in this painting also set up a very different contrast. The vamp is an image of the *femme fatale*, regarded by men as evil incarnate, which, as Michelle Montrelay and Mary Ann Doane comment, "is this evil which scandalizes whenever woman plays out her sex in order to evade the word and the law."[20] As in films, in Schapiro's painting the vamp in her masquerade acts out her femininity and subverts the masculine control of the gaze. In the traditionally gendered world she would be seen as more powerful and self-confident than the nascent artist, for whom, in our culture, there is no set image. Therefore, she masquerades as a cross between a child's toy and an artist. Dressed in her own painting the artist is "defining herself anew." Rejecting the accretions of culture she turns to the child within in order to get in touch with an authentic creative experience. In contrast to the vamp who is static, the artist is shown in motion—in the process of becoming.

In staging the self in these paintings, Schapiro uses distancing devices—such as the masquerade and the framing proscenium arch—to counteract the claustrophobic closeness, "the deficiency in relation to the structure of seeing," between, in Doane's terms, woman and the other. Through these devices Schapiro creates the space necessary to rupture the closeness to the mother that, as Irigaray has observed, does not allow woman to possess her own reality.[21] But she has also been careful, at least in two paintings in the trilogy, to retain the connection with the maternal. The paintings question the female stereotypes inscribed in culture and in the process provide several answers, none of which is final. They are part of Schapiro's process of becoming. They also are part of her missing autobiography, to which she is giving shape by claiming access to both the maternal and paternal.

The trilogy was followed by a series of playful and romantically optimistic works in which male and female figures dance, perform, and behave in unexpected ways that reverse gendered identities—"dancers who exchange qualities, men and women," as she noted in a 1980 journal entry. These images of mobile dancers and actors, which are metaphors for creative joy, express Schapiro's yearning for a world of greater freedom where male and female roles would be interchangeable and remind us of her statement that "painting . . . is the ability to make life meaningful." Done in combinations of paper cutout, paint, and stencil, these works represent faceless, marionettelike figures, single or in pairs. They range from the high-stepping woman artist, holding her palette high above her head, in *High Steppin' Strutter 1* (1985); to the

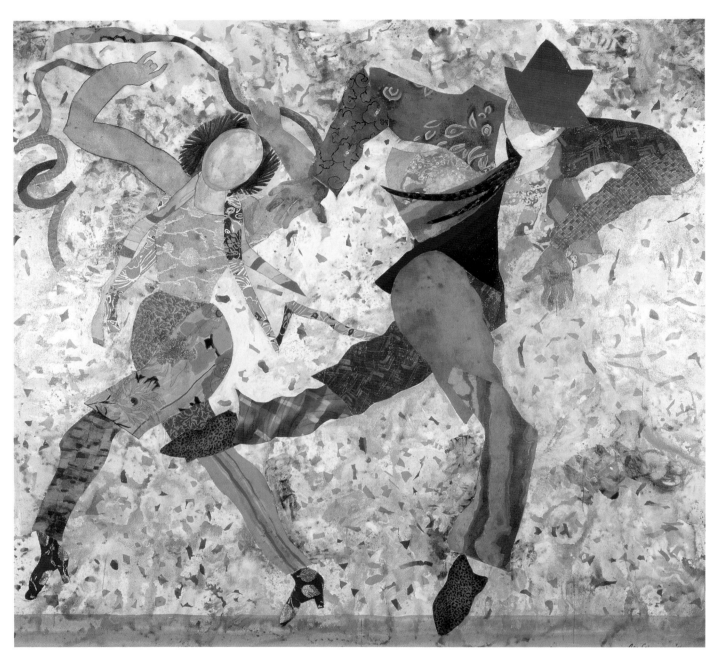

Pas de Deux. *1986. Acrylic and fabric on canvas, 90 × 96". Collection Dr. and Mrs. Anthony Acinapura*

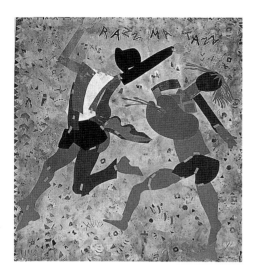

Razz Ma Tazz. *1985. Paper and acrylic on paper, 90 × 80". Courtesy Steinbaum Krauss Gallery, New York*

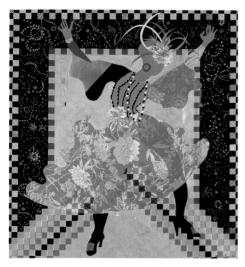

Personal Appearance. *1985. Fabric and acrylic on canvas, 85 × 77". Collection Irvin and Sandy Arthur, California*

male dancer who, having lost his threatening mien in spite of the S (Superman) on his hat, falls from above holding a bouquet of flowers as a parachute in *Free Fall* (1985); to the woman artist playfully using a palette and brushes as a shield and weapons and pursuing the skipping male dancer in *Razz Ma Tazz* (1985); to the harmoniously dancing couple moving in opposite directions in *Pas de Deux* (1986). The subject of *Pas de Deux* and the theme of the dance acquired overlifesize proportions in Schapiro's sculpture *Anna and David* (1987).[22] The colorful thirty-five-foot figures introduce mirth and vivacity among the severe facades of the office buildings surrounding the work's site in Rosslyn, Virginia. These steel cut-outs reveal their origins in girls' scrapbooks and in childhood activities inside the home. Though the playful pieces are inspired by Matisse's cutouts, in "Mimi" Schapiro's words, she "tried to Mimi-ize them," and in the process they become more narrative and episodic. They are her joyous and hopeful interpretation of man and woman and their potential relationships.

In one work of this group, *Personal Appearance* (1985), Schapiro returns to a theme she had used earlier in the paintings of movie stars taking public bows (e.g., *Garland* [1954], *Personal Appearance* [1954]). An ebullient woman, center stage, steps out in front of the proscenium arch, her arms upraised in a celebratory gesture. Her stance and gesture combine features of the artist in *Master of Ceremonies* (the legs) and the young woman in *Moving Away* (the arms). She is dressed primarily in bright reds and oranges, and her equally bright featureless face is capped by a feathered and flowered turban. The image seems to express a renewed assurance in the ability of the creative woman to step forward and say "here I am," but, as in the early paintings, she is a performer without a face, unable to face her public. Her flouncy costume and elaborately decorated headdress, as well as the rhythm of her dance, bring to mind Carmen Miranda, the exotic Portuguese/Brazilian singer and dancer who entertained American movie audiences in the forties and early fifties. Like Miranda, the dancer is there for the audience's pleasure, performing a variant of the masquerade of femininity.

Schapiro continued to investigate this subject in a series of seated performers who, unlike the dancer, have facial features and actively look back at their audience. The cabaret performer in *Ragtime* (1987) has a rather expressionless masklike face, whereas the sexy chanteuse in *The Blue Angel* (1987) recalls the famous movie role played by Marlene Dietrich. They sit confidently and look defiantly at the spectator. As performers they act out their sexuality and femininity and challenge the masculine context that cast them in their roles. In contrast to these sexually confident women is the dark-haired young woman masquerading in a man's suit in *Incognito* (1987). She is the artist, presenting herself in disguise, as the title of the painting indicates. She has acquired a face and, framed by a stage curtain, looks at her audience terrified. In her lap she holds what appears to be a watercolor, which is actually a fragment of the same piece of cloth—with the portraits and signatures of male artists—that the male dancer was pulling behind him in *I'm Dancin' as Fast as I Can*. The young artist has become part of the creative order established by male

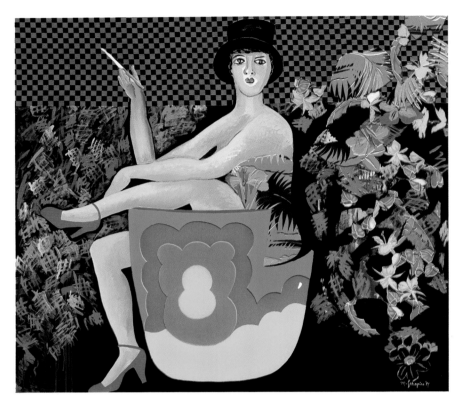

Ragtime. *1987. Acrylic and fabric on canvas, 72 × 80".
Collection Irvin and Sandy Arthur, New York*

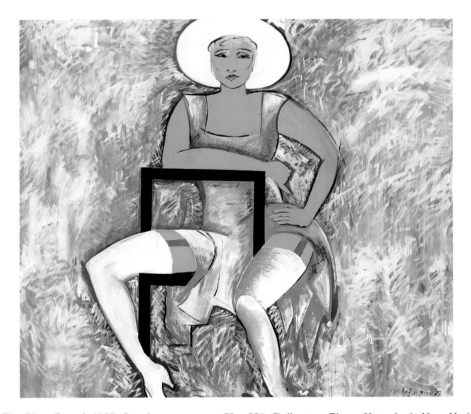

The Blue Angel. *1987. Acrylic on canvas, 72 × 80". Collection Elinor Herschaft, New York*

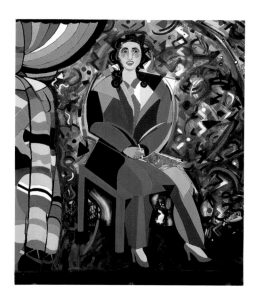

Incognito. *1987. Acrylic and fabric on canvas, 80 × 72"*

culture. She seems almost bodiless, subsumed by the loose masculine suit; she has lost her connection to the maternal body and, therefore, to her own body. The extreme anxiety of her multicolored masklike face indicates, according to Schapiro, that "she has gone mad." This painting is Schapiro's comment on the extreme price that a woman artist pays in order to be creative within a world that has denied her existence as a creative being.

In the "Mythic Pool" series (1989–90), the last series of the decade, Schapiro dealt with the subject of marriage, allegedly made in heaven but, in fact, lived imperfectly and painfully on earth. In *The Twinning of Adam and Eve in the Garden of Eden* (1989), the primordial pair, turned back to back, flank the Tree of Knowledge and the colorful serpent entwined in it. She is dressed in a typically feminine masquerade, in an elegant dress, high heels, and stockings, with a Medusa-like hairdo. He, on the other hand, is dressed in a black-and-blue striped bodysuit (akin to prison uniforms or to unitards worn by clowns) that undermines the appearance of stereotypical masculinity. His tribal headdress, however, does add a reference to power. Eve's hair, which is both snakelike and floral, and the leaf motifs and butterflies on her dress suggest that, to a certain extent, she is connected to nature. Adam, in his striped uniform, is a complete stranger, the outsider. Schapiro explained that in choosing his costume she tried to show that "men themselves are prisoners of their time and their own psychological apparatus." On the Tree of Knowledge, in a black circular cartouche, the gray silhouettes of Adam and Eve are twinned, that is, merged together back to back.[23] This double silhouette appears to be one unit with two heads—a memory of a time when the couple were still part of each other. The serpent talks to Adam in the cartouche and to the larger figure of Eve in the garden. The emphatic visual relationship of the serpent to Eve echoes the belief frequently stated in Goddess literature and reiterated by Schapiro that "snakes are friendly to women." In a second version, *The Garden of Eden* (1990; see page 116), Adam and Eve are connected back to back and entwined by the serpent. Instead of the Tree of Knowledge, an ancient fearsome and monstrous mask appears between their heads. The extremely rich and sensuously painted backgrounds evoke the fecundity of an ideal state of nature, within which the serpent exists and from which the man and woman will be expelled. The paint structure around the edges is less dense and rich and, in places, the bare canvas is visible through drips of paint and brushstrokes, reminiscent of Abstract Expressionism—nature transformed into the work of the artist.

Seen against the mythic natural setting, which is teeming with color in paint and collage, the flatly painted figures of Eve and Adam look strangely out of place. Schapiro has chosen the moment before the Fall and the final separation of man and woman. This reinterpretation of the Judeo-Christian story, in which nature is given a major role, does not alter the fixity of gender and its negative implications. In fact, the paintings suggest that gendered performance and masquerade were created in myth, as indeed the biblical story corroborates.

In a playful variation on the Edenic theme, *Presenting Eden* (1990; see page 117), the small figures of Adam and Eve run and dance around the Tree

of Knowledge, which is enclosed within a structure and flanked by gigantic columns (nature subordinated to man-made institutions). The figures are set within a temple-fronted stage, and the columns support two goblinlike creatures of indeterminate sex. These bowing and gesturing creatures contrast with the nude Eve, silhouetted in red, and Adam who, naked below the waist, runs after Eve, his flesh-colored genitals emphatically contrasted against the stage floor. The humor of the painting does not negate its commentary on the performance of sex and gender. The subversive occupation of the Tree of Knowledge by a grotesque, ghostlike, Dionysiac deity of indeterminate sex, patterned in grape motifs, suggests a seat of power beyond gender, but this does not affect the eternally gendered dancing man and woman. This play on the dance of human beings is introduced by two faceless and sexless creatures on the flanking pillars and is set in a flat crimson field framed by a patterned border of cloth, which further emphasize its illusory nature.

In 1989–90, perhaps as an antidote to the inescapably gendered human beings, Schapiro did a group of smaller works on paper, combining goddesses, nature, and fantastic beings (often androgynous or sexless). In *Our Lady of Crete* (1989; see page 118) the modernized goddess in a short blue dress stands on a stage against a burst of red and yellow paint, her ribbonlike arms and scarf alluding to snakes held by Minoan priestesses. In *Acrobat* (1989; see page 118) the abdomen of the pregnant goddess has ballooned into a circle, and her spindly snakelike arms are raised to her plumed hat. The arch above her head is filled with plants and fantastic silhouettes of hybrid beings. In *We Live in Her Dreams* (1990; see page 119) the central goddess, in a long and stately skirt, is placed within a white triangle and surrounded by an assemblage of silhouettes of bizarre oversexed or neutered beings of ambiguous gender. Schapiro had been thinking of what determines normality and abnormality and of possible future mutations in nature, and with these works she posed questions about the normality of gendered definitions.[24]

She further pursued this topic in a series of paintings and prints of Punch and Judy: e.g., *Punch and Judy and Our Demons* (1990; see page 120). She has described the series as portraying both "humorous comments on the situation of men and women in relationships of long standing" and "crystallizations of extraordinarily violent relationships." The grim silhouettes of the stereotyped duo, reduced to shadow puppets, confront each other on a miniature stage. In an eternal battle of almost Strindbergian inevitability, they appear to be engaged in the stylized repetition of acts that constitute gender difference, bringing to mind Butler's description of gender as performative.[25] Incarnations of Adam and Eve after the Fall, they are surrounded by dark silhouettes of goblins and gnomes. Dancing and bowing male, female, and neuter, fantastic and monstrous, they are caricatured human beings performing their daily acts.

Following Frida Kahlo's practice, Schapiro added small circular cartouches of Kahlo and Diego Rivera to the puppets' profiles in *The Punch and Judy Show: Frida and Diego* (1990).[26] In an interesting twist on gendered identity, she placed Frida's cartouche on Punch's face and Diego's on Judy's. By giving

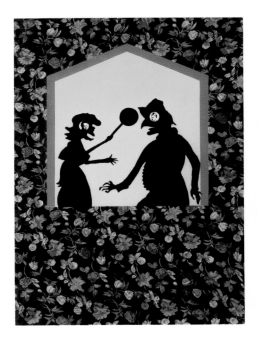

The Punch and Judy Show: Frida and Diego. *1990. Lithograph with collage, 41 × 29¼"*

the puppets specific identities she took their show out of the realm of children's entertainment and put it in the context of the embattled and ultimately tragic marriage of two famous artists. They loved each other, they needed each other, and they made each other miserable. Such have been the realities confronted by many couples because of prevailing beliefs in gender.

In the following year, Schapiro translated the Kahlo and Rivera dance into a large painting with full-size figures, entitled *Love's Labor* (1991). This strangely disturbing painting, with the walruslike Rivera engulfing the petite and forcefully resistant Frida, shows the two in a way that one does not commonly see them, either in Kahlo's art or in photographs—as lovers. Schapiro has commented on how she interprets this image: "Diego was essential to Frida as an artist . . . and Frida and Diego loved each other."[27] But the title she has chosen for the painting tells a different story. It suggests the struggles brought about by the ritualized acts of gendered identities, which were fully exemplified by Kahlo's and Rivera's lives, in spite of their relative freedom from bourgeois constraints.

Romantic views of the potential for meaningful relationships within the rigid socialized structure of gendered difference remain illusory. In her use of theater and dance as a metaphor for her life, Schapiro has explored the complexities and difficulties of these relationships. She has used performance to tell the story "that must become a story."[28] These works have been the means to give form to her "desires and yearnings" in a society that, as she has said, "really doesn't recognize the actuality of the cultural entity—WOMAN ARTIST."

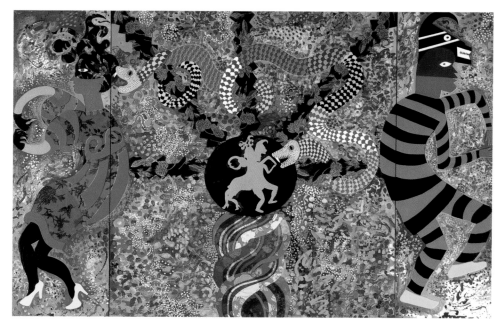

The Twinning of Adam and Eve in the Garden of Eden. *1989. Acrylic and fabric on canvas, 80 × 122". Courtesy Steinbaum Krauss Gallery, New York*

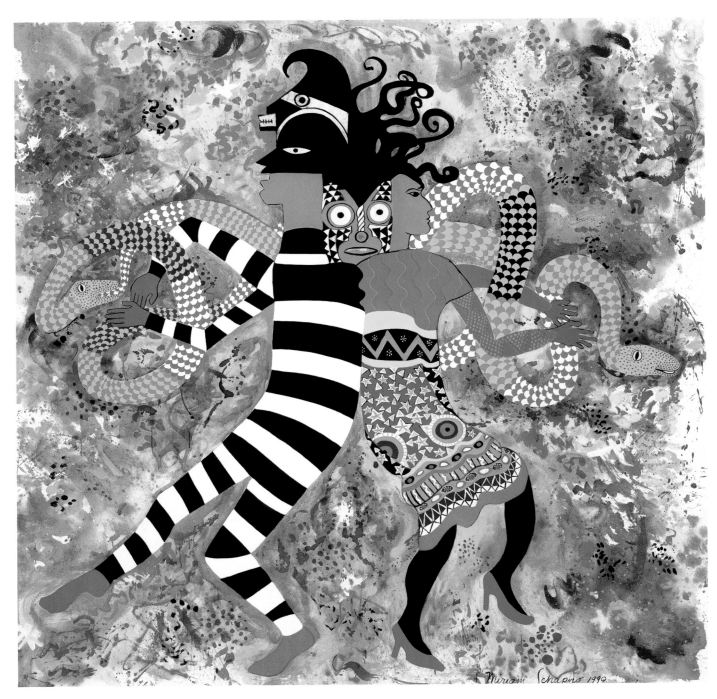

The Garden of Eden. *1990. Acrylic on canvas, 95½ × 95½"*

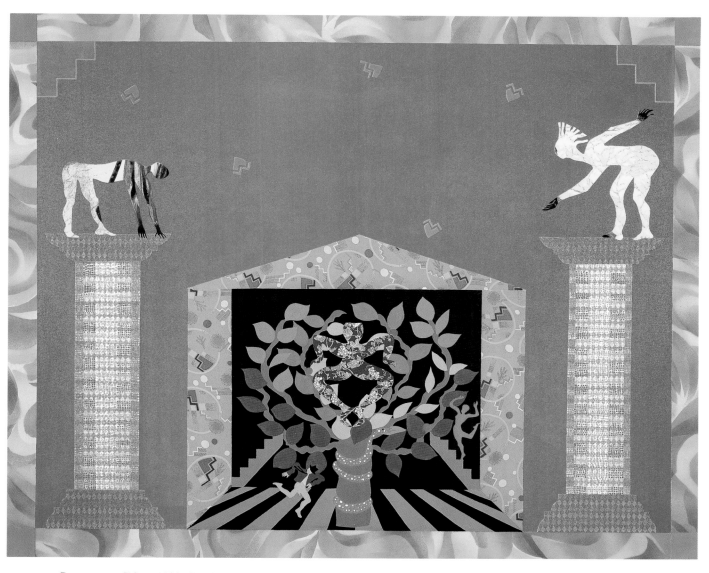

Presenting Eden. *1990. Acrylic and fabric on canvas, 65 × 80". Courtesy Steinbaum Krauss Gallery, New York*

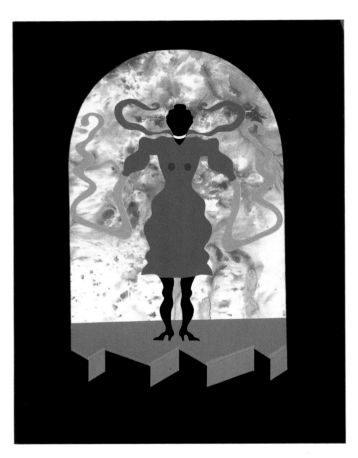

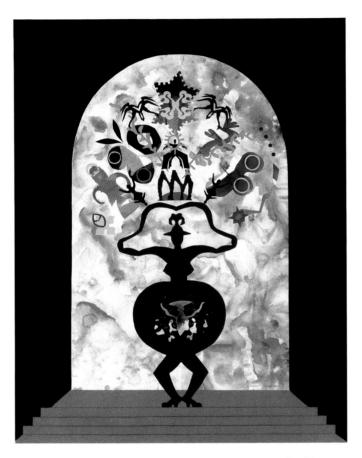

Our Lady of Crete. *1989. Acrylic and paper on paper, 50 × 38"*

Acrobat. *1989. Acrylic and paper on paper, 50 × 33"*

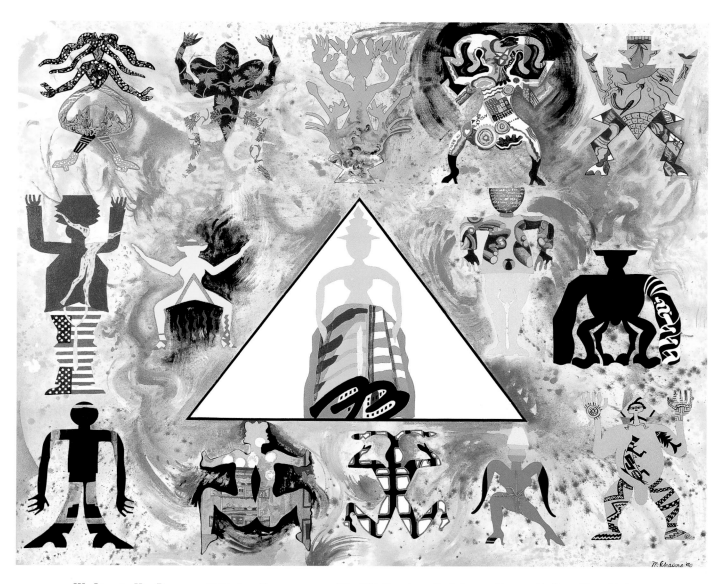

We Live in Her Dreams. *1990. Acrylic on canvas, 65 × 80". Courtesy Steinbaum Krauss Gallery, New York*

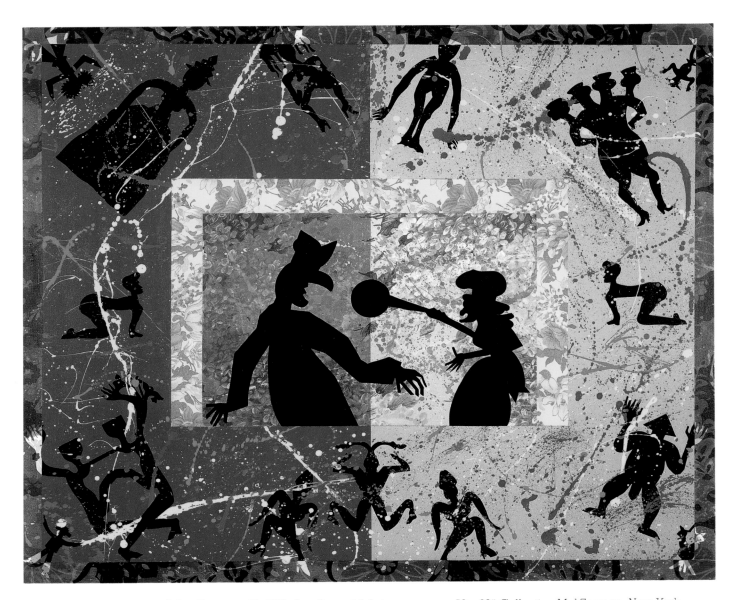

Punch and Judy and Our Demons #2. *1990. Acrylic and fabric on canvas, 50 × 60". Collection Mel Zerman, New York*

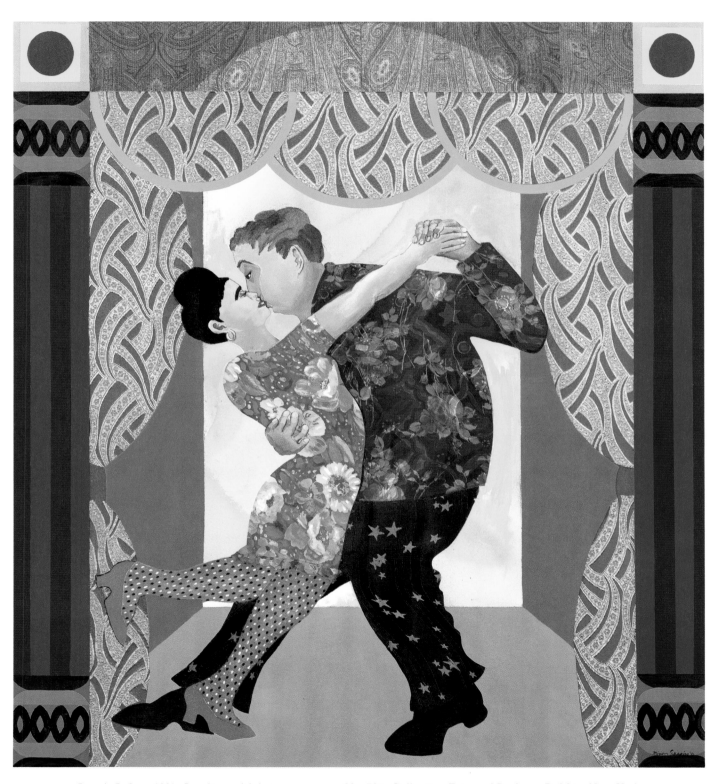

Love's Labor. *1991. Acrylic and fabric on canvas, 80 × 72". Collection Eric and Barbara Dobkin, New York*

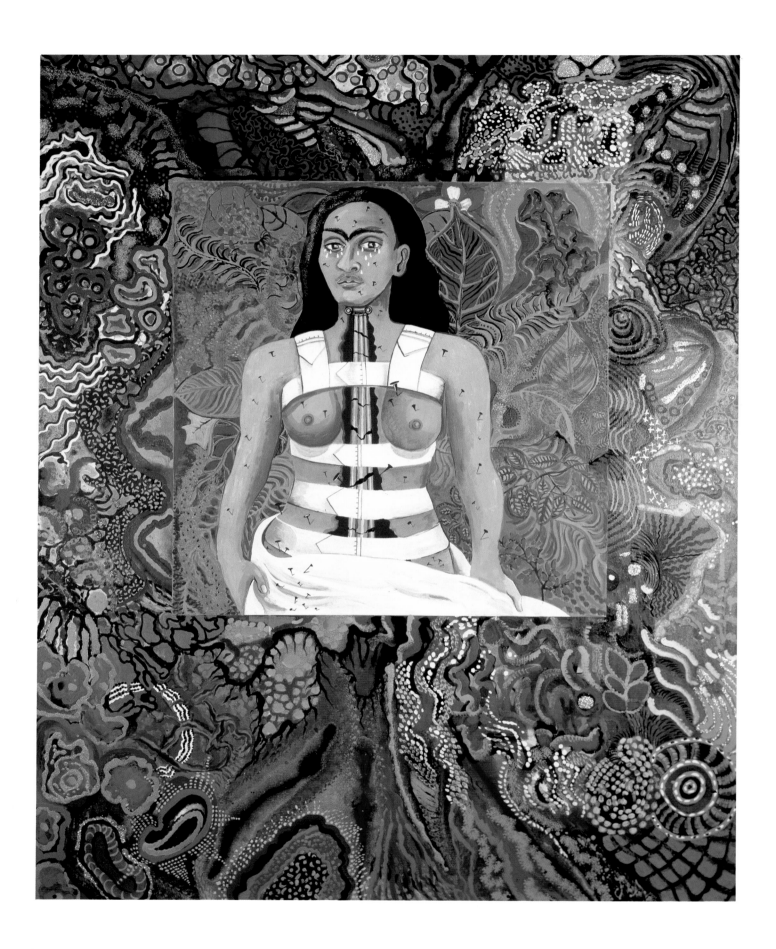

6.

"COLLABORATIONS" AND PERSONAL IDENTITIES

I am an artist looking for legitimate ancestry.

—Miriam Schapiro, 1977

"Collaboration" with artists of the past, especially women, has been one of the most significant themes in Miriam Schapiro's oeuvre, a central focus in her search for artistic identity and for connections with the history of art. It became especially prominent after *Womanhouse*, when she did her first "Collaboration Series" with famous women artists and anonymous women, past and present.[1] Centered on representations of women by women or on women's traditional work, reframed by Schapiro, these collages provided the artist with a new potential for social and cultural relations and became, during the heady years of the feminist movement, the ancestry she had been searching for.

After introducing figural representation in her autobiographical paintings of the mid-eighties, Schapiro felt free to re-create in her own terms the image of one of the women she most admired: Frida Kahlo. Schapiro's "Collaboration Series: Frida Kahlo and Me," on which she had worked intermittently since 1986, is one of her most complex and probing inquiries into "the yearnings of a woman who decided a long time ago to be a painter" and what that decision cost her. She chose Kahlo "because she was a remarkable painter, one who understood from her own house of pain, a woman's suffering and indignity. She was the consummate creator of the diaristic, intimate world she inhabited."[2] Schapiro believes that coming out of a Surrealist milieu, Kahlo had more freedom than other women of her generation living within traditional Victorian constraints, in spite of the fact that the Surrealists were notoriously sexist and chauvinistic. However, Schapiro is also aware that through much of her life Kahlo masqueraded as the object of her husband's desire, in beautiful Mexican costumes that he wished her to wear, while at the same time privately pursuing her life as an intellectual, an independent woman, and a creative artist.

In contrast to the earlier "collaborations" with Mary Cassatt and Berthe Morisot, in the Frida Kahlo series Schapiro used a larger scale and painted her own portraits of Frida, which allude with varying degrees of faithfulness to the Mexican artist's self-portraits. Kahlo's images function as prototypes on several levels. They are visual manifestations of what Schapiro has identified

Agony in the Garden. *1991.*
Acrylic on canvas with glitter,
90 × 72". The Brooklyn Museum of
Art, Purchase gift of Harry Kahn

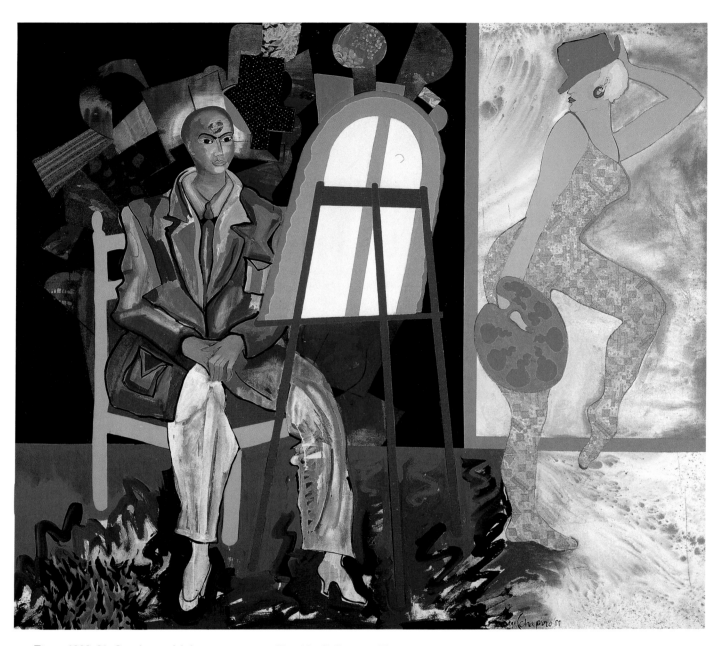

Time. *1988–91. Acrylic and fabric on canvas, 82 × 90". Collection Eleanor and Leonard Flomenhaft, Long Island, New York*

as the woman artist's existential dilemma: the contradictions she experiences in her life as, simultaneously, subject and object. But Kahlo's work is also the "symbolic arena" in which she, like other women artists, could "firmly establish a sense of personal identity." Like her other "collaborations," these paintings are part of Schapiro's search for legitimate ancestry. This is expressed in the title she chose for one of the major paintings in the series, *Conservatory*, and in the accompanying explanation in which she states that she "had chosen to be the curator of our history." "Frida Kahlo is part of my history," she adds, but then, in a more pessimistic vein, she continues "there is nothing left for the woman artist of the eighties than to be a curator of her history." This statement expresses Schapiro's disappointment with the conservatism of the mid- and late eighties and the splintering of the women's movement in that decade. The Frida Kahlo series expresses Schapiro's conflicted emotional state as the feminist movement lost its impact and no substantial changes had been made. This series and Schapiro's subsequent "collaboration" with modernist Russian women artists (1989–94) provide, in their complex symbolism, her most overt engagement with representation as a means by which the self can be constructed and made visible.

In the earliest painting of the Kahlo series, *Time* (1988–91), Schapiro further pursued the problematic dislocation of the intellectual/creative woman, the theme with which she had dealt in *Incognito*. Based on Kahlo's *Self-Portrait with Cropped Hair* (1940), the artist in *Time* is again dressed in a loosely fitting man's suit. This seated figure contrasts with the physically powerful young dancer who holds a palette and can be interpreted as either the alter ego or the progeny of the seated artist. Schapiro's concerns in this painting are the passage of time and the loss of status as part of the aging process. The older woman, who has lost her position in society and has relinquished her bleeding palette to the younger woman, is left with her painting, "the only thing she can claim as her own." The masculine costume she wears, "the clothes of power," is only an illusory disguise. The younger woman has freed herself from the constraints that still control the older artist and, in that sense, is an image of hope. But she also poses a threat to the older woman through her youth, freedom, glamour, and vitality.

But *Time* also has other layers of meaning. The melancholy seated figure, like the young artist in *Incognito*, appears to have no bodily substance; she is a purple bald head stuck in an empty suit. She faces her canvas, which, like many of Schapiro's own paintings, is arched. But since we can only see its back, we cannot be sure whether the canvas is empty (before the beginning of the creative act) or whether it contains a completed composition. That is, we do not know whether the artist is contemplating a beginning or an end. Her purple sculptural head suggests Egyptian funerary sculptures and introduces a reference to death. Behind and around this head, like a halo, are beautiful abstract passages of painting and collage—all the beauty the woman has created or has longed to create. On the right, the figure of the other woman, a powerful bodily presence in a shimmering bodysuit, dances assertively.

Schapiro sees the contrast between the two women as "the spontaneous self and the rehearsed self." But the dancing woman can also be seen as the site of sexuality and male desire: she too acts out a role that is part of the performance of gender.[3] Since she holds a bleeding palette, the icon of creativity, she too is an artist, and the framed space behind her could be read as an abstract painting—her creation. Is this younger woman an entirely separate person? Is she a fragment of the artist's self or a figment of her imagination? Schapiro certainly sees her as being of a different generation—a generation of artists (creative women) for whom it became possible to not have to sacrifice their feminine otherness in order to be accepted as creative beings. The painting reminds us of Schapiro's confused feelings, first recorded in her journal in 1970, that perhaps she was in "a woman's body with a man's concerns."

The male disguise worn by the seated woman introduces an added complexity, suggesting an overlapping of the feminine and the masculine positions, similar to that invoked by feminist authors theorizing spectatorship in

Conservatory. *1988. Acrylic and fabric on canvas, 72 × 152". Miami University Art Museum, Oxford, Ohio. Funded through Helen Kingseed Art Acquisition Fund and the Commemorative Acquisition Fund (anonymous)*

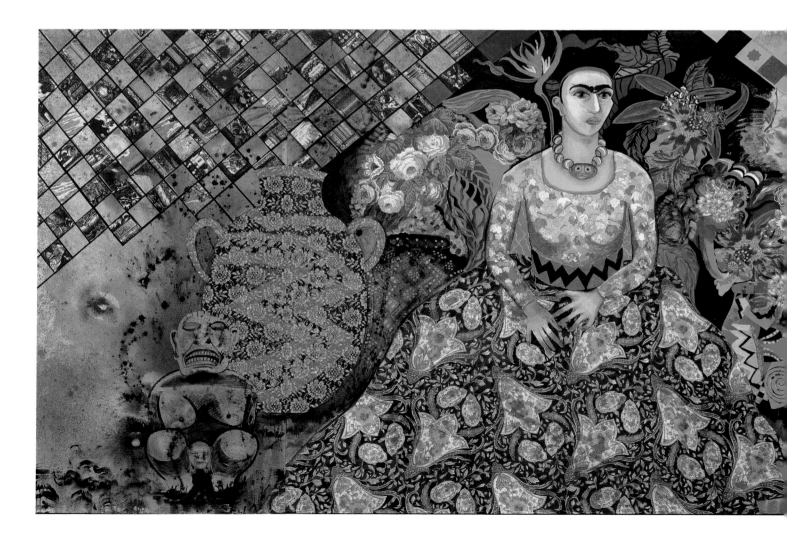

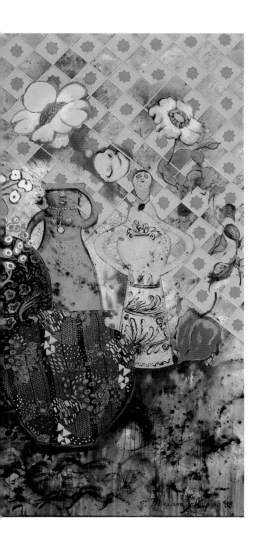

cinema.[4] In fact, the tendency in theories of the feminine gaze and female spectatorship has been to view the female spectator as the site of an oscillation between feminine and masculine positions, suggesting the metaphor of the transvestite.[5] This appears to be happening in *Time*: the seated artist, cross-dressed, is contemplating the younger feminine other. She is, however, prevented from lapsing into mere male impersonation by our recognition that she is based on Kahlo's 1940 self-portrait, which was painted, according to Schapiro, in "great sadness and pain" after her divorce from Diego Rivera because of his affair with the person she loved most, her own sister.[6] The painting records an actual event in Kahlo's life, the cutting of her long hair, the emblem of her femininity, which Rivera adored. Kahlo also represents herself wearing a man's suit that is much too large and may have been one of Rivera's suits. Regardless of whether she had worn such a suit, Kahlo defiantly painted herself in masquerade as a man, retaining only one earring to allude to her femininity. Schapiro, in identifying with Frida, shares in her pain and defiance, but also shares in Kahlo's rejection of herself as the object of male desire. The seated figure can, in fact, be interpreted on a number of levels: a defiant woman wishing to capture some male power; an aging woman who has lost her physical attraction (the sexuality of the procreative body), the only public role accorded to her in a patriarchal culture; or a woman artist who has lost contact with her feminine body to enter the masculine creative order and in old age has nothing left but her painting. These potential meanings complicate the possible relationships between the seated and dancing women. Both are shown in masquerades that emphasize, in different ways, woman's bodily otherness. However, in spite of this parallel, the questions the painting raises about the creative woman and her relation to female-gendered identity cannot be resolved in a cultural and symbolic context still dominated by the male order.

In *Conservatory*, completed in 1988, Schapiro created a fictional Frida. The painting recalls a number of Kahlo's seated self-portraits but does not represent any one of them. Serenely enthroned, with her hands placed on her abdomen, she appears as a goddess in her domain, harmoniously combining nature (the flowering garden) and culture (the various artifacts that flank her). These allusions refer to urban and rural contexts, both of which were an integral part of Kahlo's life—the urban intellectual circle surrounding her and Rivera in Mexico City and her native Mexican countryside. The clay pots, which women in rural Mexico have made since the earliest times, also refer to a heritage and art form that traditionally women have been allowed as their own within patriarchal cultures. But Kahlo also was a painter, thereby intruding into a domain that has not "belonged" to women. Therefore, Kahlo, in Schapiro's mind, was a force "that could make the world believe that even painting could belong to us [women]" (1988). *Conservatory* is Schapiro's utopia. Kahlo, the creative artist and painter, also represents the great mother goddess of fertility and childbirth, as the image of the Aztec goddess Tlazolteotl (left), in the act of childbirth, suggests. Kahlo may have had this figure in mind when she created one of her most arresting paintings, *My Birth* of 1932, which

was conceived as both a memory of her own birth and as an image of her giving birth to herself.[7] Kahlo's painting is at once tragic and powerfully assertive. The concept of Kahlo giving birth to herself as a creative artist and as a powerful and enduring force underlies Schapiro's painting.

In both *Conservatory* and *Time*, the facial features of the Kahlo figure are a cross between her own and Schapiro's. Kahlo was in fact part Jewish; and though this part of her cultural ancestry tends to be ignored in recent critical discussions, it is important for Schapiro. She has described Kahlo's face as "the strong, beautiful, Latin, Jewish face with the piercing eyes and sensual mouth." Therefore, these double self-portraits are a means for Schapiro to merge with a female prototype—a type of mother figure. Ironically, the merging occurs in *Time* at a moment when the mother is masquerading as a man, and in *Conservatory* with a fertility goddess who in real life could not bear children. In both cases the merging with the maternal body remains an impossible desire. In *Conservatory*, however, Frida's body—surrounded by flowers and covered by a blossoming skirt—is equated with the garden, a place that conserves the mother's memory and, in Schapiro's mind, is always accessible to women. A part of Schapiro's fantasies about Kahlo and her own maternal ancestry, this garden can be read as a visualization of the matrix, women's potential access to the symbolic order.

Schapiro's next "collaboration" with Kahlo, *Presentation* (1990), is in many ways atypical. The subject is one that Schapiro had used before, both in semi-abstract pieces of the early eighties and in the dance trilogy,[8] that of a woman standing between two curtains and presenting herself to an audience. But Kahlo's *Self-Portrait* of 1937, which Schapiro chose as the piece to "collaborate with," is one of her most conventional pieces. Kahlo gave this portrait, in which she presents herself as "colonial-style bourgeois or an aristocratic woman," as a present to Leon Trotsky on his birthday (November 7, 1937), a few months after she had ended their affair.[9] In this gift to an ex-lover, "she stands like a prima donna between two curtains with all the poise of a Creole maiden."[10] Her lips are painted crimson, her clothes carefully color coordinated. She holds both a bouquet of flowers and a piece of paper inscribed: "For Leon Trotsky with all love I dedicate this painting. . . ." This is Kahlo's self-image in the consummate masquerade of femaleness, dictated by what she, most likely, had internalized as the wishes of a male lover. That is the way he would have enjoyed seeing her, as a projection of the object of his desire.

Schapiro completely transformed this painting, making the figure of Frida more powerful. The iconic image of Kahlo stands against an intense green background and is framed by majestic and shimmering floral curtains of blue, red, and green. Her face and neck are framed by the traditional *Tehuana* headdress, which here becomes a wreath of large floral petals outlined in red. The bourgeois prima donna has been transformed; she no longer holds a bouquet of flowers, and the piece of paper is inscribed with a fragment of a poem that ends with the statement "I am a bird."[11] The contrasting color scheme of intense red, green, and yellow makes her look almost like an apparition float-

Details, **Conservatory.** *1988*

ing between the substantial curtains. In her "collaboration" Schapiro took Kahlo out of the realm of the feminine as constructed in culture—and as re-created by Kahlo herself—and put her into that of the imaginary and of fantasy. The bourgeois beauty has become a floral vision and acquired the freedom of a bird.

In the last paintings in this series, *Agony in the Garden* (1991; see page 122) and *Arts and Crafts* (1991), Schapiro returned to the woman-body-garden parallel. In the former, the stark and sorrowful image of the goddess is set within a garden and framed by a colorful and pulsating garden border. This central image is an enlarged copy of Kahlo's self-portrait in *The Broken Column*.[12] Painted in 1944, soon after she had undergone surgery, this image manifests Kahlo's intense emotional and physical suffering. White tears stream from her eyes, suggesting the confluence of milk and tears, the signs of the *Mater Dolorosa*.[13] Nails pierce her ruptured flesh, and the steel orthopedic corset, a symbol of the invalid's imprisonment, holds together the two parts of her body disjoined by a crevicelike gap. The cracked column in this gap replaces Frida's own deteriorating spinal column.[14] Schapiro has placed this image against a flat but lush floral ground, eliminating the barren desert vista that opens up behind the figure in Kahlo's painting. The intensity of this painting is emphasized by the total absence of fabric. Schapiro's image of Frida is both more iconic and more defiant than Kahlo's original. The painting restates the theme of a woman's separation from and connection to her body. The biomorphic border suggests internal organs as much as it does plant forms and, in the area below the image of Frida, it becomes explicitly womblike, suggestive of fluids rushing out through cervical passages.

Agony in the Garden can be interpreted on a symbolic level in layered and even contradictory ways: as a woman's loss of her body, here pierced by a columnar phallus, and as her severance from nature in order to enter male-dominated culture. The column replaces Kahlo's own spine, but is incapable of supporting her without an orthopedic brace. The phallus cannot be appropriated by woman, as Lacan has insisted. In this context the female body can only cause pain and suffering to the creative woman, for in the masculinist symbolic order she is disembodied. Through the literal representation of Kahlo's prosthetic device, Schapiro expresses her sympathy with Frida's suffering, which "brought her such tremendous pain." But in her painting Schapiro is also establishing the potential connection of this body to nature, both in the foliate surrounding field and in the pulsating organic border, to which she is inevitably tied and from which she can derive strength, since it symbolizes the garden—the power of nature—that Schapiro has always seen as woman's secret domain. Schapiro's painting is tragic but not pessimistic. The blossoming garden, which replaces the barren desert, alludes to Kahlo's continued creativity and evokes the memory of the maternal. Through the dominant border, with its references to the female body, the painting appears to be a visualization of the matrix and of women's potential access to the symbolic and the creative.

In addition to representing a creative maternal prototype, Kahlo's self-portraits have been for Schapiro a means to explore the contradictions in the

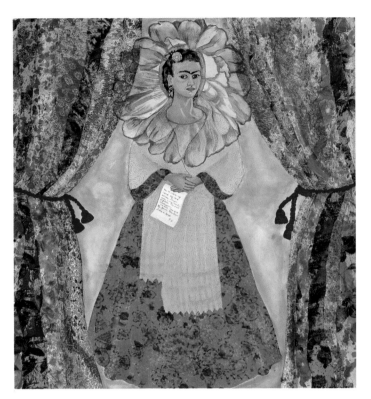

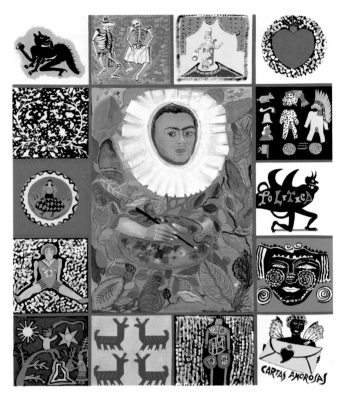

Presentation. *1990. Acrylic and fabric on canvas with glitter, 80 × 72". Collection Sarah Steinbaum, New York*

Arts and Crafts. *1991. Acrylic on canvas, 72 × 60". Collection Steinbaum Krauss Gallery, New York*

relationship of the creative woman to her body. These contradictions are, for Schapiro, an existential fact. But the tragedies of Kahlo's life have been superseded by her creative legacy. This Schapiro celebrates in *Arts and Crafts*, where the centrally placed, bodiless, and iconic portrait of Kahlo as artist, with palette and brush, is surrounded by a verdant garden and framed by images of her artistic inspiration. Many of these have also been sources for Schapiro's art.

Kahlo's masklike and androgynous face is based on several of her self-portraits,[15] but the figure as a whole is unlike any of them. Framed by the front part of a *Tehuana* headdress, which resembles both a halo and the petals of a daisy, the face simultaneously acquires an aura of sanctity and looks like a flower. The white headdress also brings to mind the gathered collar of Watteau's melancholy clown, Giles, and the typical white ruff worn by sitters in seventeenth-century portraits and self-portraits. It takes Kahlo out of a specific context and emphasizes her existence beyond the parameters of time and place, but it also fragments her presence as it isolates her face from her hands. Plants replace her body, further stressing the fragmentation of the artist. Kahlo's spiritual and symbolic victory was, ironically, a by-product of the progressive deterioration of her body. As she moved closer in her self-portraits

to her handsome and strong androgynous face, the performance of gender became almost irrelevant. She can be seen as both culture and nature, as her hands and her palette emerge out of the verdant growth that evokes her body.

In the rectangular compartments of the frame, Kahlo's artistic sources allude to Mexican and Native American art, paper cutouts and dolls, ritual masks, women's traditional arts, and Mexican politics, since a number of the images derive from Posada penny prints.[16] They also include, immediately above Kahlo's head, an enthroned goddess counterbalanced by two skeletons. In the upper right, a large crimson heart alludes to Mexican devotional art, to Kahlo's and Schapiro's paintings, and to the intense emotions that dominated Kahlo's life and for which her art became a symbolic arena. Through the presence of the palette and brush and Kahlo's sources of inspiration, this painting celebrates female artistic creativity; it also questions the notion of a unitary and coherent identity because of the fragmentation of the artist's figure, and, therefore, proposes an unfixed construction of the gendered self. It is Schapiro's most transformative "collaboration" with Kahlo.

Kahlo's art and home, her personal spaces, existed on the boundaries of sexual difference, those of the masculine constructs of the artist and of the beautiful feminine woman, boundaries across which she painfully moved. Schapiro, like Kahlo, throughout her life has tried to develop alternative models for negotiating between artistic creativity and the spaces of femininity. The crossing back and forth across the boundaries and limits of sexual difference, the movement in and out of gendered spaces, continues to be "fraught," as Teresa de Lauretis has phrased it, "with tension, contradiction, and painful pulls in opposing directions."[17] Acutely aware of this, Schapiro admires Kahlo as "a woman who persevered despite seemingly insurmountable circumstances."[18] Kahlo's self-portraits, as incorporated in Schapiro's art, are mirrors that reveal the woman artist's willed and culturally constructed selves. They provide complex answers to the question Schapiro posed in 1970: "Where is the mirror in the world to reveal who I am?"

In search of further reflections in this mirror, in 1992 Schapiro looked to a different part of the world to "collaborate" with women artists in a project entitled "Collaboration Series: Mother Russia." Her interest in Soviet and Russian women was motivated by her own ancestry (both sets of grandparents emigrated from Russia); her long-standing admiration of Sonia Delaunay, an important modernist painter who also worked in fabric; and the general parallels she saw between the Russian revolutionary movement, of which the women artists were part, and the feminist movement of the seventies.[19] Equally important was the central position these women gave to fabric as part of an empowering formal language in their work, validating Schapiro's own choices. With this series Schapiro introduced a new and varied thematic repertoire: the portraits and personalities of the Russian women, as recorded in accounts of their lives and in Russian photographs of about 1920–25, and images of their work in a variety of media. In this series, she also returned to motifs and themes in her own work of the seventies: fabric in women's work;

the costume as a creation of and allusion to the woman artist or to women in general; and the fan, the quintessential prop of femininity and sentimentality, transformed into a monumental, geometric, and profusely decorated structure that has become a powerful personal icon for Schapiro.

As a first step, Schapiro immersed herself in histories of Russian modernism, studies on Russian and Soviet women artists, monographs on individual women, and books and catalogues on Russian theater and costumes, in the creation of which the women were active participants.[20] After reading their stories, primarily as told by others (both women and men), listening to fragments conveyed by the women themselves, and looking at the images they created, she was ready to start a different chapter in her autobiography.

Schapiro was especially interested in the important role that textile, theater, and costume design played in the creative output of the Russian women. She first pursued the theme in a portfolio of three separate prints entitled *Delaunay, Goncharova, Popova and Me* (1992), highlighting three women who shared her love of textiles and also were painters. Each of the prints is devoted to one of the three artists and specifically alludes to her work in both form and content. The "Sonia Delaunay" print, showing an elegantly fashionable woman in a black-and-white gown, refers to Delaunay's modernist fashion and commercial designs, which are imbued with a sense of geometric abstraction. It is based on a photograph of the young Delaunay draped in one of the fabrics she designed and relates stylistically to the chic Parisian world of the 1930s of which she was a part. The "Natalia Goncharova" print adapts one of her peasant costumes for the play *Le Coq d'Or*, showing a Russian country woman in a brightly flowered dress, an image that, as Schapiro has observed, "brings to the fore [Goncharova's] love of traditional Russian folk motifs."[21] The "Liubov Popova" print reproduces one of her very modern clothing designs, in tonalities of brown, yellow, and orange, and bears an inscription of Popova's name with saw-toothed letters suggesting mechanical gears.[22] The print alludes to Popova's intense involvement in Russia's revolutionary and modernist ferment. Though also a painter (the background of the print makes reference to a series of her abstract paintings entitled *Painterly Architectonics*), Popova believed that "painting had less meaning in a revolutionary epoch" and wanted to create "'new' costumes for the times."[23]

In the first large painting in the Russian series, entitled *Yard Sale* (1993), Schapiro further pursued the relationship of women to fabric and costume. Here the discarded clothes of yard sales are transformed into four grand costumes, hung on a clothesline between two classical columns and framed by a romantic canopy of trees, suggesting a theatrical or operatic stage set. The costumes are presences that evoke those who created them and/or might have worn them: Frida Kahlo, Varvara Stepanova, and Sonia Delaunay. On the left, a tiered multicolored gown with a bright red wrap and a sequined cape of diaphanous silk allude to Kahlo, her love of luxury and romance, and her elegant attire. On the right a full-figured long dress, painted in flat, modernist patterns of brilliant colors, represents the creative and physical pres-

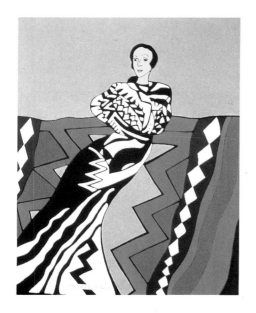 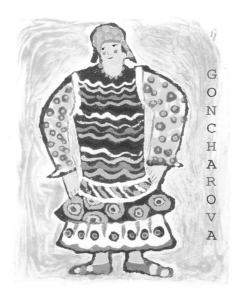 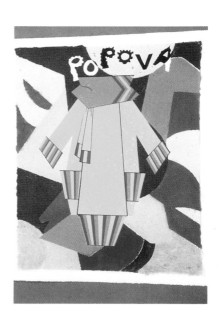

Delaunay, Goncharova, Popova and Me. *1992. From a portfolio of three prints*

ence of the mature Delaunay (and also "the mature Mimi"). The central short dress, dynamically vivid with a bright red star on its bodice, is based on one of Stepanova's designs for sports costumes.[24] The Russian modernist and revolutionary, who fully participated in both the politics and art of her country, acquired a special significance for Schapiro. In choosing to evoke the presence of the three artists through the costumes they designed and/or wore, rather than through their paintings, Schapiro is commenting on both the traditional connection of women with clothing and beauty and on the arbitrary division, in modern culture, between high art and craft, a major concern in her art of the last decades, especially in her femmages.[25]

Set on a brightly lit stage which is also a garden, *Yard Sale* is related to Schapiro's autobiographical trilogy and to her Frida Kahlo series, combining the themes of the theater and the garden with "collaboration" and masquerade. The painting, though seductively bright and beautiful and even assertively optimistic, poses complex questions. The three women artists are represented through articles of clothing and their identities, though alluded to, are not immediately recognizable to the uninitiated spectator. Their memories, as Schapiro has observed recently, have been hung "by history, on a clothesline to blow in the wind." Like old clothes in a yard sale they are "useless junk" to be discarded. But by setting these objects on a grand stage, Schapiro breathes new life into them. In returning to the theme of the costume as a metaphor for the creative woman, recalling her "Kimono" and "Vesture" series and her two versions of the *Poet*, she reiterates that the empty dress can have a double meaning as both presence and absence. As a former container of the female body it stands as its metaphor; but its emptiness also connotes absence, and therefore it is an image of the historically, culturally, and symbolically absent woman. The questions about women's visibility and potential for self-creation that Schapiro has posed through most of her life remain with her in this recent "collaboration."

The image of woman as creative artist and as revolutionary became the

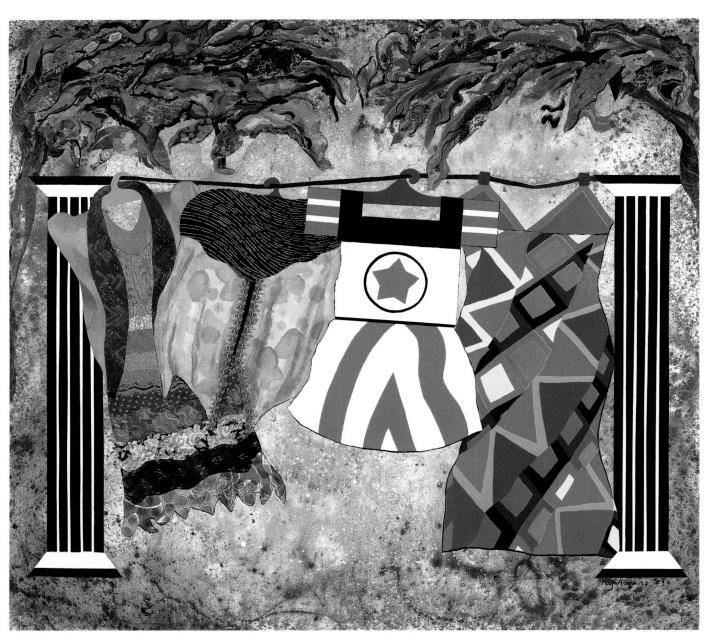

Yard Sale. *1993. Acrylic and fabric on canvas, 82 × 90". Courtesy Steinbaum Krauss Gallery, New York*

central theme in the two paintings that followed *Yard Sale* in 1993. Both center on Stepanova (1894–1958), a prime mover of the Russian avant-garde, whom Vladimir Maiakovsky has described as a "frenzied artist."[26] According to other contemporary sources, Stepanova lived "in a creative fury, never content with a single style, always experimenting with new concepts of painting, drawing, and design."[27] Stepanova was one of a group of extraordinary women artists, including Natalia Goncharova, Alexandra Exter, and Liubov Popova, "who, no less than their male colleagues, laid the foundations of Soviet culture."[28] All four were multifaceted and worked equally as painters, graphic artists, and theater and fashion designers. The Russian poet Benedikt Livshits referred to these and the other women artists of "Russia's New Age" as "Amazons."[29] M. N. Yablonskaya observes that "for the most part these women of the avant-garde sprang not from the cultural elite of Moscow and St. Petersburg but issued like 'Scythian riders' from the far-flung provinces of Russia."[30] Both authors describe the women as outsiders—Amazons, Scythian riders, not from the cultural elite—using references commonly reserved for strong women since the ancient Greeks first identified the Amazons as their prime enemy.

Three paintings that Schapiro completed in 1993–94, *Stepanova and Me, After Gulliver*; *She Flies through the Air with the Greatest of Ease*; and *My Fan Is Half a Circle*, are related to the theme of personal appearance, which has been so important for her. In *Stepanova and Me, After Gulliver*, the Russian artist has become truly heroic. The gigantic figure, dressed in a blue, red, green, and purple athletic costume (a take-off on those Stepanova designed to be worn by Russian women), covers her eyes as she stands among a crowd of tiny beings that hover around her feet. Schapiro has identified them as "the devils and demons that beset all creative people," but which, on the basis of experiences in her own life, more readily beset women who have made the decision to be artists. Is Stepanova, the painting's Gulliver, trying to ignore them or is she fearful of them? They appear too small to be able to hurt her. But, as we all know, Lilliputian beings can immobilize a giant. Even her bright athletic costume, with a yellow circle emblazoned with a red star in the center of her chest, may not protect her from the persistent demons, especially those of duty and selfishness, which, in Schapiro's mind, haunt creative women. The fictional element in this painting is visually enhanced by the abstracted gardenlike setting and the legend *Kino* (film) inscribed in the bottom right corner in Cyrillic letters, a tangible reference to the intersection of reality and illusion so crucial in Schapiro's work. Stepanova's idealized gigantic figure, reminiscent of the Colossus of Rhodes and other colossal ancient male effigies, is in disguise and is completely a figment of the artist's imagination. No colossal statue has been erected to her and nothing guarantees the ultimate permanence of her fame, stature, and place in history. The same could be said for Schapiro herself. As she has commented: "No, I am still afraid. I am still restless and I realize I will be that way to the end."[31]

In *She Flies through the Air with the Greatest of Ease* (1993–94), a humorous and ironic painting, Stepanova—or is it Schapiro disguised as Stepanova?

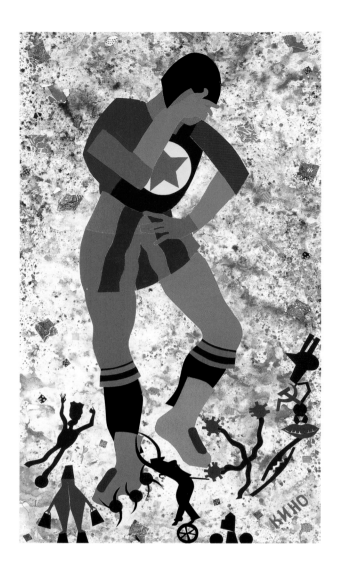

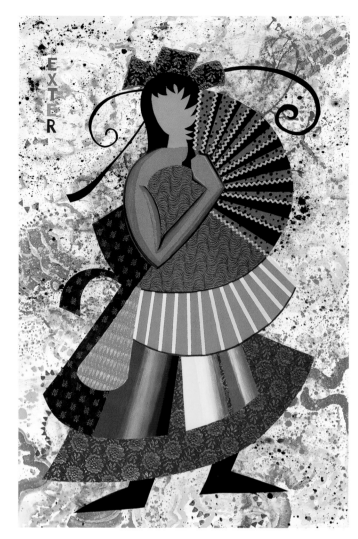

—identifies the culprit responsible for her omission from histories of culture.[32] She floats in from the left, like a sea nymph or an allegory of spring, smiling and holding a bouquet of flowers—her art with its beauty and potential transformative powers. Unlike a nymph or a conventional allegorical figure, she is dressed in a costume that is a cross between a football player's uniform and a Superman outfit. Her athletic jersey, with shoulder pads, has a large red star in the center emblazoned with an S, standing for Stepanova but also for Schapiro. With her left hand she points at the groin of a horrified man, seated with legs akimbo, bearded and rather dour-looking. He is dressed in a traditional Russian outfit and a tall fur cap, the elegance of his costume suggesting that he is an urban intellectual masquerading as the quintessential peasant. This work brings to mind all sorts of elegiac paintings in Western art: Chagall's floating brides holding bouquets of flowers; Botticelli's *Birth of Venus* and *Primavera;* and even Michelangelo's *Creation of Adam*. But the image of Stepanova also is reminiscent of Schapiro's actresses holding bouquets as they confront their public. This apparition, therefore, is no longer an allegory; it has become a specific person and a specific act that leave no doubt about

Stepanova and Me, After Gulliver. *1993. Acrylic, fabric, and paper on canvas, 75 × 42". Collection Robert Mauriello, New Jersey*

My Fan Is Half a Circle. *1994. Acrylic, fabric, and paper on canvas, 80 × 45". Courtesy Steinbaum Krauss Gallery, New York*

the intended meaning. It is Schapiro's playful and subversive answer to Lacan's claim that "It is in order to be the phallus, that is, the signifier of the desire of the Other, that woman will reject an essential part of her femininity, notably all its attributes, through masquerade."[33] The masquerade, created in collaboration by Stepanova and Schapiro, is that of an artist as a superwoman and a football player. Having donned the clothes of the athlete/superman, Stepanova engages the male patriarch. The smiling image is absurd and ironic and certainly cannot be made to fit the masquerade of womanliness.[34]

In *My Fan Is Half a Circle*, based on a costume design by Alexandra Exter for a 1921 production of *Romeo and Juliet* at Moscow's Kamerny Theater, Schapiro returns to the geometry of costume and its embellishment, which have been significant in her work since the mid-seventies, especially in her monumental *Anatomy of a Kimono* (1976). The small figure in Exter's design, which looks like a Spanish dancer rather than a Renaissance lady, provided the basic composition and the geometric scheme, which Schapiro reconstructed, enlarged, and embellished.[35] The fan and four layers of the gown form concentric circles that anchor the composition, with its rich overlay of fabrics and its variety of radial patterns in brightly contrasting hues of yellow, orange, pink, purple, blue-green, and blue. This painting is about sensuousness, idealism, and beauty, as well as the sheer pleasure of being a mature artist in "collabo-

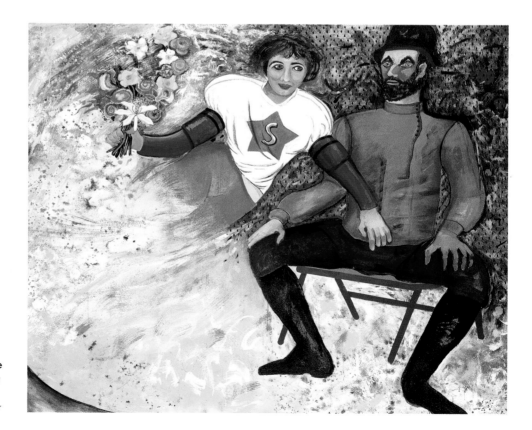

She Flies through the Air with the Greatest of Ease. *1993–94. Acrylic and fabric on canvas, 60 × 72". Courtesy Steinbaum Krauss Gallery*

ration" with other women artists. But, like so many of Schapiro's other female images, the woman dancer is faceless, and the inscription of Exter's name (upper left) is needed to record and commemorate the woman artist's presence.

Mother Russia (1994), the most monumental painting in this series, is both a link with and a departure from Schapiro's earlier fans, which she introduced in 1978. Both geometry and decoration are essential to the five monumental fans that she completed between 1978 and 1980, all of which are large shaped canvases (see, for example, *Barcelona Fan*, 1979).[36] The shaped canvas gave her the opportunity to experiment with endless variations of fabric patterns and painted passages within a set formal system—a semicircle with twenty-four radial spokes subdivided by a number of small concentric semicircles. Out of an object typically labeled feminine and trivial, a small sentimental object held by women in countless nineteenth-century paintings, Schapiro created a newly ordered visual structure, a powerful personal icon, within which she presents the histories of women artists of the Russian Revolution. On the same grand scale as her other fans, *Mother Russia* is the only one with a historical narrative and images of human beings.

Mother Russia is one of Schapiro's grandest "collaborations," her setting for her pantheon of modern Russian women artists. The silk-screened portraits, placed in the white radial segments of the fan's outermost band, are based on photographs of (left to right) Sonia Delaunay, Antonia Sofronova, Nadezda Udaltsova, Liubov Popova, Anna Golubkina, Alexandra Exter, Varvara Stepanova and (again) Popova, Olga Rozanova, Nina Simonovich Efimova, Stepanova, Natalia Goncharova, and Vera Muchkina. The portrait on the far right is of Schapiro herself. Occupying the central double-width spoke are the smiling Stepanova and Popova, derived from a frequently reproduced photograph taken by Stepanova's husband, Alexander Rodchenko.[37] In the second and largest zone of the fan are images of the works created by the women: Goncharova's peasant costumes, Delaunay's fashion designs, Exter's mechanical figures and costumes, Popova's and Stepanova's dress and uniform designs, and Muchkina's colossal sculpture *Worker and Collective Farm Worker*, created for the Soviet Pavilion at the Paris Exposition of 1937.[38] Between the two registers, a band of black fabric embroidered in gold repeats the word "journey" (*poejdka*) in Cyrillic. Segments of a black, white, and red fabric create an abstract pattern between the black-and-white spokes of the third register, and beneath it, in large Cyrillic letters, is the inscription "cooperation" (*kooperaunia*). Finally, in the innermost segment, the Soviet hammer, sickle, and star are superimposed on a sheaf of wheat.

Painted in the colors of the Russian Revolution, *Mother Russia* is impressive in the scope of its content, the vitality of its conception, and the dynamism of its graphic design. It refers to the aesthetics of the Russian artists' graphic design as it appeared in their publications and journals on politics and art. It is a true homage and celebration of a short period in time—the 1910s—when Russian women artists, among the first "artist-productionists" to work in factories,

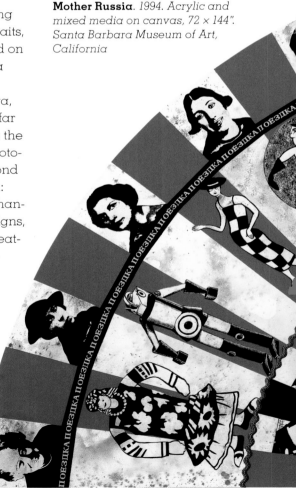

Mother Russia. *1994. Acrylic and mixed media on canvas, 72 × 144". Santa Barbara Museum of Art, California*

actively participated in laying the foundations of Soviet culture and, thus, conceived a new role for themselves.[39] But the moment was brief; many of the artists were forgotten; and seventy years later an American artist had to bring them, in Schapiro's words, to "the forefront of our cultural consciousness." This is her idealized and romanticized recording and interpretation of that special decade.

In the far right segment of *Mother Russia* is Schapiro herself in disguise, wearing a hat and veil, as she had in the photo on the cover of the exhibition catalogue of her 1974 retrospective.[40] The photograph held a special meaning for Schapiro because it had been taken by her students at the time of *Womanhouse*. Those students also found the costume for her and transformed her "into the consummate nineteenth-century person," a kind of maternal figure.[41] In the context of *Mother Russia* it becomes part of a double "collaboration"—with the Russian women modernists and with the twentieth-century women students—and in that sense establishes a genealogy of creative women, past and present, with whom Schapiro associated herself. Here, for the first time since 1948, the year she completed her master's thesis, Schapiro included an image of her face in her art.

Schapiro included the same photograph in *Russian Matrix* (1994) and *The Stronger Vessel* (1994), two of the last works to be completed in her "Collaboration Series:

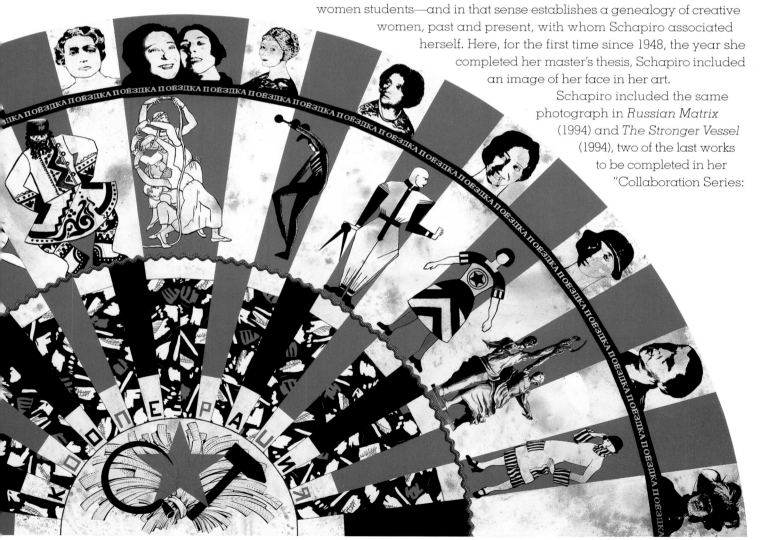

Mother Russia." In *Russian Matrix* her portrait appears again with those of her Russian artistic ancestors, but this time it occupies one of the boxes of the familiar *Sixteen Windows* grid (second row, far right). Though the faces gaze out pensively, all of them are overlaid by colorful floral and abstract screens. A few of them smile, and one holds a cigarette in her parted lips. Despite such individualized distinctions, the frontality and iconic simplification of the portraits characterizes their overall effect, making the Russian women artists seem distant and even withdrawn. They appear like memories out of a past that can only be partially reclaimed. Passing reflections in a mirror, mingled with abstract shapes and ornamental motifs, they are the "shapes" that Schapiro saw as she looked into the mirrored compartment of her *Shrines* "to find images for the future."[42] The silver mirrors, which had remained empty in *Sixteen Windows*, are now the apertures of the matrix-womb, filled with the work of women's hands and their reflected faces. Plural, fragmented, still partly concealed, Schapiro's genealogy of creative women gave her access to her own story, even if only indirectly.

In *The Stronger Vessel*, six of Schapiro's heroines have blossomed forth (Delaunay, Goncharova, Popova, Stepanova, Exter, and Muchkina) in a magnificent anthropomorphic bouquet. Here, Schapiro's symbolic image of art and beauty has expanded to include her genealogy of women. Their floating heads, set in haloes of petals, grow out of a powerful crimson vessel tied with visceral ropes resembling umbilical cords. This vessel, another of Schapiro's metaphors for the female body and the procreative womb, strongly contrasts with the fragile floral women to whom it has given birth. In the very center, in a burst of red paint, Schapiro's head emerges out of the womb. She is giving birth to herself within a circle of creative women muses. The painting, though profoundly different, may be an homage to Kahlo's painting *My Birth*. Unlike Kahlo's lonely and tragic figure, who has only the Virgin as witness to her birth, Schapiro has adduced an ancestry of creative women—those who have made it possible for her to continue being an artist and will allow for the birthing of women artists in the future. The womblike vessel, an object to which women have given shape for centuries, gives birth to women who have transgressed the lines of gender demarcation and dared to be painters and sculptors in a cultural milieu dominated by men. But, even in this potentially triumphant moment, Schapiro again presents herself in disguise, using the same image as in *Mother Russia* and *Russian Matrix*. However, through its repeated use in this series, the photograph becomes an easily identifiable emblem, equivalent to a signature. Furthermore, in *The Stronger Vessel* Schapiro includes only the head of the image and camouflages the hat within the burst of red paint. The focus on the face and the stronger yellow coloration brings out the features behind the veil, including the eyes. It seems then that within her flowering garden and her blossoming maternal genealogy, Schapiro the artist can finally break through the masquerade of womanliness. The faceless dancers and performers have been replaced by the Russian women artists whose portraits Schapiro intentionally made plain and direct,

removing any painted refinements or cosmetic embellishment ("cosmetics make you look like a woman, otherwise people look alike"). For the first time since her 1948 self-portrait, she is allowing her face to be seen, in its plainness and vulnerability. As an artist and a woman with a public life, she confronts her audience.

Having raised her mirror to the world, Miriam Schapiro has reflected for us a parade of women marching by. They have provided her with images of who she might be. Eager to discover women as they have existed in history, she continues to record their differences from men and to celebrate their achievements. In bonding with these women, listening to their stories, listening to stories told about them, and retelling their stories, she is painting into the texts of culture her missing autobiography.

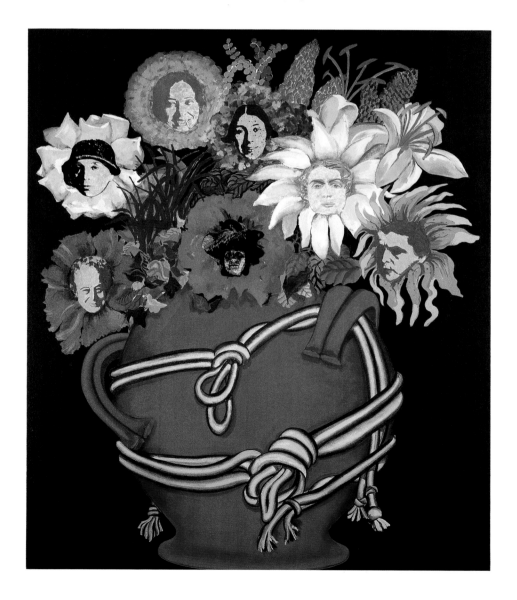

The Stronger Vessel. *1994.*
Silkscreen and acrylic on canvas,
72 × 60". Courtesy Steinbaum
Krauss Gallery, New York

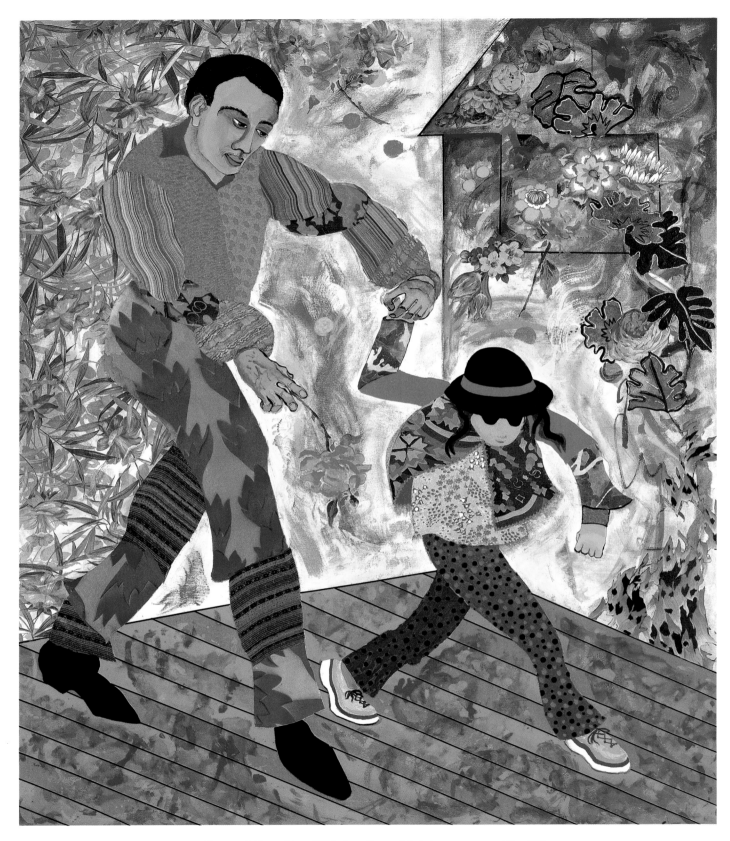

Father and Daughter. *1997. Acrylic and fabric on canvas, 72 × 60".*
Collection Aaron and Marion Borenstein, Fort Wayne, Indiana

AFTERWORD

Spiritual survival depends on the harboring of memories.

—Miriam Schapiro, 1979

After years of living in a culture that lacked female artist prototypes, Schapiro, now in her seventies, rejoices in the creative energy of her genealogy of women and their power of survival, but she is also acutely aware of their absences from the official records and histories of cultures. Throughout her life she has continued to pose questions as a creative woman in search of legitimate ancestry, and has articulated these questions, visually, in a variety of ways.

In 1997, during her mother's final illness and death at age 99, Miriam Schapiro completed a new body of work through which she brought back memories of her life and art and the demons that have plagued her. She recalled the long years during which "there was no language to speak our discontent," and how she created the visual language that enabled her to harbor the memories on which spiritual survival depends. In order to do so she had to turn to fantasy and to imagine that she could "collaborate with women who are dead." She included her own image among theirs because she "wanted so much to be like them." The portraits of Frida Kahlo (her surrogate friend), Sonia Delaunay (her surrogate mother), and the other Soviet women—her artistic ancestry—and the images of their art that she incorporated in her paintings and "femmages" helped fill the gap of their unbearable absence from official histories.

Memories of her childhood also returned. In one of the most important paintings of this recent body of work, *Father and Daughter* (1997), she acknowledged for the first time in her work her father's role as her mentor. As they dance together holding hands, father and daughter are framed by the house and flowering garden, woman's domain. Dressed in masquerade—he in a colorful costume with Russian peasant overtones, she as a street-smart kid—they move in harmony; he offers her a large flower, the gift of art. Though absent as a human image, the mother's presence is represented by the house with the streams of flowers tumbling out of the window. This is her mother's house, as had been the case in most of the houses throughout Schapiro's oeuvre. As the father teaches her how to dance on the hard studio floor, covered with splotches of paint, the powerful little girl holds on to pre-Oedipal memories of the maternal that will always be part of her.

In this most recent group of paintings, also for the first time, Schapiro has dealt explicitly with her Jewish ancestry. In *My History* (1997), a painting that combines the familiar house-shaped canvas with the grid of the "Sixteen Windows" series and *Russian Matrix*, she has filled the compartments, which here number twenty, with fragmented memories of her cultural, familial, and artistic ancestry. The Menorah on the pediment sets the major theme, reiterated on the central axis of the composition by the word "Jew," in French, Dutch, and German, and the star of David Jews were obliged to wear in Germany, France, and Holland. On this axis is a photograph of the young Chagall in an art class with a group of his friends. This axis is framed by images that reiterate the main theme (for example, a Jewish funeral and a medieval painting of Jewish people dancing). But the painting also introduces women's work in the home, in the needlework used to cover the Challah bread served on Friday night (top row). Women as artists appear in the monumental image of Frida Kahlo (right column) and, immediately below, in Schapiro's *Razz Ma Tazz* (1985). In the lower left compartment is a photograph of the young and stylish Alice B. Toklas and Gertrude Stein; to the right, a screaming profile confronts compartments containing the word "Jew" and the star. Acknowledging the fact that she was raised as "a cultural Jew" added one more fragment to the shape of Schapiro's life and her art.

Miriam Schapiro's art is part of a body of contemporary work that challenges the notion of a unified, coherent identity. In her complex and layered paintings and femmages, the self is represented through other people, articles of clothing, fragments of cloth, real and fictional characters, and cultural icons. In her search she has problematized the idea of identity as something stable, immediately apparent, and readily recognizable. With her art Schapiro has provided for herself an arena for self-realization, in which she has questioned the notion of male and female fixity. As she has given shape to her autobiography, her paintings have become visual statements on major contemporary feminist issues, such as individual subjectivity and the constructed self, not because these issues have concerned her on a theoretical level but because they have met, intersected, and diverged throughout her life and art. It is at these junctures that she can be identified, not as a closed unit but as an individual in the process of formation, involved in constant negotiations with conflicting inner and outer messages. Like herself, her images of women function on the stage of life in varied and complex forms; they are multiple, plural, and partial. Schapiro restructures these images—layers them and reframes them—thereby resisting the induction of the female image as a singular and static entity into the visual order of patriarchal culture. Creating her own changing persona and establishing her own artistic and cultural genealogies have enabled Miriam Schapiro to confront the contradictions in her life. Her work, a formal and visual language that has empowered her to name her experiences, to create the memories necessary for spiritual survival, and to compose an autobiography, is part of a continuing process and quest. It has become a heritage that younger artists, both women and men, can invoke.

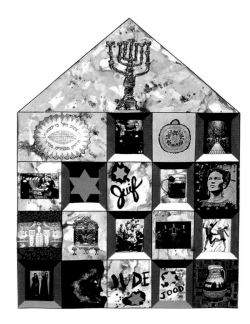

My History. *1997. Acrylic, fabric, and Xerox on paper, 35 × 26¼". Collection Eleanor and Leonard Flomenhaft, Long Island, New York*

NOTES

INTRODUCTION

1. Unless otherwise indicated, all statements by Miriam Schapiro derive from her unpublished journals and notes, covering the years 1952 to 1990, and from correspondence, informal discussions, and interviews I have conducted with her during the last fifteen years. I am grateful to the artist for her generosity and for her willingness to share this wealth of information with me.

2. Thalia Gouma-Peterson, "The House as Private and Public Image in Miriam Schapiro's Art," in *Miriam Schapiro: A Retrospective: 1953–1980,* The College of Wooster, Sept. 1980 (Wooster, Ohio, 1980), 10–18; Linda Nochlin, "Feminism and Formal Innovation in the work of Miriam Schapiro," in Ibid., 20–24; John Perreault, "The Heart of the Matter," in Ibid., 40–42; Gouma-Peterson, "'Collaboration' and Personal Identity in Miriam Schapiro's Art," *Miriam Schapiro. Collaboration Series: Mother Russia,* Steinbaum Krauss Gallery, New York, Sept. 1994 (New York, 1994), 3–9.

3. Miriam Schapiro, "Notes from a Conversation on Art, Feminism, and Work," in Sarah Ruddick and Pamela Daniels, eds., *Working It Out* (New York, 1977), 284.

4. Simone de Beauvoir, *The Second Sex,* trans. H. M. Parshley (New York, 1970), 675. Naomi Schor, "This Essentialism Which Is Not One," in Naomi Schor and Elizabeth Weed, eds., *The Essential Difference* (Bloomington and Indianapolis, Ind. 1994), 46.

5. Moira Roth, "Interview with Miriam Schapiro," *The Shrine, the Computer, and the Dollhouse: Miriam Schapiro,* Mandeville Art Gallery, University of California at San Diego (La Jolla, Calif., 1975), 9. The exhibition was curated by Roth.

6. Shoshana Felman, *What Does a Woman Want? Reading and Sexual Difference* (Baltimore, 1993), 14. She proposes that "we might be able to engender, or access our story only indirectly—by conjugating literature, theory and autobiography together through the act of reading and by reading, thus, into the texts of culture, at once our sexual difference and our autobiography as missing."

7. Teresa de Lauretis, *Technologies of Gender* (Bloomington, Ind., 1987), 26.

8. Schapiro, in Ruddick and Daniels, eds., *Working It Out,* 293.

9. Schapiro and Melissa Meyer, "Femmage," *Miriam Schapiro: Femmages 1971–1985,* Brentwood Gallery, May–June 1985 (St. Louis, MO, 1985), no pagination, originally published in *Heresies* 4 (Winter 1978): 66–69. The word *femmage* for Schapiro literally means "a woman-centered fabric collage." It has been included as a new word in the third edition of the *American Heritage Dictionary of the English Language.*

10. Gouma-Peterson, "The House as Private and Public Image," in Gouma-Peterson, ed., *Miriam Schapiro: A Retrospective,* 17; Miriam Schapiro, "How Did I Happen to Make the Painting *Anatomy of a Kimono,*" in Ibid., 26–30 and 49–51 for foldout color illustration of the whole piece.

11. Schapiro, in Ruddick and Daniels, eds., *Working It Out,* 296.

12. Gouma-Peterson, "The Theater of Life and Illusion in Miriam Schapiro's Recent Work," *I'm Dancin' as Fast as I Can: New Paintings by Miriam Schapiro,* Bernice Steinbaum Gallery, March–April 1986 (New York, 1986), 3–8, originally published in *Arts Magazine* 60, 7 (Mar. 1986): 38–43. The notion of femininity as a masquerade, as part of the mechanism of gender construction, was first introduced by Joan

Rivière, "Womanliness as Masquerade," in Victor Burgin et al., eds., *Formations of Fantasy* (London and New York, 1986), 35–44. Rivière, a psychoanalyst living in London in the 1920s, discussed the culturally induced need of women to appear womanly, in order to avert the fear of male retribution. Her article was first published in 1929 (*International Journal of Psychoanalysis* 10, 1929), the year after British women were granted the vote.

13. Teresa de Lauretis, *Alice Doesn't. Feminism Semiotics Cinema* (Bloomington, Ind., 1984), 5.

14. Judith Butler, *Gender Trouble* (New York, 1990), 25, 140, elaborates that "identity is performatively constituted by the very expressions that are said to be its results." Her position on gender is a corollary to Nietzsche's claim that "the doer is merely a fiction added to the deed."

15. Anne Gabhart and Elizabeth Broun, *Old Mistresses,* Walters Art Gallery (Baltimore, 1972); Ann Sutherland Harris and Linda Nochlin, *Women Artists 1550–1950* (New York, 1976).

16. Schapiro, in Jan Avgikos, "The Decorative Politic: An Interview with Miriam Schapiro," *Art Papers* (Nov./Dec. 1982): 8.

17. Luce Irigaray, "In Memory of Her," in Schor and Weed, *The Essential Difference,* 75.

18. Gouma-Peterson, "'Collaboration' and Personal Identity," 3–9. For further discussion see Chapter 6.

19. Irigaray's influence has been decisive for this recent work by British, European, and American theorists. As Irigaray observes "The important thing is for them [women] to find their own genealogies, the necessary conditions for their identity." See the recent discussion on these issues in the collection of essays edited by Schor and Weed in *The Essential Difference.*

20. Julia Kristeva, "Motherhood According to Bellini" (1975), in Leon S. Roudiez, ed., *Desire in Language: A Semiotic Approach to Literature and Art* (Oxford, 1980), 237–70; and "A New Type of Intellectual Dissent" (1970), in Toril Moi, ed., *The Kristeva Reader* (Oxford, 1986), 292–300. Irigaray, "The Bodily Encounter with the Mother" (1981), in Margaret Whitford, ed., *The Irigaray Reader* (Oxford, 1991), 34–46. Hélène Cixous, "Castration and Decapitation," *Signs* 7 (1981): 41–55.

21. Jacques Lacan, in Juliet Mitchell and Jacqueline Rose, eds., *Feminine Sexuality: Jacques Lacan and the école freudienne,* trans., Jacqueline Rose (New York, 1982), 144. Lacan's position is based on Freud but goes beyond Freud's identification of women's lack of and desire for power as penis envy. Lacan's essays were originally published in French in 1966, 1968, and 1975.

22. *Matrix* is defined in the dictionary as "That which gives origin or form to a thing, or which serves to enclose" and, in its archaic form, as "the womb," *Random House Dictionary of the English Language.* In Ettinger's thinking the matrix corresponds to a plural or fragmented subjectivity—the experience of the prenatal and pre-Oedipal—that "our phallic conscious cannot reach." She argues for "the concept of the Matrix not against but alongside a relativized concept of the Phallus in a universe which is plural partial," and identifies "metramorphosis" as "the specific routes of passability and transmissibility" between various psychic strata and between a subject and several other subjects. See Bracha Lichtenberg Ettinger, "Matrix and Metramorphosis," *Differences* 4 (1992), esp. 176, 200–6.

23. Griselda Pollock, "The Case of the Missing Mothers," in Mike Ball and I. E. Boer, eds., *The Point of Theory* (New York, 1994), 95–96, 101. In

this article she suggests that it is necessary, in order to provide access to "desires and fantasies" that challenge and transform phallic masculinity, to construct archives based on "feminist exploration of representations by women of women, especially their mothers."

24. Pollock, Ibid. Irigaray, "The Bodily Encounter," 35–40.

25. Schapiro, in Ruddick and Daniels, eds., *Working It Out,* 284.

26. de Beauvoir, *The Second Sex,* 249. Irigaray, "In Memory of Her," in Schor and Weed, *The Essential Difference,* 75. Schor, "Introduction," in *The Essential Difference,* XV, 42.

27. For a recent discussion of the debate between de Beauvoir and the Beauvoirian "equality feminists" and the newer French "difference feminists," Irigaray and Hélène Cixous, see Schor, "Introduction," in *The Essential Difference,* VII–XIV, 41–62. The debate, which has been pervasive in recent constructionist and feminist critical writing has, in most cases, rejected essentialism, as Schor, who holds to an essentialist position, observes.

28. Schor, Ibid.

29. For recent discussions see: de Lauretis, *Technologies of Gender;* Butler, *Gender Trouble;* Tania Modelski, *Feminism without Women: Culture and Criticism in a "Postfeminist Age"* (New York, 1991); Kaja Silverman, "Fassbinder and Lacan: Reconsideration of Gaze, Look, and Image," in Norman Bryson et al., eds., *Visual Culture* (Bloomington, Ind., 1994), 272–301. For a critical discussion of these debates see most recently Patricia Mathews, "The Politics of Feminist Art History," forthcoming.

30. Hollis Clayson, "Materialist Art History and its Points of Difficulty," *The Art Bulletin* 77 (Sept. 1995): 3, 369.

31. Pollock, "Inscriptions in the Feminine," in M. Catherine De Zegher, ed., *Inside the Visible* (Cambridge, Mass., 1996), 73.

32. Pollock, in De Zegher, ed., *Inside the Visible,* 82–83, points out the paradox of this as it pertains "to those of us formed in this feminine."

CHAPTER 1

1. Schapiro, "Notes from a Conversation on Art, Feminism, and Work," in Ruddick and Daniels, eds., *Working It Out,* 284.

2. All quotations in this chapter derive from Schapiro's unpublished journals, from 1952 to 1990, and notes in her personal archives in East Hampton and New York. Dates in brackets indicate the year the particular statement was written. In the longer quotations there may be several different dates because Schapiro discussed the same or related issues at different times.

3. Gouma-Peterson, ed., *Miriam Schapiro: A Retrospective,* 100–1.

4. This concept of the studio that Schapiro discusses was seen as characteristically American by European artists and authors.

5. I am using the term *creative order* as a parallel to the Symbolic Order and the absence of woman from it, as discussed by Lacan; see Mitchell and Rose, eds., *Feminine Sexuality: Jacques Lacan and the école freudienne,* 144.

6. de Lauretis, *Technologies of Gender,* 25–26.

7. Schapiro, in Ruddick and Daniels, eds., *Working It Out,* 288.

8. Ibid., 289.

9. For a fuller discussion of *OX,* see Chapter 3.

10. Chicago was hired by Brach over the protestations of some of his male colleagues; Schapiro, conversation with author, 1997.

11. On *Womanhouse,* see most recently Arlene Raven, "*Womanhouse,*" in Norma Broude and

Mary D. Garrard, eds., *The Power of Feminist Art* (New York, 1994), 48–64. See also Broude and Garrard, "Conversations with Judy Chicago and Miriam Schapiro," Ibid., 66–85.
12. See Chapter 3.
13. Pollock, "Modernity and the Spaces of Femininity," in *Vision and Difference: Femininity, Feminism and the Histories of Art* (London, 1988), 54–56.
14. For Schapiro the term literally means "woman-centered fabric collage."
15. The exhibition was organized and curated by Ann Sutherland Harris and Linda Nochlin. For further discussion, see Chapter 6.
16. Schapiro, "At Long Last an Historical View of Art Made by Women," *Woman Art* (winter/spring, 1977): 4–7.
17. See Chapter 4.
18. For further discussion of this piece see Chapter 4.
19. de Lauretis, *Technologies of Gender*, 25–26.
20. Ibid.
21. As observed by John Perreault, *Pattern Painting* (New York, 1979), 33. See also Diana Crane, *The Transformation of the Avant-Garde: The New York Art World, 1940–1985* (New York, 1991), 59–61.
22. The influence and popularity of Pattern Painting lasted much longer in Europe, where it continued to be collected and where artists continued to use its structures and motifs, as for example the German artist Sigmar Polke.
23. Crane, *The Transformation of the Avant-Garde*, 60.
24. In April 1980, Gerald Marzorati had asked Schapiro and a group of other artists for their responses to Picasso. The quote is from Schapiro's letter, which included three different comments on Picasso.
25. David Douglas Duncan, *The Private World of Pablo Picasso* (New York, 1958); *The Treasures of La Californie* (New York, 1961); *The Silent Studio* (New York, 1976).
26. See Chapter 6.

CHAPTER 2

1. Schapiro, in Ruddick and Daniels, eds., *Working It Out*, 303.
2. Schapiro, in Roth, ed., *The Shrine, the Computer and the Dollhouse*, 11.
3. Much has been written about Abstract Expressionism and the New York School. On the construction of its triumphant image see: Irving Sandler, *The Triumph of American Painting* (New York, 1970), and *The New York School: The Painters and Sculptors of the Fifties* (New York, 1978); Dore Ashton, *The New York School: A Cultural Reckoning* (New York, 1979); William C. Seitz, *Abstract Expressionist Painting in America* (Cambridge, Mass., 1983). For more recent reconsiderations, see: Serge Guilbaut, *How New York Stole the Idea of Modern Art: Abstract Expressionism, Freedom, and the Cold War* (Chicago, 1983), and "The New York Adventure of the Avant-Garde in America: Greenberg, Pollock, or from Trotskyism to the New Liberalism of the Vital Center," in Francis Frascina, ed., *Art in Modern Culture* (New York, 1985); Frascina, ed., *Pollock and After: The Critical Debate* (New York, 1985); Michael Leja, *Reframing Abstract Expressionism: Subjectivity and Painting in the 1940s* (New Haven, 1993).
4. She commented in 1991: "I would sit for hours and cut pictures out of magazines (I had seen my father do that), and make endless, endless scrapbooks, which I still have. And so I would find a painting which would fit my mood." Interview with the author in East Hampton, N.Y.
5. André Emmerich, "The Artist as Collector," *Art in America* (summer 1958).
6. Her final self-portrait in the thesis project has been lost.
7. See Chapter 5.
8. Ibid.
9. Cixous, "Castration and Decapitation," 41–55.
10. Joan Rivière, "Womanliness as Masquerade," 35–44.

11. Schapiro, in Roth, ed., *The Shrine, the Computer and the Dollhouse*, 11.
12. For illustration, see Gouma-Peterson, ed., *Miriam Schapiro: A Retrospective*, 11.
13. Her son Peter was born in December 1955.
14. Sigmund Freud, "Three Essays on the Theory of Sexuality," *SE* 7, 1905, 123–25; and "The Infantile Genital Organization: An Interpolation into the Theory of Sexuality," *SE* 19, 1923, 124.
15. See Chapter 5.
16. *Facade* was painted in her new apartment at 235 West 76th Street, where she combined her living and studio spaces, and after a summer in East Hampton during which she had not painted while recovering from a meningeal virus.

CHAPTER 3

1. Rivière, "Womanliness as Masquerade," 35–44. She concluded that her patients exhibited an unresolved rivalry with both parents and, as a result, refused to adopt the required passivity of so-called normative femininity.
2. In February 1961, she again commented in her journal on her feelings of inadequacy and imperfection:
 When I write in my book I try to be positive and declarative. When I read over what I've written since this notebook began [December 1956], it seems to me a bore. Where are the hours of anguish and yearning—more of them than actual painting. . . . No amount of excitement from the outside can compensate for the essential hurt—namely that to be given the sense of sight and the intimations of perfection means that one must constantly live with the knowledge of imperfection. The imperfect being is one self. The imperfect work of art is one's own.
3. For a more extensive discussion of this group of works see Chapter 2.
4. Schapiro first expressed verbally her thoughts on the female body in 1971 and framed them as a question: "What does it feel like to be a woman; to be formed around a central core and have a secret place which can be entered and a passageway from which life emerges?"
5. Gouma-Peterson, "The House," in Gouma-Peterson, ed., *Miriam Schapiro: A Retrospective*, 11–12.
6. For an illustration, see Ibid., 13.
7. Schapiro, in Ruddick and Daniels, eds., *Working It Out*, 289–91.
8. *Random House Dictionary of the English Language*.
9. Ettinger, "Matrix and Metramorphosis," 193–95, emphasizes that her concept of the symbolic matrixial is a means to reject the totalizing effects of singularity and oneness contained in Lacan's symbolic use of the phallus. She has further developed and refined her concepts of *matrix* and *metramorphosis* in a series of articles: "Woman-Other-Thing: A Matrixial Touch," in *Bracha Lichtenberg Ettinger: Matrix Borderlines* (Oxford, 1993); "The Becoming Thresholds of Matrixial Borderlines," in George Robertson et al., eds., *Traveller's Tales* (London, 1994); "Metamorphic Borderlinks and Matrixial Borderspace in Subjectivity as Encounters," in John Welchman, ed., *Rethinking Borders* (New York, 1995); *The Matrixial Gaze* (Leeds, 1995); "The With-In-Visible Screen," in De Zegher, ed., *Inside the Visible*, 89–111. For Griselda Pollock's commentary on Ettinger's theoretical positions see "Inscriptions in the Feminine," in De Zegher, ed., *Inside the Visible*, 67–87. See also Pollock, "Gleaning in history or coming after/behind the reapers: the feminine, the strange and the matrix in the work and theory of Bracha Lichtenberg Ettinger," in Pollock, ed., *Generations and Geographies in the Visual Arts: Feminist Readings* (London, 1996), 267–88.
10. Denying the principle of oneness is at the basis of Ettinger's concept of the matrixial subject, which is formed by means of divisions, multiplicities, and fragmentations. See her "Matrix and Metramorphosis," 176–206, and "The With-

In-Visible Screen," 89–113.
11. Jacques Lacan, "The Meaning of the Phallus," in Mitchell and Rose, eds., *Feminine Sexuality*, 84. See also Ettinger's discussion in "The With-In-Visible Screen," 94.
12. Ettinger, "Matrix and Metramorphosis," 193, emphasizes the multiplicity of the matrix as a symbol. She describes it as "one+one+one" and as "a woman's way out of the Total and One suggested by Lacan."
13. Ettinger observes that "in the matrixial stratum of subjectivity, the connection between phantasy and desire allows heterogeneity, while in the phallic plane phantasy and desire exclude each other. The matrix intertwines the woman as *between* subject and object and *between* center and nothingness . . . while the phallus posits her as *either* a subject in the masculine format or an object patterned upon masculine desire"; "The With-In-Visible Screen," 105. This issue is one to which Schapiro returned in her work of the eighties. See Chapter 5.
14. Gouma-Peterson, "Collaboration and Personal Identity," 3–9. Felman, *What Does a Woman Want?*, 14. For further discussion of Schapiro's portrait in *Russian Matrix* and other works in the "Collaboration Series: Mother Russia," see Chapter 6.
15. Moira Roth, in correspondence with the author, 1979.
16. Quoted in Ettinger, "Matrix and Metramorphosis," 193.
17. Schapiro, in Ruddick and Daniels, eds., *Working It Out*, 291.
18. Barbara Rose, "Abstract Illusionism," *Artforum* 6, no. 2 (Oct. 1967): 33–37. Lawrence Campbell, "A Crash of Symbols," *ARTnews* 68, no. 1 (Mar. 1969): 42–43, 64.
19. Schapiro, in Roth, ed., *The Shrine, the Computer and the Dollhouse*, 9.
20. Schapiro, journal entry, 1992.
21. Schapiro, in Campbell, "A Crash of Symbols," 42.
22. Lecture notes in Schapiro's 1992 journal.
23. *Random House Dictionary of the English Language*.
24. Rivière, "Womanliness," 35–44.
25. The women are, from top to bottom and from left to right:
 1. Sonia Delaunay, Vera Muchkina, Alexandra Exter, Olga Rosanova
 2. Exter, Natalia Goncharova, Lyubov Popova, Miriam Schapiro
 3. Nadezhda Udalstova, Antonia Sofornova, Nina Simonovich-Efimova, Goncharova
 4. Anna Golubkina, Popova, Varvara Stepanova, Delaunay
26. Lacan, in *Feminine Sexuality*, 14. See also the Introduction.
27. See the cover of *The Shrine, the Computer and the Dollhouse*.
28. Butler, *Gender Trouble*, 139. Butler's characterization of gender as a performance, which gives the illusion of stability only because it is continually repeated in a belief structure, parallels the message in Schapiro's autobiographical work of the mid-eighties and the self-portrait in *Russian Matrix*. But Schapiro's work of the late-seventies and eighties anticipates Butler's theoretical writings by almost a decade.
29. For further discussion of this portrait, see Chapter 6.
30. See especially the work discussed in Chapters 5 and 6. Butler, *Gender Trouble*, 147, does not provide a definitive answer either. She considers the central purpose of her project finding ways to "destabilize and render in their phantasmatic dimension the 'premises' of identity politics."

CHAPTER 4

1. Schapiro, in the exhibition catalogue, *Miriam Schapiro: Femmages, 1971–1985*, Brentwood Gallery, St. Louis, Missouri, May–June, 1985, defines *femmage* as "a word invented to include all of the above activities [collage, assemblage, photomontage, and décollage] as

they were practiced by women using traditional women's techniques . . . sewing, piercing, hooking, cutting, appliquéing, cooking and the like. . . ." This catalogue also includes Schapiro's and Melissa Meyer's article "Waste Not, Want Not: Femmage," originally published in *Heresies* 1, no. 4 (winter 1977–78): 66–69.

2. Schapiro, "Recalling *Womanhouse*," *Women's Studies Quarterly* 15, nos. 1, 2 (spring/summer 1987): 25–30; Judy Chicago and Schapiro, *Womanhouse* (The Feminist Art Program, Institute of the Arts, Valencia ,Calif., 1972) n.p.; Chicago, *Through the Flower* (New York, 1975), 93–132. Arlene Raven, "*Womanhouse*," in Broude and Garrard, eds., *The Power of Feminist Art*, 48–64; and Broude and Garrard, "Conversations with Judy Chicago and Miriam Schapiro," Ibid., 66–85. Shortly thereafter *Womanhouse* also became a legend in Europe. Pirated slides of it have been found in Germany, and women from all over the world have come to the U.S. to interview Schapiro about it (Taiwan, France, England, Belgium, Japan, Turkey).

3. Schapiro, in Ruddick and Daniels, eds., *Working It Out*, 296.

4. Schapiro, in *Miriam Schapiro: Femmages, 1971–1985*, n.p.

5. Arthur C. Danto, "The Breakthrough Decade," *The Nation* 249, no. 22 (Dec. 25, 1989): 749–98.

6. Schapiro, unpublished notes, 1974.

7. Ettinger, "The With-In-Visible Screen," in De Zegher, ed., *Inside the Visible*, 93. The unitary linguistic symbol of the phallus cannot include these pre-Oedipal memories, which can exist in art through an interconnecting visual web. Pollock, "Inscriptions in the Feminine," Ibid., 78, makes this point about Ettinger's art and theory.

8. On the central-core issue see Lawrence Alloway, "Women's Art in the Seventies," *Art in America* (May/June 1976): 64–72; and letters in response to his article in *Art in America* (Nov./Dec. 1976): 17. In a 1971 journal entry, Schapiro wrote: "Thesaurus gives us the following synonyms for containers: Boxes, tunnels, corridors, vestibules, hallways, centers, cores, openings, holes, hollows, cavities, passages, receptacles, compartments, vessels, vaults, cubbys, nooks, bags, sacs, pockets, chests, cofers, caskets, shrines, bins, trunks, cages, pots, barrels, bowls, basins, plates, cupboards, cabinets, entrance halls, portal, threshold, anteroom, room." It is interesting to note how many of these synonyms she has used as images in her art.

9. Gabhart and Broun, *Old Mistresses;* Harris and Nochlin, *Women Artists 1550–1950*.

10. Part of Schapiro's project of the early seventies was to record a series of taped interviews with older women artists (e.g., Lee Krasner, Perle Fine). She also prompted a group of women artists to propose a session for the annual College Art Association meeting, in 1976, entitled "Women Talk About Women." She commented in 1990 how at the time she could not find a single woman art historian to participate in the session: "Whoever heard of a woman artist in history? Nobody was allowed to do that."

11. Schapiro, in conversation with the author, 1997.

12. See Mary Stofflet's review of Schapiro's exhibition at the Mitzi Landau Gallery and Art Space, in Los Angeles, in *Arts* (May 1977): 12; and Melinda Wortz's in *Art News* (summer 1977): 160. Schapiro has recently explained that she used the work of the male artists because she could not find color reproductions of the work of women, aside from O'Keeffe, Morisot, and Cassatt. She wanted to continue with her new visual and conceptual approach to the past and was very frustrated. "I couldn't find any in 1976. Things have changed."

13. Schapiro, in Patrick Merrill and Gail Jacobs, "A Feminist Response: An Interview with Miriam Schapiro," *Newsprint: The Journal of the Los Angeles Printmaking Society* (winter 1994–95): 7.

14. *Miriam Schapiro: Femmages, 1971–1985*, n.p.

15. Ibid.

16. Schapiro, "How Did I Happen to Make the Painting *Anatomy of a Kimono*," in Gouma-Peterson, ed., *Miriam Schapiro: A Retrospective*, 26–27.

17. Perreault, *Pattern Painting*, 33.

18. Perreault, "The Heart of the Matter," in Gouma-Peterson, ed., *Miriam Schapiro: A Retrospective*, 40–42.

19. After 1980 the issues raised by pattern painting lost their significance in the New York art world. However, when Schapiro in a 1980 lecture in Sacramento said that P. and D. had lost its appeal, irate hands "flew up after the lecture, 'not for us' the women yelled." The influence and popularity of pattern painting lasted much longer in Europe, where it continued to be collected and where artists continued to use its structures and motifs, as, for example, the German artist Sigmar Polke.

20. See Chapter 2.

21. Though the largest number of her kimonos and vestitures date from 1976 to 1979, she returned to the ceremonial robe in, for example, *Princess Style* (1982), *The Poet* (1982), and *Maid of Honor* (1984).

22. The heart and house, in fact, have a long tradition as images of devotion in private piety. First used primarily by nuns and lay orders of women in paintings, drawings, and textiles, the heart had a direct association with Christ, whose initials it often bore. In the eighteenth century, it became part of a repertoire of images used by women in handicrafts. In this process the heart became secularized and its pietal sentiment lost its exclusively Christian meaning. On the heart as a devotional image, see Hubert Schrade et al., *Das Herz Im Umkreis der Kunst*, vol. 2 (Frankfurt, Mann, 1966). I thank Jeffrey Hamburger of the University of Toronto for bringing this book to my attention.

23. In introducing this new motif, Schapiro studied a substantial number of books, such as Nancy Adams, *A Collector's History of Fans* (New York, 1974); Carol Dorrington-Ward, *Fans from the East* (New York, 1978); and Ann G. Bennett with Ruth Brenson, *Fans in Fashion: Selections from the Fine Arts Museum of San Francisco* (San Francisco, n.d.).

24. Cixous, "Castration and Decapitation," 45–51, has observed that the paradox of a woman's relation to herself in modern intellectual culture is that it is premised on the "murder of the mother . . . her own decapitation."

25. Gouma-Peterson and Patricia Mathews, "The Feminist Critique of Art History," *The Art Bulletin* 69, no. 3 (Sept. 1987): 326–57. In 1976 Schapiro was one of the founders of a magazine on art and politics, *Heresies*. Other founding members of the *Heresies* collective were her friends Harmony Hammond, Joyce Kozloff, Lucy Lippard, May Stevens, Michelle Stuart, and Joan Snyder.

26. Hal Foster, "Postmodernism: A Preface," in Foster, ed., *The Anti-Aesthetic* (Port Townsend, Wash., 1983), XIV. Craig Owens, "Feminists and Postmodernism," Ibid., 58.

27. On the subject of women and autobiography see Felman, *What Does a Woman Want?*

CHAPTER 5

1. Artist's statement for exhibition at the Bernice Steinbaum Gallery, New York City, 1985.

2. Gouma-Peterson, "The House," in Gouma-Peterson, ed., *Miriam Schapiro: A Retrospective*, 10–18.

3. That the source of this work, and of the series of smaller works that followed it, continues to be Goncharova is clear in the formal structure of these pieces and was acknowledged by Schapiro in the title of one of the smaller collages, *Presentation for Goncharova*.

4. In the mid-seventies she had bought Arlene Croce's *The Fred Astaire and Ginger Rogers Book* (New York, 1972), and in 1984 she purchased Tony Thomas's *That's Dancin'* (New York, 1984).

5. See Introduction and Gouma-Peterson, "The Theater of Life," *Arts Magazine* 60, no. 7 (1986): 38–43.

6. Ibid.

7. Rivière, "Womanliness," 35–44.

8. Schapiro has admired Sonia Delaunay for many years, sharing her love for and use of cloth, her Russian ancestry, and her Jewishness. Though her own Jewish origin has not been a central issue in Schapiro's life and art, it is always an added pleasure for her to find that a woman artist whom she admires is also Jewish. Two of Schapiro's most treasured books in her library are: Jacques Damase, *Sonia Delaunay: Rythmes et Couleurs* (Paris, 1971), and Arthur Cohen, *Sonia Delaunay* (New York, 1975).

9. Toril Moi, *Sexual Textual Politics* (London and New York, 1986), 99.

10. Montrelay, as discussed by Mary Ann Doane, "Film and the Masquerade: Theorizing the Female Spectator," *Screen* 23, nos. 3–4 (Sept./Oct. 1982): 82.

11. For the full quote see Chapter 3.

12. Rivière, "Womanliness," 35–44.

13. de Lauretis, *Alice Doesn't*, 5.

14. Cixous, "Castration and Decapitation," 51.

15. Rivière, "Womanliness," 35–44.

16. Schapiro observed in a 1982 journal entry: "Every woman has to move out from some place to some place. She moves out territorially and psychologically."

17. See Rivière, "Womanliness," 35–44, who is using Melanie Klein's research about the daughter's antagonistic relation to the mother.

18. Ibid., 39.

19. Schapiro's 1949 M.F.A. thesis at the University of Iowa culminated in a painting of a self-portrait, now destroyed, and a portrait of her husband, Paul Brach. For an earlier self-portrait drawing (1946) see Gouma-Peterson, "The House," 10.

20. Doane, "Film and the Masquerade," 82.

21. Irigaray, "This Sex Which Is Not One," in Elaine Marks and Isabelle de Courtivon, eds., *New French Feminisms* (Amherst, 1980), 104–5.

22. Broude, "Report from Washington II: Alternative Monuments," *Art In America* 79, no. 2 (Feb. 1991): 73–79. The thirty-five-foot painted stainless steel and aluminum sculpture is located in front of the 1525 Wilson Boulevard Building in Rosslyn, Virginia.

23. The source for Adam was a Mimbre ware painting of a dancing human figure in what may be a dog mask. For the "Mythic Pool" Series, Schapiro consulted: Buffie Johnson, *Lady of the Beasts: Ancient Images of the Goddess and Sacred Animals* (San Francisco, 1981); Marija Gimbutas, *The Gods and Goddesses of Old Europe 7000–3500 B.C.* (Berkeley and Los Angeles, 1989) and *The Language of the Goddess* (San Francisco, 1989); and Elinor Gadon, *The One and Future Goddess* (San Francisco, 1989).

24. See the artist's statement for the exhibition of the "Mythic Pool" series at the Steinbaum Krauss Gallery, New York, 1990.

25. Butler, *Gender Trouble*, 25.

26. Kahlo added small cartouches to her self-portraits to express what she was thinking about, for example, Diego or a skull and bones for death. See Hayden Herrera, *Frida: A Biography of Frida Kahlo* (New York, 1983).

27. Raven, "Frida and Mimi," *The Village Voice* 37, no. 2 (Jan. 12, 1992): 88.

28. Felman, *What Does a Woman Want?*, 14.

CHAPTER 6

1. See Chapter 4.

2. Schapiro, artist's statement for exhibition of "Collaboration Series: Frida Kahlo and Me," Bernice Steinbaum Gallery, December 7, 1991–January 11, 1992.

3. Butler, *Gender Trouble*, 25.

4. Montrelay, "Inquiry into the Feminine," *m/f* 1 (1979): 91–92. The problematic of a female gaze has been raised primarily by feminist scholars in connection with the position of the female

spectator and her relation to the female image in narrative cinema. Montrelay has observed that while the male has the possibility of displacing the first object of desire (the mother), the female must become that object of desire. Mary Ann Doane has added that "for the female spectator there is a certain over-presence of the image—she is the image"; "Film and the Masquerade," 75–76. Luce Irigaray similarly has commented on the proximity of woman to herself, when she wrote "woman enjoys a closeness with the other that is so near she can not possess it any more than she can possess herself"; "This Sex Which Is Not One," in Marks and de Courtivon, eds., *New French Feminisms*, 104–5.

5. Montrelay, "Inquiry into the Feminine," 91–92.
6. Herrera, *Frida*, 285, pl. XVIII, and *Frida Kahlo: The Paintings* (New York, 1991). For Kahlo's intense emotional and sexual feelings about Rivera see her recently published diary: Carlos Fuentes and Sarah Lowe, *The Diary of Frida Kahlo: An Intimate Self-Portrait* (New York, 1995), 212–17, 234–35, 237.
7. Herrera, *Frida*, 157–58, pls. VI–VII.
8. See Chapter 5.
9. Herrera, *Frida*, 213.
10. Ibid.
11. The full text of the poem in Schapiro's painting reads as follows: "Now he comes, my// hand, my red// vision larger// more yours martyr// of glass. The great unreason// the ink, the spot,// the form, the color.// I am a bird." Schapiro created this text from passages of Monique Wittig's book *Les Guérillères*, trans. David Le Vay (New York, 1973).
12. Herrera, *Frida*, 76, pl. XXVIII.
13. Julia Kristeva, "Stabat Mater," in Susan Rubin Suleiman, ed., *The Female Body in Western Culture* (Cambridge, Mass., 1986), 109.
14. Ibid., 77.
15. See, for example, Herrera, *Frida*, pls. XXI, XXV.
16. In preparation for her "collaborations" with Frida Kahlo, in addition to Herrera's monographs, Schapiro consulted the following books on Mexican arts and crafts: Frederick V. Field, *Pre-Hispanic Mexican Stamp Designs* (New York, 1974); Donald Corby, *Mexican Masks* (Austin and London, 1980); Richard Conn, *Robes of White Shell and Sunrise* (Denver, Colo., 1975); Henry Glassie, *The Spirit of Folk Art: The Girard Collection at the Museum of International Folk Art* (New York, 1989); Chloe Sayer, *Costumes of Mexico* (Austin, 1985).

17. de Lauretis, *Technologies of Gender*, 25–26.
18. Schapiro, artist's statement for exhibition of "Collaboration Series: Frida Kahlo and Me," Bernice Steinbaum Gallery, New York, December 7, 1991–January 11, 1992.
19. Schapiro is not sympathetic to communism as a political movement. She is only interested in the intense artistic activity during the early years of the revolution and the significant role women played during that artistic flowering.
20. Among the books Schapiro consulted are the following: Magdalena Dabrowski, *Liubov Popova* (New York, 1991); Centre National d'Art et de Culture Georges Pompidou, *Paris and Moscow* (Paris, 1979); Boris Kochno, *Diaghilev and the Ballet Russes*, trans., Adrienne Foulke (New York, 1970); *Russian Women Artists of the Avant-Garde*, exhibition December 1979–March 1980, Galerie Gmurzynska (Cologne, 1980); Alexander Lavrentiev, *Varvara Stepanova: The Complete Work*, ed. John Bolt (Cambridge, Mass., 1988); *Dance. Theater. Opera. Music Hall*, catalogue of sale, Sotheby Park Bernet, December 18, 1980 (New York, 1980); Konstantine Rudnitsky, *Russian and Soviet Theater 1905–1932*, trans. Roxana Premar, ed. Lesley Milne (New York, 1988); Larissa Salmina-Haskell, *Russian Drawings: Victoria and Albert Museum* (London, 1972); Tatiana Strizhenova, *Soviet Costume and Textiles 1917–1945* (Paris and Verona, 1991); M. N. Yablonskaya, *Women Artists of Russia's New Age 1900–1935*, ed. Anthony Parton (New York, 1990). The last she considers the most important of the books she has consulted.
21. Artist's statement in the folio of prints *Delaunay, Goncharova, Popova and Me*, Fall 1992. This series of prints, produced at Pyramid Atlantic, was a collaboration in the literal sense; in their creation Schapiro collaborated with Helen Frederick, a paper maker and printmaker, and Susan Goldman, a master printer.

22. Devorah Knaff, "Miriam Schapiro: To Russia with Love," *Women in the Arts* 10, no. 4 (winter 1993): 3.
23. Artist's statement, "Delaunay, Goncharova, Popova and Me." Schapiro had a similar intent in creating *The Anatomy of a Kimono*.
24. For an illustration, see Lavrentiev, *Stepanova*, 78.
25. See Chapter 4.
26. Lavrentiev, *Stepanova*, 7.
27. Ibid.
28. Ibid., 11.
29. Yablonskaya, *Women Artists of Russia's New Age*, 6.
30. Ibid., 11.
31. Schapiro, interview with Jan Avgikos, "The Decorative Politic," 7.
32. The painting was started in 1993 at the same time as *Stepanova and Me, After Gulliver*. Both works are primarily painted but do have passages of fabric collage in relatively minor areas.
33. Lacan, "The Meaning of the Phallus," in Mitchell and Rose, eds., *Feminine Sexuality*, 84.
34. Rivière, "Womanliness," 35–44.
35. For an illustration of Exter's costume see *Dance. Theater. Opera. Music Hall*, fig. 123 A.
36. *Black Bolero* is in the collection of the New South Wales Gallery, Sidney, Australia, *Azerbaijani Fan* is in a private collection in the United States, and the two other large Fans are in European collections. All are acrylic paint and fabric on canvas.
37. For illustrations see, among others, Yablonskaya, *Women Artists of Russia's New Age*, title pages; and Strizhenova, *Soviet Costume and Textiles*, 137.
38. The sources for these images are the books cited in note 20, especially *Women Artists of the Russian Avant-Garde* (1980) and Salmina-Haskell, *Russian Drawings* (1972).
39. Yablonskaya, *Women Artists of Russia's New Age*, 7. Strizhenova, *Soviet Costume*, 137. Lavrentiev, *Stepanova*, 11.
40. Roth, ed., *The Shrine, the Computer, and the Dollhouse*.
41. Schapiro, conversation with author, 1996.
42. See Chapter 3.

SELECTED BIBLIOGRAPHY

BOOKS, CATALOGUES, AND BROCHURES

1999
Miriam Schapiro: Works on Paper: A Thirty Year Retrospective. exh. cat. Tucson, AZ: Tucson Museum of Art.
Mittler, Gene, and Rosalind Ragans. *Exploring Art*. New York: Glencoe/McGraw-Hill.
Mittler, Gene, Rosalind Ragans, Jean Morman Unsworth, and Faye Scannell. *Introducing Art*. New York: Glencoe/McGraw-Hill.

1998
Fichner-Rathus, Lois. *Understanding Art*. 5th ed. Upper Saddle River, NJ, and New York: Prentice-Hall and Simon & Schuster.
Jeffrey, Anne, and Aletta Dreller. *Art Lover's Guide to Florida*. Sarasota, FL: Pineapple Press.
Turner, Robyn Montana. *State of the Art*. Grades 2 and 4. Austin, TX: Barrett Kendall Publishing, Ltd.

1997
Constantine, Mildred, and Laurel Reuter. *Whole Cloth*. New York: The Monacelli Press.
Crossing the Threshold. exh. cat. New York: Steinbaum Krauss Gallery.
Gaze, Delia, ed. *Dictionary of Women Artists*. vol. 2, Artists J–Z. London and Chicago: Fitzroy Dearborn Publishers.

Hanging by a Thread. exh. cat. Yonkers, NY: Hudson River Museum of Westchester.
Remer, Abby. *Pioneering Spirits: The Lives and Times of Remarkable Women Artists in Western History*. Worcester, MA: Davis Publications.
Sayre, Henry M. *A World of Art*. 2nd ed. Englewood Cliffs, NJ, and New York: Prentice-Hall and Simon & Schuster.
Schor, Mira. *WET, On Painting, Feminism, and Art Culture*. Durham, NC, and London: Duke University Press.
Shaw, Robert. *The Art Quilt*. Southport, CT: Hugh Lauter Levin Associates, Inc.
Wilkins, David G., Bernard Schultz, and Katheryn M. Linduff. *Art Past and Present*. 3rd ed. New York: Harry N. Abrams, Inc.

1996
Chave, Anna C. "Disorderly Order." *Valerie Jaudon*. exh. cat. Jackson, MS: Mississippi Museum of Art.
Feinstein, Hermine. *Reading Images: Meaning and Metaphor*. Reston, VA: The National Art Education Association.
Jones, Amelia, ed. *Sexual Politics: Judy Chicago's Dinner Party in Feminist Art History*. UCLA/Armand Hammer Museum. Los Angeles and Berkeley: University of California Press.
Moyers, Bill. *Genesis: A Living Conversation*. Companion to public television series. New York: Doubleday, Public Affairs Television, Inc.
Smith, Beryl, Joan Arbeiter, and Sally Shearer Swensen. *Lives and Works: Talks with Women Artists*. vol. 2. Lanham, MD: Scarecrow Press.
Tansey, Rigard G., and Fred S. Kleiner. *Gardner's Art Through the Ages*. 10th ed. Fort Worth, TX: Harcourt Brace and Co.
Woman's Work: A Century of Achievement in American Art. exh. cat. Columbus, GA: The Columbus Museum.

1995
Buser, Thomas. *Experiencing Art Around Us*. St. Paul, MN: West Publishing Co.
Division of Labor: "Women's Work" in Contemporary Art. exh. cat. Bronx, NY: The Bronx Museum of the Arts.
Fichner-Rathus, Lois. *Understanding Art*. 4th ed. Englewood Cliffs, NJ, and New York: Prentice-Hall and Simon & Schuster.
Heller, Jules, and Nancy G. Heller, eds. *North American Women Artists of the Twentieth Century*. New York: Garland Publishing.
Katz, Elizabeth L., Louis Lankford, and Janice D. Plank. *Themes and Foundations of Art*. St. Paul, MN: West Publishing Co.
Lippard, Lucy R. *The Pink Glass Swan: Selected Feminist Essays on Art*. New York: New Press.

Lucie-Smith, Edward. *Artoday*. London: Phaidon Press Ltd.

Ragans, Rosalind. *Arttalk*. Westerville, OH: Glencoe/McGraw-Hill.

Sterling, Susan Fisher. *Women Artists*. The National Museum of Women in the Arts. New York: Abbeville.

Stokstad, Marilyn. *Art History*. New York: Harry N. Abrams, Inc.

1994

Broude, Norma, and Mary Garrard, eds. *The Power of Feminist Art: The American Movement of the 1970s, History and Impact*. New York: Harry N. Abrams, Inc.

Chafe, William H. *The Road to Equality, American Women Since 1962, The Young Oxford History of Women in the United States*, vol.10. Edited by Nancy F. Cott. New York: Oxford University Press.

Continuing Innovation: Contemporary American Quilt Art. exh. cat. Notre Dame, IN: Saint Mary's College.

Gouma-Peterson, Thalia, and Judith E. Stein. Essays in *Collaboration Series 1994: Mother Russia*. exh. cat. New York: Steinbaum Krauss Gallery.

House Sweet House. exh. cat. Summit, NJ: New Jersey Center for Visual Arts.

Memories of Childhood . . . so we're not the Cleavers or the Brady Bunch. exh. cat. New York: Steinbaum Krauss Gallery.

The Rutgers Archives for Printmaking Studios, Catalogue of Acquisitions 1991–1993. New Brunswick, NJ: Jane Voorhees Zimmerli Art Museum, Rutgers, The State University of New Jersey.

Sayre, Henry M. *A World of Art*. Englewood Cliffs, NJ: Prentice-Hall.

1993

Dolls in Contemporary Art: A Metaphor of Personal Identity. exh. cat. Milwaukee, WI: The Patrick and Beatrice Haggerty Museum of Art, Marquette University.

Russell, Stella Pandell. *Art in the World*. 4th ed. Austin, TX: Holt, Rinehart and Winston, Inc.

Schapiro, Miriam. *Alphabet BookMobile; Crazy Clothes BookMobile; Kaleidoscope BookMobile; Numbers BookMobile*. Four mobile books. Rohnert Park, CA: Pomegranate Artbooks.

1992

Art and the Law. 17th annual exh. cat. Eagan, MN: West Publishing Co.

Betti, Claudia, and Teel Sale. *Drawing: A Contemporary Approach*. 3rd ed. Austin, TX: Holt, Rinehart and Winston, Inc.

Chapman, Laura H. *Art: Images and Ideas*. Worcester, MA: Davis Publications, Inc.

Coller, Barbara, and Donald Kuspit. Essays in *The Edge of Childhood*. exh. cat. Huntington, NY: The Heckscher Museum.

Farmer, Jane M. *Crossing Over Changing Places: An Exhibition of Collaborative Print Projects and Paperworks*. Riverdale, MD: Pyramid Atlantic.

Hunter, Sam, and John Jacobus. *Modern Art*. 3rd ed. New York: Harry N. Abrams, Inc.

Industrious Art: Innovation in Pattern and Print. New York: W.W. Norton and Co.

Miriam Schapiro: The Politics of the Decorative. exh. cat. East Hampton, NY: Guild Hall Museum.

Schapiro, Miriam. "Breaking Bread: Etching the Plate." *Ladies Lunch: Exploring the Tradition*. exh. cat. Louisville, KY, and New Harmony, IN: Louisville Visual Art Association and New Harmony Gallery of Contemporary Art.

Seigel, Judy, ed. *Mutiny and the Mainstream: Talk That Changed Art, 1975–1990*. New York: Midmarch Arts Press.

Swartzlander, Susan, and Marilyn R. Mumford, eds. *That Great Sanity: Critical Essays*. Ann Arbor, MI: The University of Michigan Press.

Weisman, Leslie Kanes. *Discrimination by Design, A Feminist Critique of the Man-Made Environment*. Champaign: The University of Illinois Press.

1991

Aspects of Collage. exh. cat. East Hampton, NY: Guild Hall Museum.

Collage Unglued. exh. cat. North Miami: North Miami Museum Center of Contemporary Art.

Contemporary American Women Artists. 1st ed.

San Raphael, CA: Cedco Publishing Co.

Graphic Studio: Contemporary Art from the Collaborative Workshop at the University of South Florida. exh. cat. Washington, DC: National Gallery of Art.

Lefton, Lester A. *Psychology*. 4th ed. Needham Heights, MA: Allyn and Bacon.

"A Seamless Life." *NAEA Keynote Addresses*. Reston, VA: National Art Education Association 31st Annual Conference catalogue.

1990

Chadwick, Whitney. *Women, Art and Society*. London and New York: Thames and Hudson.

Definitive Contemporary American Quilt. exh. cat. New York: Bernice Steinbaum Gallery.

East Hampton Avant-Garde, A Salute to the Signa Gallery. East Hampton, NY: Guild Hall Museum, East Hampton Center for Contemporary Art.

Four Centuries of Women in the Arts, The National Museum of Women in the Arts. Japan: Asahi Shimbun.

Gardner, James. *Art Through the Ages*. 9th ed. New York: Harcourt Brace Javonovich, Inc.

Intaglio Printing in the 1980s. exh. cat. New Brunswick, NJ: Jane Voorhees Zimmerli Art Museum, Rutgers, The State University of New Jersey.

Pattern & Decoration: Selections from the Roth Collection of Works on Paper. Brochure. Lakeland, FL: Polk Museum of Art.

Rubinstein, Charlotte Streifer. *American Women Sculptors*. Boston: K. Hall and Co.

1989

Brown, Betty Ann, and Arlene Raven. *Exposures, Women & Their Art*. Photographs by Kenna Love. Pasadena, CA: New Sage Press.

The Complete Printmaker. New York: Macmillan Publishing Co.

Crane, Diane. *The Transformation of the Avant Garde: The New York Art World 1940–1985*. Chicago: University of Chicago Press.

Hoffman, Katherine. *Collage: Critical Views*. Ann Arbor and London: UMI Research Press.

Lucie-Smith, Edward. *Art Now, 1989 Edition*. Edison, NJ: Wellfleet Press.

Moore, Sylvia, ed. *Yesterday and Tomorrow: California Women Artists*. New York: Midmarch Arts Press.

Preble, Duane, and Sarah Preble. *Art Forms: An Introduction to the Visual Arts*. New York: Harper and Row.

Schapiro, Miriam. *Rondo*. San Francisco: Bedford Arts Press.

Slatkin, Wendy. *Woman Artists in History*. Englewood Cliffs, NJ: Prentice-Hall.

Tompkins, Calvin. *Post to Neo: The Art World of the 1980s*. New York: Penguin Books.

Wagner, Dr. Van, and Judy Kay Collischan. *Lines of Vision: Drawings by Contemporary Women*. New York: Hudson Hills Press Inc.

1988

Contemporary American Collage 1960–1986. exh. cat. Amherst, MA: Herter Art Gallery, University of Massachusetts at Amherst.

Just Like a Woman. exh. cat. Greenville, SC: Greenville County Museum of Art.

Malin, Lenore. *The Politics of Gender*. exh. cat. Bayside, NY: Queensborough Community College of the City University of New York.

Nochlin, Linda. *Women Art and Power*. New York: HarperCollins.

Raven, Arlene. *Crossing Over: Feminism and the Art of Social Concern*. Ann Arbor and London: UMI Research Press.

Raven, Arlene, and Lauger French. *Feminism, Art Criticism*. New York: HarperCollins.

WCA Honors Awards. exh. cat. Houston: National Women's Caucus for Art Conference.

Woods, Laura Cater. *20th Annual Art Auction*. exh. cat. Billings, MT: Yellowstone Art Center.

Wye, Deborah. *Committed to Print*. exh. cat. New York: Museum of Modern Art.

1987

Goodman, Cynthia. *Digital Visions: Computers and Art*. exh. cat. Syracuse and New York: Everson Museum and Harry N. Abrams, Inc.

The Hamptons in Winter. exh. cat. New York: Gallery International 52.

Manhart, Marcia, and Tom Manhart, eds. *The Eloquent Object*. exh. cat. Tulsa: The Philbrook Museum of Art.

1986

Arnason, H. H. *History of Modern Art*. 3rd ed. New York: Harry N. Abrams, Inc.

Bell, Tiffany, Dore Ashton, and Irving Sandler. *After Matisse*. exh. cat. New York: Independent Curators, Inc.

Gouma-Peterson, Thalia. *I'm Dancing as Fast as I Can*. exh. cat. New York: Bernice Steinbaum Gallery.

Swartz, Joyce P. *Art in the Environment*. exh. cat. Boca Raton, FL: Boca Raton Museum of Art.

1985

American Art: American Women 1965–1985. exh. cat. Stamford, CT: Stamford Museum and Nature Center.

Bevlin, Marjorie E. *Design Through Discovery*. Austin, TX: Holt, Rinehart and Winston, Inc.

Collaboration Works: Women in Art. exh. cat. DeLand, FL: DeLand Museum of Art.

Miriam Schapiro: Femmages 1971–1985. exh. cat. St. Louis, MO: Brentwood Gallery.

The New Culture, Women Artists of the '70s. exh. cat. Akron, OH: Art Gallery, University of Akron.

1984

Koplin, Monica. *Komposition Im Halbrund*. exh. cat. Stuttgart and Zurich: Staatsgalerie and Graphische Sammlung, Museum Bellerive.

Raven, Arlene. *The New Culture: Women Artists of the Seventies*. exh. cat. Terre Haute, IN: Indiana State University.

Robins, Corinne. *The Pluralist Era: American Art 1968–1981*. New York: Harper and Row.

Wagner, Van, and Judy K. Collischan. *Women Shaping Art: Profiles of Power*. Westport, CT: Praeger.

1983

Actual Art Skira, A Special Issue 1970–1980. Geneva: Editions Skira S.A.

Back to the USA. exh. cat. Lucerne, Bonn, and Stuttgart: Kunstmuseum, Rheinisches Landesmuseum and Wurttembergische Kunstverein.

Biennale of Sydney. New South Wales: Art Gallery of New South Wales, Australia.

Bradley, Paula. Ph.D. diss. on Miriam Schapiro. Chapel Hill: University of North Carolina.

Broude, Norma. "Miriam Schapiro and Femmage: Reflections on the Conflict Between Decoration and Abstraction in Twentieth-Century Art." *Feminism and Art History: Questioning the Litany*. Norma Broude and Mary D. Garrard, eds. New York: Harper and Row.

Jenson, Robert, and Patricia Conway. *Ornamentalism*. New York: Clarkson N. Potter, Inc.

Johnson, Ellen H., ed. *American Artists on Art from 1940–1980*. New York: Harper and Row.

New Decorative Works from the Collection of Norma and William Roth. exh. cat. Orlando, FL: Loch Haven Art Center.

Raven, Arlene, ed. *At Home*. exh. cat. Long Beach, CA: Long Beach Museum.

Schapiro, Miriam. "Geometry and Flowers." *The Artist & the Quilt*. Charlotte Robinson, ed. New York: Alfred A. Knopf.

Rubinstein, Charlotte. *American Women Artists*. New York: Avon.

1981

Kozloff, Max. *Miriam Schapiro*. exh. cat. Cologne: Rudolf Zwirner Galerie.

1980

Gouma-Peterson, Thalia, ed. *Miriam Schapiro: A Retrospective: 1953–1980*. exh. cat. Wooster, OH: The College of Wooster.

Les Nouveaux Fauves De Neuen Wilden. 2 vols. Aachen, Germany: Ludwig Museum.

Pattern Painting/Decoration Art. Vienna and Innsbruck: Modern Art Galerie and Galerie Krinzinger.

Plagens, Peter, Walter Gabrielson, and Michael Curcfield. *Decade: Los Angeles Painting in the Seventies*. Pasadena, CA: Art Center College of Design.

Senie, Harriet. Essay in *Fabric into Art*. Old Westbury, NY: State University of New York at Old Westbury.

Women and Art. exh. cat. Essay by Erma Bombeck. Scottsdale, AZ: Suzanne Brown Gallery.

1979

Kardon, Janet. *The Decorative Impulse.* Philadelphia: Institute of Contemporary Art.

Lindenburg, Rosa, ed. *Feministische Kenst International.* Haags, The Netherlands: Gemeentemuseum.

Loeb, Judy. *Feminist Collage: Educating Women in the Visual Arts.* New York: Teachers College Press, Columbia University.

Munro, Eleanor. *The Originals.* New York: Simon & Schuster.

Perreault, John. *Pattern Painting.* Introduction by K. J. Geirlandt. Brussels: Palais des Beaux-Arts.

1978

Naylor, Colin, and G.P. Orridge, eds. *Contemporary Artists.* Calne, Wiltshire, U.K.: Hilmarton Manor Press.

Schapiro, Miriam. "How Did I Happen to Make the Painting *Anatomy of a Kimono*?" in Charles Rhyne, *Miriam Schapiro, Anatomy of a Kimono.* exh. cat. Portland, OR: Reed College.

1977

Schapiro, Miriam. "Notes From a Conversation on Art, Feminism, and Work." *Working It Out: 23 Women Writers, Artists, Scientists and Scholars Talk About Their Lives and Work.* Sara Ruddick and Pamela Daniels, eds. New York: Pantheon Books.

Torre, Susana, ed. *Women in American Architecture.* New York: Whitney Library of Design.

Wilding, Faith. *By Our Own Hands.* Santa Monica, CA: Double X.

1975

Roth, Moira, ed. *The Shrine, the Computer and the Dollhouse: Miriam Schapiro.* exh. cat. La Jolla, CA: Mandeville Art Gallery.

Schapiro, Miriam, and members of the Feminist Art Program. *Art, a Woman's Sensibility.* Valencia, CA: California Institute of the Arts.

1974

Plagens, Peter. *Sunshine Muse: Contemporary Art on the West Coast.* New York and Washington D.C.: Praeger.

Schapiro, Miriam, and members of the Feminist Art Program. *Anonymous Was a Woman.* Valencia, CA: California Institute of the Arts.

1972

21 Artists–Invisible/Visible. Introduction by Judy Chicago and Miriam Schapiro. Long Beach, CA: Long Beach Museum of Art.

Womanhouse. Feminist Art Program. Introduction by Judy Chicago and Miriam Schapiro. Valencia, CA: California Institute of the Arts.

1971

Tamarind: A Renaissance of Lithography. Los Angeles: International Exhibitions Foundation.

1969

Drawings: An Exhibition of Contemporary American Drawings. Essay by Peter Plagens. Fort Worth, TX: Fort Worth Art Center.

1965

One Hundred Contemporary American Drawings. Essay by Dore Ashton. Ann Arbor: The University of Michigan Museum of Art.

1963

Toward a New Abstraction. exh. cat. Essay by Dore Ashton. New York: The Jewish Museum.

1958

Abstract Impressionism. exh. cat. Essay by Lawrence Alloway. London: Arts Council Gallery

SELECTED ARTICLES AND REVIEWS

1998

Clifford, Katie. "Faster Than You Can Say Chiaroscuro." *ARTnews* 97, no. 9 (June): 32.

Cotter, Holland. "Messages Woven, Sewn or Floating in the Air." *The New York Times* (Jan. 9): E37.

———. "Gallery opens season with 'Selections from SoHo.'" *The Daily Times* (Aug. 21–27).

Hogrefe, Jeffrey. "Miramax 'Love Story' Arouses Art World Debate." *The New York Observer* (May 4).

McMullen, Cary. "Hidden Treasures." *The Ledger* (FL) (July 1): D1–7.

"Miriam Schapiro: A Woman's Way." *Art/Quilt Magazine,* no. 9 (1st Quarter): 32.

Mulligan, Kate. "Miriam in Wonderland." *AARP Bulletin* 39, no. 6 (June): 21–22.

———. "Advocates for Art." *Stanford Center Focus* (Stanford Univ. Medical Center) (summer): 3.

Raaberg, Gwen. "Collage as Feminist Strategy in the Arts." *Mosaic, a journal for the interdisciplinary study of literature* 31, no. 3 (Sept.): 153.

Reynolds, Judith. "A Banquet on the Mesa" and "Mary Tso—Persuasive FLC Gallery Director." *The Durango Herald,* section B (Aug. 27).

Schapiro, Miriam. "Artemesia Gentileschi—Who?" *The East Hampton Star* (Sept. 10).

Stein, Linda. "Miriam Schapiro: Woman–Warrior with Lace, Changing the way women see art, and the way art sees women." *FiberArts* 24, no. 5 (Mar./Apr.): 35–40.

Stewart, Marilyn. "Miriam Schapiro: An Artistic Journey." *SchoolArts* 97, no. 7 (Mar.): 27–30.

Stewart, Marilyn, Kate Stewart, and Miriam Schapiro. "A Three-Generation Conversation with Miriam Schapiro." *SchoolArts* 97, no. 7 (Mar.): 34–35.

———. "W & L's duPont Gallery to Show Schapiro Art." *The News Gazette,* Section A, Lifestyles (Jan. 14): 6.

1997

Bass, Ruth. "Miriam Schapiro/Steinbaum Krauss." *ARTnews* 96, no. 8 (Sept.): 135.

Bell, J. Bowyer. "Miriam Schapiro, Collaged, Femmaged, Printed and Painted." *Review* (Apr. 15): 6, 7.

Braff, Phyllis. "Kimonos, Prints and Images of the Cross." *The New York Times* Long Island ed. (Apr. 20): 12.

Glueck, Grace. "Miriam Schapiro: Collaged, Femmaged, Printed and Painted." *The New York Times* (Apr. 4): C28.

Gouma-Peterson, Thalia. "Miriam Schapiro: An Art of Becoming." *American Art* 11, no. 1 (spring): 10–45.

Gouveia, Georgette. "Weaving and exhibit on fabrics function." *Gannett Newspapers* (Oct. 21): 1C.

James, Curtia. "Workshop features handmade books." *Richmond Times-Dispatch* (Sept. 7): H3.

MacLeod, Chris. "Old Tales, New Tellers." *Manhattan Spirit* (Apr. 4): 30.

Michelman, Dorothea S. "Kulturspiegel." *Das Fenster* (Aug.).

"*Miriam Schapiro and Us* at Artforms Gallery Manayunk." *Art Now: Gallery Guide.* Philadelphia/Mid-Atlantic Region (Jan.): PH3.

Nickell, Amy, and Tanya Stanciu. "Creating Beauty: An Interview with Feminist Artist Miriam Schapiro." *Gadfly* 1, no. 7 (Sept.): 18–19, 27.

Okamoto, Susanne. "Pioneer feminist artist shows at ArtForms." *Art Matters* (Fort Washington, PA) (Feb.): 14

———. "On-the-Wall Feminism." *Philadelphia Weekly* (Jan. 8): 51.

Pomeranz, Judy. "National Gallery: Calder, NMAA: 'A Woman's Way.'" *The Journal* (June 27).

Rice, Robin. "Critic's Pick." *Philadelphia City Paper* (Jan. 10–16).

Richard, Paul. "Miriam Schapiro: Feminism's 'Mimi Appleseed.'" *The Washington Post,* Section G (May 11).

Sozanski, Edward. "Uniting Gestures of Homage and Friendship." *Philadelphia Inquirer* (Jan. 24): 38.

Stein, Linda. "Paul Brach & Miriam Schapiro: A Study in Contrasts." *The Independent* (East Hampton, NY) (Aug. 13): B-17.

Tabor, Brenda Kean. "Spotlight—Schapiro: Seeking Respect for All Things Domestic." *The Torch* no. 97–7 (July).

———. "A Talk with Miriam Schapiro." *The Washington Post* (May 8).

Weiss, Marion Wolberg. "Miriam Schapiro at Steinbaum Krauss Gallery." *Dan's Papers* (Apr. 11): 46.

Wilkinson, Jeanne C. "Miriam Schapiro: Collaged, Femmaged, Printed and Painted." *Review* (Apr. 15): 23.

1996

Annas, Teresa. "Feminist Artist Cleared Path for Others." *Virginian-Pilot* (Feb. 25).

Haynes, Deborah J. "Miriam Schapiro's Collaboration Series: 'Mother Russia.'" *Women's Art Journal* (spring/summer): 57–58.

Henkin, Stephen. "Kudos for the Kimono: Exotic Garment as Art Icon." *Washington Times* 11, no. 8 (Aug.): 96–103.

Muchnic, Suzanne. "Push-Pull of Feminist Art." *Los Angeles Times* (Apr. 21): 8, 9, 78, 80.

Nichols, Ann. "Schapiro to Lecture at Hunter Museum." *Chattanooga Free Press* (Mar. 3): L8.

Schrager, Joan Meyerson. "Schapiro Led the Way." Letters to the Editor. *Seven Arts* (Philadelphia, PA) (Sept.).

1995

Anson, Libby. "Division of Labor: 'Women's Work' in Contemporary Art." *Arts Monthly* (Apr.): 185.

Armitage, Diane. "The Power of Feminist Art." *The Magazine. Santa Fe's monthly magazine of the arts* (June).

Atkins, Robert. "As Ye Sew." *Village Voice* (Apr. 25).

Cotter, Holland. "Feminist Art, 1962 Until Tomorrow Morning and International." *The New York Times* (Mar. 17).

Crowder, Joan. "Museum does 'About Faces.'" *The Santa Barbara News-Press Scene* (Mar. 31): 23, 25.

Davis, Rachel. "Division of Labor: 'Women's Work' in Contemporary Art." *Women's Caucus for Art Newsletter* (spring): 3.

Felshin, Nina. "Clothing as Subject." *Art Journal* 54, no. 1 (spring).

———, ed. "Women's Work: A Lineage, 1966–94." *Art Journal* 54, no. 1 (spring): 71.

Karmel, Pepe. "Emma Amos—Paintings and Prints." *The New York Times* (Mar. 3).

Knight, Christopher. "'Women's Work' Is Never Done at MOCA." *Los Angeles Times* (Oct. 1): 59, 62.

Lord, M.G. "Women's Work Is (Sometimes) Done." *The New York Times* (Feb. 19).

Malone, Scott. "'Women's Work' on Display at Bronx Museum." *Norwood News* (May 11–17).

Merrill, Patrick, and Gail Jacobs. "A Feminist Response: An interview with Miriam Schapiro." *Newsprint: The Journal of the Los Angeles Printmaking Society* (winter 1994/95): 4–10.

Raven, Arlene. "Overworked? Overwhelmed?: These Artists Understand." *On the Issue* (spring): 42–44, 53.

Raynor, Vivien. "An Exhibition Emphasizing the Feminist Role in Politics." *The New York Times* Westchester ed. (May 7).

Rosen, Rita. "For art's sake, two women canvas the world." *Exponent Extra* (Philadelphia, PA) (May, 26).

Schwendener, Martha. "Division of Labor: 'Women's Work' in Contemporary Art." *The New Art Examiner* 22, no. 10 (summer).

Walker, Marie. "Strictly Women." *Museum New York* 1, no. 6 (Mar./Apr.).

Wei, Lilly. "Feminists in the Art World." *Art in America* 83, no. 1 (Jan.).

"'Women's Work in Contemporary Art' exhibit." *Bronx News* (Apr. 20).

Wu, Mali. "Looking Back to the Women, Art and Education of the '70s in the U.S.A.: We Are Women, We Are Very Good." *Artist* (Taipei, Taiwan) (Apr.).

1994

Abbe, Mary. "Artistic Heroine." *Star Tribune* (May 16).

———. "A Philosopher's Stone: Radical Changes in Teaching." Convocation Address. *CAA News* 19, no. 2 (Mar./Apr.).

———. "Art Event showcases women." *The Charleston Gazette* (WV), (Nov. 10): 3D.

———. "Art Movement Leader Speaks on Campus." *SesquiComm* (Saint Mary's College, Notre Dame, IN) (Sept.).

Addison, Christopher. "Pyramid Atlantic, Fourteen Years of Collaboration." *Pyramid Atlantic/The Print News* (Riverdale, MD).

Aude, Karen. ". . .The Female Consciousness: Woman, Art, and the 1990s . . ." *Cape Cod Antiques & Arts* (Sept): 18–21.

———. "Femmage Autobiography at Castle Hill." *Cape Cod Antiques & Arts* (Aug.).

Bornstein, Lisa. "Feminist Artist Rips Fine-Art Establishment." *South Bend Tribune.* Punch

Arts/Entertainment (Sept. 14).
———."Feminist Painter to Give Slide Lecture."
 Indiana Statesman 100, no. 66 (Mar. 18).
Hess, Elizabeth. "The Women." *Village Voice* (Nov.
 8): 91.
Kozlove, N. "Miriam Schapiro." *Novoye Russkoye
 Slovo* (Russian-American Daily Newspaper) 85,
 no. 29.693 (Sept. 16): 17.
Lattea, Charlene. "Fabric, paint, found objects are
 part of creativity for feminist art movement
 founder." *Mountaineer Spirit* (West Virginia
 University, Morgantown) (Oct. 20): 5.
Lipson, Karin. "Sequins, Feathers, Paper, Nails:
 Neo-Quilt." *Newsday* (Feb. 11).
Logan, Heather. "Sketches and collages on show at
 CAC." *The Daily Athenaeum* (WV) (Nov. 2).
Mahoney, Robert. "Kathleen Holmes: Embracing A
 Crochet Heritage." *FiberArts* (summer).
Mayernik, Becky. "Sesquicentennial Quilts Patch
 Tradition, Change." *The Observer* (IN) (Sept. 2): 2.
———. "Miriam Schapiro to Speak at
 Convocation." *CAA News, Newsletter of the
 College Art Association* (Jan./Feb.).
Op De Beek, Nathalie. "When Men Were Men and
 Women Were Wymyn." *Washington City
 Paper* (Jan. 13).
Queen, Pamela Cyphert. "Artists—and Proud of
 It!" *The Dominion Post* (WV) (Nov. 10).
Robinson, Hilary. "New York, New York: The Big
 Apple is still on top." *Women's Art Magazine*
 (London) no. 58 (May/June): 24.
———. "Schapiro to Lecture March 29." *Campus
 Connection* (Indiana State University) 4, no. 9
 (Mar. 14).
Tull, Becky. "Exhibit to feature works by 10 quil-
 ters." *The South Bend Tribune* (Aug. 31).
Vanney, Susan. "She Didn't Want to Be Second
 Anything." *The Post-Crescent, Fox Cities* (Apr.
 13): B-1.
Watkins, Eileen. "Images of Houses Find Happy
 Home in Summit Exhibit." *The Sunday Star
 Ledger* Section 4 (May 22): 17.
Weiss, Marion Wolberg. "Miriam Schapiro at
 Steinbaum Krauss Gallery." *Dan's Papers*
 (Dec. 23): 52.
———. "Works of Pioneering Organization of
 Women Artists at the Zimmerli." *NEWZ, The
 Friends of the Zimmerli Art Museum,
 Newsletter* (1994): 9.

1993
Auer, James. "Modern Art Plays with Dolls for a
 Reason." *The Milwaukee Journal* (Mar. 14).
Basa, Lynn. "Breaking the Glass Ceiling."
 FiberArts 20, no. 3 (Nov/Dec.).
Dyer, Carolyn Price. "Art and the Quilt . . . A
 Symposium." *FiberArts* 20, no. 3 (Nov/Dec.).
———. "Exhibit Plants the Seed for Imagination."
 Daily Press (Virginia Beach) (May 23).
Harbaugh, Pam. "Art Supporters Organize to
 Keep Stadium Sculpture." *Florida Today* (Nov.
 3).
Hubbard, Guy. "Heartland." *Arts & Activities* 114,
 no. 4 (Dec.).
Jan, Alfred. "A Brief Account of Recent Feminist
 Art and Criticism." *A Journal of Art Criticism*
 (fall): 2–3.
Knaff, Devorah. "Fighting Back: Issues of
 Oppression at OCCCA." *Artweek* 24, no. 15
 (Aug. 5).
———. "Miriam Schapiro: To Russia with Love."
 Women in the Arts, National Museum of
 Women in the Arts, 10, no. 4 (winter).
———. "Members Offered Schapiro Print." *CAA
 News, Newsletter of the College Art
 Association* 18, no. 5 (Sept./Oct.).
Moorehead, Jennifer. "The Quilt: An American Art
 Form." *Portsmouth Daily Times* (July 11).
———. "Ms. Supports Women in the Arts." *Ms.* 4,
 no. 2. (Sept./Oct.).
Paine, Janice T. "Artists Turn to 'Dolls' to Explore
 Human Needs." *Milwaukee Sentinel* (Apr. 23).
Priesser, Alfred. "Something Entirely Different."
 Hello Belgrade 1, no. 5 (Aug.).
Roth, Charlene. "A Conversation with Miriam
 Schapiro, Artist/Juror." *Artweek* 24, no. 15
 (Aug. 5).
Vender, Marla. "Miriam Schapiro & A.R.C." *Artist's
 News* (Chicago Arts Coalition) (May).

1992
Avgikos, Jan. "Seeing with Our Bodies." *Tema
 Celeste Contemporary Art Review* no. 37–38
 (Autumn).
Brace, Eric. "Women's Reunion at Corcoran."
 Washington Post (Apr. 13).
Braff, Phyllis. "Testimony to Magic of Gifted
 Installation." *The New York Times* (May 24).
Copelon, Dianne. "Artists Redefine the American
 Quilt." *The Orlando Sentinel* (June 21).
Harbaugh, Pam. "BACAM Exhibit Puts Stitch in
 Traditional Art Form." *Florida Today* (June 7).
Mifflin, Margot. "Feminism's New Face." *ARTnews*
 91, no. 9 (Nov.).
———. "Museum Plans Opening of Contemporary
 'Quilt' Exhibit." *WSU Week* (Pullman, WA)
 (Nov. 6).
"Miriam Schapiro's Russian Revolution." *Women In
 The Arts* 10, no. 3 (fall).
Norman, Sally. "Women and Art: Miriam
 Schapiro." *Fort Collins, Coloradoan* (Sept. 22).
Parker, Lin C. "The Woman's Perspective."
 Chattanooga News-Free Press (Apr. 12).
Raven, Arlene. "Frida and Mimi." *The Village Voice*
 37, no. 2 (Jan. 12): 88.
Schapiro, Miriam. "Rembrandt and Me."
 M/E/A/N/I/N/G Contemporary Art Issues no. 12
 (Nov.): 30–32.

1991
Abbott, Shirley. "Celebrating the Great American
 Quilt." *McCalls* (Apr.)
Apgar, Evelyn. "Novel Programs Put Fun in
 SummerFest." *The Sunday Home News* (New
 Brunswick, NJ) (June 16).
———. "Rutgers SummerFest Series Beginning on
 High Note." *The Sunday Home News* (New
 Brunswick, NJ) (June 9).
———. "Art Museum to Exhibit Major Acquisition."
 The Oxford Press (OH) (May 9).
Braff, Phyllis. "Liberation Through Collage." *The
 New York Times* (May 19).
Brody, Jacqueline, ed. "Prints and Photographs
 Published." *The Print Collector's Newsletter* 21,
 no. 6 (Jan./Feb.).
Broude, Norma. "Report From Washington II:
 Alternative Monuments." *Art in America* 79, no.
 2 (Feb.): 73–80.
"Femmage Credited." *Art in America*. Letters to the
 Editor (May).
Findsen, Owen. "Miami Gets Collage Portrait." *The
 Cincinnati Enquirer* (May 14).
———. "Painting Celebrates Kahlo." *The
 Cincinnati Enquirer* (May 19).
Foerstner, Abigail. "Breaking Through." *Chicago
 Tribune*, section 6 (Feb. 10).
Harbaugh, Pam. "Miriam Schapiro, Artist
 Celebrates Women, Life Through 'Femmages.'"
 Florida Today (Apr. 7): 5F–6F.
Hughes, Laura. "New Art That Warms the Soul."
 Mobile Bay Monthly 6, no. 4 (May).
Kohen, Helen L. "Artists Blend as Well as Their Art
 in Collage Exhibition." *The Miami Herald*
 (October 6).
Krebs, Betty Dietz. "Femmage at Miami Celebrates
 Frida Kahlo's Life." *Dayton Daily News* (May
 18).
Miami University Report (Oxford, OH) 10, no. 36
 (May 9).
Raynor, Vivien. "Blending Elements and
 Reconciling Opposites." *The New York Times*
 (Jan. 6).
———. "Women's Views on Women." *The New York
 Times* (July 7).
Rosensweig, Ilene. "Critic's Consuming Vision."
 The Jewish Women/Forward (June 7).
———. "Quilting Sex, Art and Politics." *Forward*
 (Nov. 29): 11–13.
Schor, Mira. "You Can't Leave Home Without It."
 Artforum 30, no. 2 (Oct).
Slivka, Rose C. S. "From the Studio." *East Hampton
 Star* (May 9).
Taylor, Samantha. "The Quilt as Art Form." *The
 World and I* (June): 184.
Twardy, Chuck. "To Break Down Barriers, Artist
 Establishes Ties." *The Orlando Sentinel* (Apr. 3):
 E1, E3.
White, Bob. "Beneath The Tower." *The Oxford Press*
 (OH) (May 23).

1990
Apgar, Evelyn. "Infinite Varieties in Colorful Exhibit
 of Intaglio Prints." *The Home News* (New
 Brunswick, NJ) (Dec. 9).
———. "Stitches in Time: Magnificent Quilt Show
 May Heat Up Artistic Debate." *The Home News*
 (New Brunswick, NJ) (Dec. 16): C1–C2.
Bass, Ruth. "Miriam Schapiro." *ARTnews* 89, no. 8
 (Oct.): 185.
Braff, Phyllis. "They Were Driven to Abstraction."
 The New York Times (Aug. 26).
Burnham, Sophy. "Portrait of the Artist as a
 Woman." *New Woman* 20, no. 6 (June).
Filler, Marion. "Exhibit Is Born of Feminine
 Experience." *Daily Record* (Morris County, NJ)
 (Dec. 9): D13.
Gerstler, Amy. "Fancy Work." *Art Issues* no. 10
 (Mar./Apr.).
Gomez, Edward M. "Quarreling Over Quality: A
 Feminist Critique Blasts Old Assumptions
 About How We Judge an Artist's Work." *Time*
 136, no. 19 (fall): 61–62.
Graybill, Robert. "Schapiro Dives into the Mythic
 Pool." *The Santa Fe, New Mexican Pasatiempo*
 (June 29): 11.
Habich, John. "Best Bet, an Artsy Fund-Raiser." *Star
 Tribune* (Nov.15): 3E.
Herrera, Hayden. "Why Frida Kahlo Speaks to the
 '90s." *The New York Times*, Section 2 (Oct. 28).
Kutner, Janet. *The Dallas Morning News* (Sept. 21).
Ladd, Susan. "Advocacy and the Arts."
 Greensboro News & Record (Jan. 21).
———. "Miriam Schapiro." *Art Talk* (June/July).
———. "Miriam Schapiro 'Rondo'." *The East
 Hampton Star* (May 17).
———. *Mother Jones* (June): 50
———. *The New Yorker* (Apr. 30): 21.
O'Hara, Catherine. "The Postfeminist Dilemma."
 Dialogue: Arts in the Midwest (Jan./Feb.).
Slesin, Suzanne. "Quilts That Warm in New Ways."
 The New York Times (Dec. 6).
———. "Quilts Off the Bed and on the Wall." *Grand
 Forks Herald* (Dec. 7).
Slivka, Rose C. S. "From the Studio." *The East
 Hampton Star* (Apr. 19).
Watkins, Eileen. "Feminist Belies Her 'Label' with
 Upbeat, Clever Works." *The Sunday Star-
 Ledger* (NJ) (Dec. 23): 13.
Wolverton, Terry. "The Women's Art Movement
 Today." *Artweek* 21, no. 5 (Feb. 8).
1989
Danto, Arthur C. "The Breakthrough Decade:
 Women in the Arts." *The Nation* 249, no. 22
 (Dec. 25): 749–98.
Delatiner, Barbara. "Feminist Art, Traditional
 Forms." *The New York Times* (July 16).
Donnely, Kathleen. *San Jose Mercury Newspaper*
 (June 1).
———. "Art Throb." *Lear's* 2, no. 3 (Nov.).
Findsen, Owen. "Pioneer in Women's Art Still
 Follows Her Vision." *The Cincinnati Enquirer*
 (Mar. 1).
———. "Making Their Mark: A Traveling
 Exhibition Surveys the Influence and Role of
 Women Artists in Contemporary American
 Art." *The Journal of Art* 1, no. 3 (Feb./Mar.).
Freire, Norma. "A America alinhava sua memoria
 em retalhos." *Estilo* (Nov. 26).
Gallagher, Maria. "Mama." *Philadelphia Daily
 News* (Oct. 20).
Hoffberg, Judith. "Artist Books." *High Performance*
 (spring).
Katzoff, Nancy. "'Quilting Partners' Stitch Art to Craft."
 São Paulo Village News 1, no. 17 (Nov. 16).
May, Liz Cowan. "Art for Development's Sake."
 Building Washington (summer).
Valverde, Franklin. "Retalhos que fazem arte." *Veja
 em São Paulo* (Dec. 6): 124.
1988
Barry, Ann. "Jacquard Coverlets Weave a Spell."
 The New York Times (Feb. 28).
Bell, Jane. "Miriam Schapiro." *ARTnews* (Sept.).
Crump, Constance. "Primal Places: Lecturer Offers
 Look into Magic of Women Artists." *Ann Arbor
 News* (Sept. 18).
Fabricant, Florence. "A 'No Sweat' Artists'
 Celebration." *The New York Times* (Nov. 23) .
Gerards, Inemie. "Framing Feminism." *Ruimte* (Feb.)

Guild, Katherine. "Strength in Numbers." *Houston Home & Garden Magazine* (Feb.): 12, 14.

Leigh, Candace. "Honoring the Artists of the Hamptons." *Dan's Papers* (July 29).

Lipson, Karin. "East End Drawings: With Bounds, Diversity." *Long Island Newsday* (Oct. 7).

Perczak, Lisa, and Mark Kolar. "Women Artists Praised in Speech." *The Michigan Daily* (Sept. 27).

Raynor, Vivien. "A Musical Theme Binds Together an Exhibition of 40 Works." *The New York Times* (Dec. 4).

Reynolds, Judith. "Collage and Femmage." *City Newspaper*.

Russell, John. "Miriam Schapiro." *The New York Times* (Apr. 1).

Smith, Virginia Warren. "Stereotypical images mar 'Herstory's' impact." *The Atlanta Journal* (Feb.).

Sombke, Laurence. "Viewer-friendly sculpture is just around the bend." *USA Weekend* (Jan. 8–10).

Talley, Charles. "A Retardative View of Crafts." *Artweek* 19, no. 16 (Apr. 23).

Wennblom, Audrey. "Arts Groups in Virginia Seek More State Funding." *The Washington Post* (Jan. 14).

Witzling, Mara. "Lamont Gallery, Phillips Exeter Academy/Exeter Adornments." *Art New England* 9, no. 3 (Mar.).

1987

"An Artistic High-Rise." *The Washington Post Metro* (Oct. 8).

Babcock, Pamela. "Sculptures Set Rosslyn Building Apart." *Washington Business* (Oct. 12).

Bates, Dennis. "Sculpture of dancers installed in Rosslyn." *The Washington Times* (Oct. 16).

Cottingham, Laura. "Women Artists: A Question of Difference." *Art & Auction* (Mar.).

Delatiner, Barbara. "Exploring the Artist–Mother Bond." *The New York Times* (Nov. 8).

Ferragamo, Elsie. "Artists Review Art History." *Women Artists News* (June): 17, 18.

Foote, Cornelius F., Jr. "Artful Office Landscapes." *The Washington Post* (Dec. 19): E1, E6.

Glueck, Grace. "A New Showcase for Art by Women." *The New York Times* (Apr. 1).

Gouma-Peterson, Thalia, and Patricia Mathews. "The Feminist Critique of Art History." *The Art Bulletin* 69, no. 3 (Sept.).

Heartney, Eleanor. "How Wide Is the Gender Gap?" *ARTnews* (summer): 39–145.

"Joey and Anna and David." *Dossier* (Dec.): 74–75.

Koch, Anne. "Going Public with Art." *The Washington Post Virginia Weekly* (Oct. 1).

Marter, Joan. "Strategies for Women in Art," in "Special Feature: Teaching About Women and the Visual Arts." *Women's Studies Quarterly* 15, nos. 1, 2 (spring/summer).

Mullins, Hattie-Jo P. "Picture This." *Ms.* (Mar.).

Nolan, Chris. "Art Gets a Hand in Rosslyn." *The Fairfax Journal* (Springfield, VA) (Oct. 9).

Pistolesi, Edie. "Looking/Learning Miriam Schapiro." *School Arts* (Feb.): 29, 32.

Schapiro, Miriam. Statement in article entitled "Forum." Edited by Susan Bee and Mira Shor. *M/E/A/N/I/N/G* (Nov.).

———. "Recalling Womanhouse." *Women's Studies Quarterly* 15, nos. 1, 2 (spring/summer): 25–30.

———. *Sculpture* (Nov./Dec.).

Smith, Nancy S. "Get your kicks at this exhibit." *The News & Courier/The Evening Post* (Charleston, SC) (Mar. 15): 20D.

1986

Applebaum, Anne. "Feminism and the Art of Museum Maintenance." *Washington Free Weekly* 8, no. 29 (July 18–24).

Blair, Nancy. "Femmage at Feminists' Artists Institute . . ." *Women Artists News* 11, no. 3 (June).

Carlton, William. "Honoring Women in the Arts: Artist Fights for Feminist Viewpoint." *Ft. Wayne News Sentinel* (IN): 1D–2D.

Cummings, Mary. "Miriam Schapiro Celebrating Women's Lives." *Southampton Press*: 1, B8.

Day, Sara. "A Museum for Women." *ARTnews* (summer).

Degener, P. "Artists' Messages from the Heart." *St.*

Louis Post-Dispatch (May 17).

———. "East End Artists with an Impact." *The New York Times* (Aug. 3).

Dishman, Laura Stewart. "Miriam Schapiro: Profile." *The Orlando Sentinel* (Jan. 16).

Ford, Dell. "Theatre of Color." *Ft. Wayne Journal-Gazette* (IN).

Garrard, Mary D. Speech at Second Annual Membership Banquet, Women's Caucus for Art. *Hue Points* 16, no. 1 (spring): 39–41.

Gill, Susan. "From 'Femmage' to Figuration." *ARTnews* 85, no. 4 (Apr.): 94–101.

Gouma-Peterson, Thalia. "The Theatre of Life and Illusion in Miriam Schapiro's Work." *Arts* 60, no. 7 (Mar).

Heartney, Eleanor. "Miriam Schapiro at Bernice Steinbaum." *Art in America* (July).

Lipson, Karin. "After Matisse." *New York Newsday* (Apr. 18).

Niss, Bob. "Exhibit Examines Legacy of Matisse." *Portland, Maine, Evening Express* (Dec. 11).

Raynor, Vivian. "Miriam Schapiro." *The New York Times* (Mar. 28).

Sanford, Christy Sheffield, and Enid Shorter. "An Interview with Miriam Schapiro." *Women Artists News* 2, no. 2 (spring): 22–26.

"Schapiro's One Day Workshop." *Women Artists News* 2, no. 3 (June).

Shepard, J. "Arts Community." *New York Daily News* (Feb. 9).

1985

Degener, Patricia. "Artist's Messages from the Heart." *St. Louis Post-Dispatch* (May 17).

Doss, Erika, and Gary J. Schwindler. "Two Views of the New Culture." *Dialogue: An Art Journal.*

Gilam, Abraham. "Feminism, Womanhood Celebrated in Miriam Schapiro's Art Works." *St. Louis Jewish Light* (June 5): 7.

Harper, Paula. "The First Feminist Art Program: A View from the 1980s." *Signs: Journal of Women in Culture and Society* 10, no. 4 (summer).

Lipson, Karen, and E. H. Star. "100 Anniversary Portfolio." *Newsday* (Dec. 20).

Lyons, Harriet. "The Art Biz." *Ms.*, "Working at What You Love and Getting Paid for It, New Directions For Women" issue (Nov.).

1984

Auer, James. "Fibres Knit into Solid Exhibition." *Milwaukee Journal* (Aug. 5).

Freedman, Shirley M. "Visual Needlework Artistry Comes Alive at Quilt Exhibit." *The Sun Star Ledger* (Jan. 29).

Glueck, Grace. "Art: Janis Presents American Women." *The New York Times* (Jan. 27).

Harris, Betsy. "The Artist & the Quilt Has Roots in Feminist Movement." *Indianapolis Star* (Jan. 22).

Parks, Cynthia. "Quilted Art." *Florida Times Union/Jacksonville Journal* (Mar. 18).

Poe, Joy. "Texas Art News." *Women Artists News* (winter).

Sozanski, Edward J. "At Moore College a Celebration of the Collaborative Quilt." *Philadelphia Inquirer* (Mar. 20).

Welles, Elenore. "Miriam Schapiro at Koplin." *Images and Issues: Contemporary Art Review* (Jan./Feb.).

1983

Cohen, Ronny. "Review of Miriam Schapiro Exhibit at Barbara Gladstone Gallery in November, 1982." *Artforum* (Feb.).

Heller, Faith. "Gallery: The Quilt as Fine Art." *Winston-Salem Journal* (Dec. 4).

Stein, Judith. "The Artist's New Clothes." *Portfolio* (Jan./Feb.).

1982

Avgikos, Jan. "The Decorative Politic: An Interview with Miriam Schapiro." *Art Papers* (Nov./Dec.).

Frank, Elizabeth. "Miriam Schapiro: Formal Sentiments." *Art in America* (May).

Sello, Gottfried. "Miriam Schapiro." *Brigitte* (Dec. 25).

Tulloch, Lee. "The Biennale of Sydney." *Vogue Australia* 23, no. 4, whole number 214 (Apr.).

1981

"Artists' Valentines." *The Atlantic Monthly* 247, no. 2 (Feb.).

Butera, Virginia Fabbri. "The Fan as Form in Contemporary Art." *Arts Magazine* 5, no. 9 (May).

Donnelkj-Kotrozo, Carol. "Women and Art." *Arts* (Mar.).

Larson, Kay. "Minds and Hearts." *New York* (Apr. 27).

Lewis, Jo Ann. "Return to Splendor." *Washington Post* (Mar. 14).

Nadelman, Cynthia. "Replacing Papa's Pipes." *ARTnews* 80, no. 6 (June).

Perreault, John. "The Heart of the Matter." *Helicon Nine* no. 4 (spring).

Schapiro, Miriam. "Femmage." *Helicon Nine* no. 4 (spring): 38.

Silverthorne, Jeanne. "Miriam Schapiro." *Artforum* (summer).

1980

Berman, Avis. "A Decade of Progress." *Art News* (Oct.).

Broude, Norma. "Miriam Schapiro and 'Femmage': Reflections on the Conflict Between Decoration and Abstraction in Twentieth-Century Art." *Arts* 54, no. 6 (Feb.): 83–87.

Glueck, Grace. "Women Artists '80." *Art News* (Oct.).

———. "Art People." *The New York Times* (Mar. 9).

———. "Critics Choice." *The New York Times* (Apr. 19–25).

Larson, Kay. "For the First Time Women Are Leading, Not Following." *Art News* (Oct).

———. "Space Walk." *The Village Voice* (Feb. 25).

Perreault, John. "The Heart of the Matter." *The SoHo Weekly News* (Feb. 13): 22.

Raynor, Vivien. *The New York Times* (Feb. 8).

Tapley, George. *The New Art Examiner* (Feb. 25).

Tompkins, Calvin. "The Art World: Matisse's Armchair." *The New Yorker* (Feb. 25).

White, Claire Nicholas. "Schapiro's Femmage." *Art/World* (Feb. 15).

1979

Bradley, Paula. "Placing Women in History: Miriam Schapiro's Fan and Vestiture Series." *Arts* 53, no. 6 (Feb.): 8, 9.

Bongard, Willi. "Geht die Kunst Neu Wege? Pattern Painting." *Architektur und Wohnen* (May).

Buonagurio, Edgar. "Persistent Patterns." *Arts* 53, no. 41 (June).

"Froher Eindrock: seigeszug einer neuen Malerei aus neuen Malerei asu den USA, Pattern Painting." *Der Speigel* (June).

Kingsley, April. "Womanhood Is Powerful." *Village Voice* (Feb. 12).

Kuspit, Donald. "Betraying the Feminist Intention, the Case Against Feminist Decorative Art." *Arts* 54, no. 3 (Nov.).

Monteil, Annemarie. "Miriam Schapiro in Basel." *Basler Seitung* (May 17).

Perreault, John. "The New Decorativeness." *Portfolio* 1, no. 2 (June/July).

Rickey, Carrie. "Art of Whole Cloth." *Art in America* 67, no. 7 (Nov.): 78.

———. exh. review. *Artforum* 17 (Apr.).

———. "Decoration, Ornament, Pattern, and Utility." *Flash Art* (June/July).

Senie, Harriet. "Range from Geometry to Architecture." *The New York Post* (Feb. 24).

Stein, Judith, Robert Kushner, and Kim McConnell. "Letters to the Editor." Rebuttal of Kuspit's article. *Arts* 54, no. 4 (Jan.).

Szeeman, Harold. "Pattern and Decoration." *Du Magazine* (June).

1978

Meyer, Melissa, and Miriam Schapiro. "Waste Not, Want Not: Femmage." *Heresies* 1, no. 4 (winter 1977–78).

Perrone, Jeff. Review of "Pattern Painting." *Artforum* (Dec.).

1977

Askey, Ruth. "Miriam Schapiro's Paintings and Collages." *Art Week* (Mar.).

Glueck, Grace. "Women Artists 1550–1950." *The New York Times* (Sept. 29).

Kuspit, Donald. Interview with Miriam Schapiro. *Artforum* 65, no. 83 (Sept.).

Perreault, John. "The New Decorativeness." *SoHo Weekly News* (June 2).

———. "Issues in Pattern Painting." *Artforum* 16, no. 32 (Nov.).

"Reply to Lawrence Alloway." *Art in America* (Sept.).

Schapiro, Miriam. "At Long Last a Historical View of Art Made by Women." *Woman Art* (winter/spring 1977): 4–7.
———. "Canvassing our History." *Ms.* (July): 27–29.
Snyder, Joan. "The Great Debate: Lawrence Alloway and Miriam Schapiro on Women's Art at A.I.R." *Women Artists Newsletter* 2, no. 8 (Feb.).
Stofflet, Mary. "Miriam Schapiro." *Arts* 51, no. 12 (May).

1976
Alloway, Lawrence. "Women's Art in the Seventies." *Art in America* 64, no. 3 (May/June) 64–72.
Bourdon, David. "Decorative Is Not a Dirty Word." *The Village Voice* (Oct. 11).
Henry, Gerrit. "New York Reviews." *Art News* 75, no. 9 (Nov.).
Kaufman, Victoria Kogan. "Miriam Schapiro." *Visual Dialog* (Jan./Feb.).
Perrone, Jeff. "Approaching the Decorative." *Artforum* 15, no. 4 (Dec.).
Sieberling, Dorothy. "Lacy Fare." *New York Magazine* (July 12).
Stofflet, Mary. "The Shrine, the Computer and the Dollhouse." *Artweek* (Oct. 11).
Wilson, William. "Schapiro Gets Her Selves Together." *Los Angeles Times* (Apr. 21).

1975
Frankenstein, Alfred. "Catching up on the Visual Arts." *San Francisco Chronicle* (Oct. 11).
Henry, Gerritt. "New York Reviews." *Art News* 75, no. 9 (Nov.).
Orenstein, Gloria Feman. "Review Essay: Art History." *Signs* 1, no. 2 (winter).
Smith, Howard, and Brian Van Der Horst. "The Hirsute Cup: A Woman's Sensibility." *The Village Voice* (July 28).

1974
Marmer, Nancy. "Miriam Schapiro at Comsky." *Art in America* 62, no. 5 (Sept./Oct.)
Rose, Barbara. "Vaginal Iconography." *New York Magazine* (Feb. 11).

1973
Boice, Bruce. "Exhibition at the Emmerich Gallery." *Artforum* 12, no. 81 (Sept.): 80–81.
Frankenstein, Alfred. "Putting the MS in the Arts." *San Francisco Chronicle* (Jan.).
Marmer, Nancy. "Womanspace, a creative battle for equality in the Art world." *Art News* 72, no. 6 (June).
Nochlin, Linda. "Miriam Schapiro Recent Work." *Arts* 48, no. 38 (Nov.): 38–41.
Ratcliff, Carter. "Exhibition at the Emmerich Gallery." *Art International* 17 no. 63 (summer).
Raven, Arlene. "Woman's Art: The Development of a Theoretical Perspective." *Womanspace Journal* 1, no. 1 (Feb./Mar.).

1972
Burton, Sandra. "Bad Dream House." *Time* 99, no. 12 (Mar. 20).

1971
Feldman, Morton. "Give My Regards to Eighth Street." *Art in America* 59, no. 2 (Mar./Apr.).

1969
Campbell, Lawrence. "A Crash of Symbols: Miriam Schapiro at the Emmerich Gallery." *Art News* 68, no. 1 (Mar.).
Finkelstein, Louis. "Exhibition at the Emmerich Gallery." *Artforum* 7, no. 26 (Mar. 1).
Mellow, James. "Exhibition at the Emmerich Gallery." *Art International* 13, no. 56 (May).

1967
Ashton, Dore. "New Paintings at the Emmerich Gallery." *Studio* 174, no. 48 (July).
Rose, Barbara. "Abstract Illusionism." *Artforum* 6, no. 2 (Oct.).

1965
McDevitt, Jan. "Cloisonne." *Craft Horizons* (Nov./Dec.).

1963
Hess, Thomas. "The Phony Crisis in American Art." *Art News* (summer).
Rosenberg, Harold. "Toward a New Abstraction." *The New Yorker* (June 15).

1962
Ashton, Dore. "Art U.S.A." *Studio* 163, no. 90 (Mar.).

1961
Sandler, Irving. "Exhibit at the Emmerich Gallery." *Art News* 60, no. 13 (Dec.).

1960
Munro, Eleanor. "Exhibition of Paintings by Miriam Schapiro." *Art News* 58, no. 18 (summer).

1958
"First One Man Show at Emmerich Gallery." *Arts* 32, no. 53 (summer).

1957
Munro, Eleanor. "New Talent at the Museum of Modern Art." *Art News* 56, no. 11 (May).

1956
Finkelstein, Louis. "New Look: Abstract Impressionism." *Art News* 55, no. 38 (Mar.).

1955
de Kooning, Elaine. "Subject: What, How or Who." *Art News* 54, no. 29 (Apr.).
Ventura, Anita. "Exhibition of Paintings at the Stable Gallery." *Art Digest* 29, no. 6 (May).

1954
Ashton, Dore. "Exhibition of Abstract Paintings at the Tanager Gallery." *Art Digest* 28, no. 26 (May 15).
Campbell, Lawrence. *Art News* 53, no. 59 (May).

1952
"Exhibition of Paintings at the Tanager Gallery." *Art News* 51, no. 55 (Nov.).

UNPUBLISHED MATERIAL

1989
Duncan, Katherine Maxwell. "Miriam Schapiro: The Reconciliation of Art and Feminism." M.A. thesis, Florida State University.
McGinty, Katheryn. "Miriam Schapiro and the Language of Quilts." M.A. thesis, California State University, Long Beach.

1983
Bradly, Paula W. "Miriam Schapiro: The Feminist Transformation of an Avant-garde Artist." Ph.D. diss., University of North Carolina, Chapel Hill.

EXHIBITION CHRONOLOGY

Miriam Schapiro
Born: November 15, 1923, Toronto, Ontario, Canada

DEGREES

1949 M.F.A. State University of Iowa, Iowa City, IA
1946 M.A. State University of Iowa, Iowa City, IA
1945 B.A. State University of Iowa, Iowa City, IA

AWARDS AND HONORS

1995
Honorary Doctorate Degree, Moore College of Art, Philadelphia, PA
Honorary Doctorate Degree, Miami University, Oxford, OH

1994
Honors Award, New York State NARAL (twenty-fifth anniversary)
Honorary Doctorate Degree, Minneapolis College of Art and Design, Minneapolis, MN
Commencement Address, Minneapolis College of Art and Design, Minneapolis, MN
Honorary Doctorate Degree, Lawrence University, Appleton, WI
Convocation Address "The Democratization of Art," Lawrence University, Appleton, WI
Keynote, "A Philosopher's Stone: Radical Changes in Teaching," CAA Convocation Address, New York, NY

1993
Rockefeller Foundation Grant for artist's residency at the Bellagio Study and Conference Center, Bellagio, Italy

Commencement Address, Chicago Art Institute, Chicago, IL

1992
Honors Award, National Association of Schools of Art and Design (NASAD)

1989
Doctor of Fine Arts, California College of Arts and Crafts, Oakland, CA
Commencement Address, California College of Arts and Crafts, Oakland, CA

1988
Honors Award, The Women's Caucus for Art

1987
John Simon Guggenheim Memorial Foundation Fellowship
Commencement Address, Pennsylvania Academy of Art, Philadelphia, PA

1986
Commencement Address, Atlanta College of Art, Atlanta, GA

1985
National Endowment for the Arts, Panelist

1984
Women's Caucus for Art, Guest of Honor at National Conference, Toronto
University of South Florida, Graphic Workshop II
Djerassi Foundation Residency, Woodside, CA
Atlantic Center for the Arts, Residency—Master Class

1983
Doctor of Fine Arts, College of Wooster, Wooster, OH

1982
Skowhegan Medal for Collage

1981
Yaddo Residency

1976
National Endowment for the Arts, Fellowship
1964
Ford Foundation Grant—Lithography Workshop at Tamarind, Los Angeles, CA

SELECTED ONE-PERSON EXHIBITIONS

1999
"Miriam Schapiro: A Retrospective," curated by Thalia Gouma-Peterson
"Miriam Schapiro: Works on Paper, A Thirty Year Retrospective," curated and organized by Robert A. Yassin, Director, Tucson Museum of Art, Tucson, AZ

1998
"Miriam Schapiro: A Seamless Life," duPont Gallery, Washington and Lee University, Lexington, VA

1997
"Miriam Schapiro: A Woman's Way," National Museum of American Art, Smithsonian Institution, Washington, DC
"Miriam Schapiro: Collaged, Femmaged, Printed & Painted," Steinbaum Krauss Gallery, New York, NY
"Miriam Schapiro," Artforms Gallery, Philadelphia, PA

1996
"Miriam Schapiro: A Seamless Life," Sawhill Gallery, James Madison University, Harrisonburg, VA

1994
"Miriam Schapiro, Collaboration Series 1994: Mother Russia," Steinbaum Krauss Gallery, New York, NY

"Miriam Schapiro," West Virginia University, College of Creative Arts, Morgantown, WV

1993
"Miriam Schapiro," Twentieth Anniversary Celebration, A.R.C. Gallery, Chicago, IL

1992
"Miriam Schapiro," Fullerton College Art Gallery, Fullerton, CA
"Miriam Schapiro," Mendelson Gallery, Chicago, IL
"The Nature of Miriam Schapiro," Curfman Gallery, Colorado State University, Fort Collins, CO
"The Politics of the Decorative," Guild Hall Museum, East Hampton, NY

1991
"Collaboration Series: Frida Kahlo and Me," Bernice Steinbaum Gallery, New York, NY
"Miriam Schapiro," Brevard Art Center and Museum, Melbourne, FL
"A New Acquisition in Context," Miami University Art Museum, Oxford, OH

1990
"Miriam Schapiro," LewAllen/Butler Fine Art, Santa Fe, NM
"Miriam Schapiro, Works on Paper," Phyllis Rothman Gallery, Fairleigh Dickinson University, Madison, NJ
"The Mythic Pool," Bernice Steinbaum Gallery, New York, NY

1988
"Ragtime," Bernice Steinbaum Gallery, New York, NY

1987
"Miriam Schapiro," Simms Fine Art Gallery, New Orleans, LA
"Miriam Schapiro: Theatrics," Gibbes Art Gallery, Charleston, SC

1986
"I'm Dancin' as Fast as I Can," Bernice Steinbaum Gallery, New York, NY; Guilford College, Greensboro, NC
"Miriam Schapiro," Vered Gallery, East Hampton, NY
"Miriam Schapiro," Broadway Windows, New York University, New York, NY
"Miriam Schapiro: A Decade," Artlink Contemporary Artspace, Ft. Wayne, IN

1985
Appalachian State University, Boone, NC
"Femmages," Brentwood Gallery, St. Louis, MO

1984
Atlanta Center for the Arts, New Smyrna Beach, FL
Dart Gallery, Chicago, IL

1983
Barbara Gilman Gallery, Miami, FL
Kent State University, Kent, OH
Koplin Gallery, Los Angeles, CA
Marian Locks Gallery, Philadelphia, PA
Thomas Segal Gallery, Boston, MA

1982
Axiom Gallery, Victoria, Australia
Douglas Drake Gallery, Kansas City, KS
"The Heartist Series," David Heath Gallery, Atlanta, GA
Hodges Taylor Gallery, Charlotte, NC
"Invitation and Presentation," Barbara Gladstone Gallery, New York, NY

1981
"Miriam Schapiro, The Black Paintings," Barbara Gladstone Gallery, New York, NY
"Miriam Schapiro: Neue Bilder," Galerie Rudolf Zwirner, Cologne, Germany

1980
"The Heartist Series," Barbara Gladstone Gallery, New York, NY
Lerner-Heller Gallery, New York, NY
"Miriam Schapiro: A Retrospective, 1953–1980," College of Wooster Museum, Wooster, OH
"New Paintings, Chicago," Dart Gallery, Chicago, IL

1979
"An Approach to the Decorative," Gladstone-Villani, New York, NY; Lerner-Heller Gallery, New York, NY
"Anonymous Was a Woman," Center Gallery, Madison, WI
"Femmages," Davenport Municipal Art Gallery, Davenport, IA
Gallerie Liatowitsch, Basel, Switzerland
"Handkerchief Works," Douglas Drake Gallery, Kansas City, KS

1977
"Anatomy of a Kimono," "Apron," and "Handkerchief Series," Andre Emmerich Gallery, New York, NY
"Collaboration Series," Mitzi Landau Gallery, Los Angeles, CA
Fairbanks Gallery, State University of Oregon, Corvallis, OR
"Femmages," Oberlin College, Oberlin, OH

1976
Andre Emmerich Gallery, New York, NY
Mitzi Landau Gallery, Los Angeles, CA
"Selected Paintings–Woman Artist Series," Mabel Smith Douglass College Library, Douglass College, New Brunswick, NJ
"The Shrine, the Computer and the Dollhouse," University of Wisconsin at La Crosse, WI
"Works on Paper," A.R.C. Gallery, Chicago, IL; Douglas Drake Gallery, Kansas City, KS

1975
"The Shrine, the Computer and the Dollhouse," Mandeville Art Gallery, University of California at San Diego, CA; Mills College, Oakland, CA
"Works on Paper," Benson Gallery, Bridgehampton, NY; Comsky Gallery, Los Angeles, CA

1974
"Miriam Schapiro: New Paintings, A Cabinet for All Seasons," Comsky Gallery, Los Angeles, CA

1973
"Miriam Schapiro: New Work," Andre Emmerich Gallery, New York, NY

1971
Andre Emmerich Gallery, New York, NY

1969
"Recent Paintings by Miriam Schapiro," Andre Emmerich Gallery, New York, NY

1967
Andre Emmerich Gallery, New York, NY

1966
"Paintings by Miriam Schapiro: The Evolution of a Theme, 1952–1966," Lyman Allen Museum, New London, CT

1965
"Miriam Schapiro: Paintings, Collages, Prints," Franklin Siden Gallery, Detroit, MI

1964
Skidmore College, Saratoga Springs, NY

1963
"Miriam Schapiro: New Paintings," Andre Emmerich Gallery, New York, NY

1961
"Miriam Schapiro: Paintings and Drawings," Andre Emmerich Gallery, New York, NY

1960
Andre Emmerich Gallery, New York, NY

1958
"Miriam Schapiro: New York," Andre Emmerich Gallery, New York, NY

1951
Illinois Wesleyan University, Bloomington, IL
University of Missouri, Columbia, MO

SELECTED GROUP EXHIBITIONS

1998
"Gallery Artists," Steinbaum Krauss Gallery, New York, NY
"High Art/High Jinks in Contemporary Art," Foster Gallery, Museum of Fine Arts, Boston, MA
"The Legacy," Brevard Museum of Art and Science, Melbourne, FL
"Selections from SoHo: Steinbaum Krauss Gallery Artists," Fort Lewis College Art Gallery, Durango, CO

1997
"Art Patterns," Austin Museum of Art, Austin, TX
"Crossing the Threshold," Steinbaum Krauss Gallery, New York
"Expanding Expression: Berghoff-Cowden Editions," Polk Museum of Art, Lakeland, FL
"Female Artists from Graphic Studios," Polk Museum of Art, Lakeland, FL
"Hanging by a Thread," Hudson River Museum of Westchester, Yonkers, NY
"The Kimono Inspiration: Art and Art-to-Wear in America," The Parrish Art Museum, Southampton, NY
"Patchwork: Contemporary Interpretations of the Quilt Form," Islip Art Museum, East Islip, NY
"Real(ist) Women II," Northwood University, West Palm Beach, FL
"Wild Women Salon," Morgan Gallery, Kansas City, MO

1996
"Artists Portraits and Statements," Mabel Smith Douglass Library, Douglass and Cook Colleges, Rutgers University, New Brunswick, NJ
"Contemporary Printmaking in America: Collaborative Prints and Presses," National Museum of American Art, Washington, DC
"Gallery Artists, Summer Exhibition," Steinbaum Krauss Gallery, New York, NY
"Mother and Child: A Contemporary View," Arlene Bujese Gallery, East Hampton, NY
"25 Years of Feminism, 25 Years of Women's Art," Mary H. Dana Women Artist Series, 25th Anniversary Exhibition, Mason Gross School of the Arts, Rutgers University, New Brunswick, NJ
"Women's Work: A Century of Achievement in American Art," The Columbus Museum, Columbus, GA

1995
"About Faces," Santa Barbara Museum of Art, Santa Barbara, CA
"Contemporary Symbolism: Sacred & Profane," Arlene Bujese Gallery, East Hampton, NY
"Division of Labor: 'Women's Work' in Contemporary Art," The Bronx Museum of the Arts, NY; Museum of Contemporary Art, Los Angeles, CA
"Focus on Women: Women at the End of the 20th Century," The Cultural and Civic Center of Southampton, Southampton, NY
"Making Faces: American Portraits," The Hudson River Museum of Westchester, Yonkers, NY
"A Matter of Synthesis: Collage & Assemblage," Arlene Bujese Gallery, East Hampton, NY
"Skirting the Decorative," Harbor Gallery, University of Massachusetts, Boston, MA

1994
"Continuing Innovation: Contemporary American Quilt Art," Saint Mary's College, Moreau Galleries, Notre Dame, IN
"The Figure: Gallery Artists +2," Steinbaum Krauss Gallery, New York, NY
"Give Me Shelter," Saint Paul Companies, Minneapolis, MN
"House Sweet House," New Jersey Center for Visual Arts, Summit, NJ
"The Label Show: Contemporary Art & the Museum," The Museum of Fine Arts, Boston, MA
"Memories of Childhood . . . so we're not the Cleavers or the Brady Bunch," Steinbaum Krauss Gallery, New York, NY
"Pyramid Atlantic, Evolution of the Print, Fourteen Years of Collaboration," Addison/Ripley Fine Art, Washington, DC
"Town and Country," Museum of Modern Art Advisory Service for General Electric Corp., New York, NY
"A View of One's Own," Jane Voorhees Zimmerli Art Museum, Rutgers University, New Brunswick, NJ (inaugural exhibition of the National Association of Women Artists–N.A.W.A.)
"West Virginia Collects: Three Generations of American Art," Sunrise Art Museum, Charleston, WV

1993
"The Artist & the Quilt," Janice Charach Epstein Museum Gallery, Jewish Community Center of Metropolitan Detroit, Westbloomfield, MI
"Contemporary American Quilts," Crafts Council, London, England
"Dolls in Contemporary Art: A Metaphor of Personal Identity," Patrick & Beatrice Haggerty Museum of Art, Marquette University, Milwaukee, WI
"Establishing the Legacy," The National Museum of Women in the Arts, Washington, DC
"Gallery Artists," Steinbaum Krauss Gallery, New York, NY

"Look at the Book," Guild Hall Museum, East Hampton, NY
"Master Prints from the Rutgers Center for Innovative Printmaking," The Noyes Museum, Oceanville, NJ
"Women's Art, Women's Lives, Women's Issues," Tweed Gallery, New York, NY, and New York Commission on the Status of Women

1992
"The Edge of Childhood," The Heckscher Museum, Huntington, NY
"Floored Art," Steinbaum Krauss Gallery, New York, NY
"Master Prints: From the Rutgers Center for Innovative Printmaking, the First 5 Years," The Gallery at Bristol-Myers Squibb, Princeton, NJ
"Narrative Art," Vered Gallery, East Hampton, NY
"Parallel Visions: Modern Artists and Outsider Art," Los Angeles County Museum of Art, Los Angeles, CA
"Personages," Benton Gallery, Southampton, NY
"17th Annual West Art and the Law," West Publishing Company, St. Paul, MN

1991
"AIGA Annual," The American Institute of Graphic Arts, NY
"Art on Paper," Weatherspoon Art Gallery, Greensboro, NC
"Aspects of Collage," Guild Hall Museum, East Hampton, NY
"Collage Unglued," North Miami Museum, Center of Contemporary Art, North Miami, FL
"Crossing Over/Changing Places," The Print Club, Philadelphia, PA
"Designing Women," Rutgers Summerfest, Walters Hall Gallery, Douglass College, Rutgers, The State University of New Jersey, New Brunswick, NJ
"Gallery Selection 1991," LewAllen Gallery, Santa Fe, NM
"Graphicstudio: Contemporary Art from the Collaborative Workshop at the University of South Florida," National Gallery of Art, Washington, DC
"Invitational," Hebrew Home for the Aged at Riverdale, Riverdale, NY
"Presswork: The Art of Women Printmakers," The Lang Communications Corporate Collection, National Museum of Women in the Arts, Washington, DC
"Quilts in Context," Whyte Museum of the Canadian Rockies, Banff, Alberta, Canada
"Reprise," Phyllis Rothman Gallery, Fairleigh Dickinson University, Madison, NJ
"20th Year Visiting Artists Invitational Exhibition," CU Art Galleries, University of Colorado at Boulder, CO

1990
"Art and Fashion," Contemporary Arts Center, New Orleans, LA
"The Art of Fashion," Bernice Steinbaum Gallery, New York
"Art on Paper," Weatherspoon Art Gallery, Greensboro, NC
"The Complete Printmaker," Sylvan Cole Gallery, New York
"Contemporary Women, Works on Paper," Carnegie Museum of Art, Pittsburgh, PA
"Definitive Contemporary American Quilt Show," Bernice Steinbaum Gallery, New York
"East Hampton Avant Garde: A Salute to the Signa Gallery," Guild Hall Museum, East Hampton, NY
"In Bloom," Museum of Modern Art Advisory Service for Pfizer Corp., New York, NY
"Lines of Vision: Drawings by Contemporary Women," University of North Texas
"Paint, Print & Pedestal," LewAllen/Butler Fine Art, Santa Fe, NM
"Pattern & Decoration, Selections from the Roth Collection of Works on Paper," Polk Museum of Art, Lakeland, FL
"Prints of the Eighties," Guild Hall Museum, East Hampton, NY
"Quilting Partners," Northern Illinois Art Museum, Chicago, IL
"Season Celebration," Benton Gallery, Southampton, NY
"The Southeast Bank Collection," Norton Gallery of Art, West Palm Beach, FL

1989
"Art in Fashion," Alexandra Monett Fine Arts, New Orleans, LA
"Collage Assemblage and Construction," Vered Gallery, East Hampton, NY
"The Eloquent Object," Orlando Museum; Orlando, FL
"Lines of Vision," Hillwood Art Gallery, Long Island University, C.W. Post Campus, Greenvale, NY
"Making Their Mark: Women Artists Today: A Documentary Survey 1970–1985," Cincinnati Art Museum, Cincinnati, OH; The New Orleans Museum of Art, New Orleans, LA; The Denver Art Museum, Denver, CO; Pennsylvania Academy of Fine Arts, Philadelphia, PA
"Masters 4 Exhibition," Fine Arts Gallery, Long Island University, Southampton Campus, Southampton, NY
"Quilting Partners," São Paulo/Illinois Partners, Museu da Casa Brasileira, São Paulo, Brazil
"Selections From the Bernice Steinbaum Gallery," Axis Twenty, Inc., Atlanta, GA

1988
"Alice, and Look Who Else, Through the Looking Glass," Bernice Steinbaum Gallery, New York, NY
Anne Reed Gallery, Ketchum, ID
"Art and the Law," The American Bar Association meeting, Toronto, Canada
"Committed to Print," The Museum of Modern Art, New York, NY
"Drawing on the East End," The Parrish Art Museum, Southampton, NY
Elaine Benson Gallery, Bridgehampton, NY
"Extraordinarily Fashionable," Columbia Museum of Art, Columbia, SC
"The Feminine," Sherry French Gallery, New York, NY
"Figuration," Museum of Modern Art Advisory Service for General Electric Company, New York, NY
"Herstory: Women and the U.S. Constitution," Atlanta College of Art, Atlanta, GA
"Hothouse," Kohler Arts Center, Sheboygan, WI
"Just Like a Woman," Greenville County Museum of Art, Greenville, SC
"100 Women's Drawings," Hillwood Art Gallery, Long Island University, C.W. Post Campus, Greenvale, NY
"The Politics of Gender," Queensborough Community College Gallery, The City University of New York, Queens, NY
"Romance Is Back," Lintas New York/Lintas Worldwide, New York, NY
Vered Gallery, East Hampton, NY
Wilson Arts Center, The Harley School, Rochester, NY
"The Women's Caucus for Art 1988 Honor Awards Exhibition," Houston Museum of Fine Arts, Houston, TX

1987
"Art in Fashion/Fashion in Art," Bernice Steinbaum Gallery, New York, NY; Prichard Gallery, University of Idaho, Moscow, ID; The Nickle Arts Museum, The University of Calgary, Calgary, Alberta, Canada; Boston University Art Gallery, Boston, MA; Anderson Gallery, Virginia Commonwealth University, Richmond, VA; Bass Museum, Miami, FL; The Atlanta College of Art, Woodruff Arts Center, Atlanta, GA; Wustum Museum of Fine Arts, Racine, WI; Museum of Art, Munson–Williams–Proctor Institute, Utica, NY
"The Artist's Mother," The Heckscher Museum, Huntington, NY; National Portrait Gallery, Washington, DC
"Computers and Art," Everson Museum of Art, Syracuse, NY
"Contemporary American Collage 1960–1985," Herter Art Gallery, University of Massachusetts, Amherst; Benton Museum of Art, University of Connecticut, Storrs, CT; Lehigh University Gallery, Bethlehem, PA; Butler Institute of American Art, Youngstown, OH; Stedman Art Gallery, Rutgers University, Camden, NJ; Johnson Museum of Art, Cornell University, Ithaca, NY
"The Eloquent Object," Philbrook Museum of Art,

Tulsa, OK; The Oakland Museum, Oakland, CA; Museum of Fine Arts, Boston, MA; The Chicago Public Library Cultural Center, Chicago, IL; The Orlando Museum of Art, Orlando, FL; Virginia Museum of Fine Arts, Richmond, VA
"The Hamptons in Winter," Gallery International 52, New York, NY
"The Political Is Personal," NY Feminist Art Institute/ Women's Center for Learning, New York, NY
"Second Annual Invitational Exhibition," Benton Gallery, Southampton, NY
"39th Annual Purchase Exhibition Hassam and Speicher Fund," American Academy of Arts and Letters, New York, NY
"Whisper Project," collaboration with Suzanne Lacy, Minneapolis, MN
"The Years of Passage: 1969–1975," Fresno Art Center and Museum, Fresno, CA

1986
"After Matisse," Independent Curators, Inc., Queens Museum, Flushing, NY; Chrysler Museum, Norfolk, VA; Portland Museum of Art, Portland, ME; Bass Museum of Art, Miami Beach, FL; The Phillips Collection, Washington, DC; Dayton Art Institute, Dayton, OH; Worcester Art Museum, Worcester, MA
"American Art: American Women," Stamford Museum and Nature Center, Stamford, CT
"Artist's Choice," Tampa Museum, Tampa, FL
"Gold," Museum of Modern Art, New York, NY
"The Heroic Female: Images of Power," Ceres Gallery, New York, NY
"Let's Play House," Bernice Steinbaum Gallery, New York, NY
"The Watercolor Show," Elaine Benson Gallery, Bridgehampton, NY

1985
"Academy–Institute Purchase Exhibition," American Academy and Institute of Arts and Letters, New York, NY
"Adornments," Bernice Steinbaum Gallery, New York; Muscarelle Museum of Art, College of William and Mary, Williamsburg, VA; Prichard Gallery, University of Idaho, Moscow, ID; Amarillo Art Center, Amarillo, TX; The Tampa Museum, Tampa, FL; UWM Museum, Milwaukee, WI; Toledo Museum of Art, Toledo, OH; Wake Forest University, Winston–Salem, NC; Boca Raton Museum of Art, Boca Raton, FL; Hunter Museum of Art, Chattanooga, TN; Arkansas Art Center, Little Rock, AR; The Butler Institute of American Art, Youngstown, OH; Lamont Gallery, Phillips Exeter Academy, Exeter, NH
"American Baskets and Quilts: New Forms from Old Traditions," Woodmere Art Museum, Philadelphia, PA
"American Women in Art: Works on Paper," Midmarch Associates, New York, NY; Nairobi, Kenya; and US tour
"The Artist & the Quilt," Textile Museum, Washington, DC
"The Artist & the Quilt Companion Exhibit," Bradley University, Peoria, IL
"Artists Choose Artists," East Hampton Center for Contemporary Art, East Hampton, NY
"Collaboration Works: Women in Art," DeLand Museum of Art, DeLand, FL
"Collage: The State of the Art," Bergen Museum of Arts and Science, Paramus, NJ
"Costumes," Bette Stoler Gallery, New York, NY
"The Doll Show: Artists' Dolls and Figurines," Hillwood Art Gallery, Long Island University, C.W. Post Campus, Greenvale, NY
"East Hampton Star 100th Anniversary Portfolio," Guild Hall Museum, East Hampton, NY
"Letters," Hillwood Art Gallery, Long Island University, C.W. Post Campus, Greenvale, NY
"The New Culture, Women Artists of the Seventies," University of Akron Art Gallery, Akron, OH; Truman Gallery, Indiana State University, Terre Haute, IN
"100th Anniversary Benefit Exhibition," Independent Curators, Inc., New York, NY
"Palladium Guerrilla Girl Exhibition," Palladium, New York, NY
"Ten Years Later, a look at the effects on recent works of a collaboration beginning ten years

ago between contemporary women artists and traditional quiltmakers," Wallace Wentworth Gallery, Washington, DC

1984
"Art and the Law," West Publishing, St. Paul, MN
"Black and White Bal Mask," Newport Harbor Art Museum, Newport Beach, CA
"The Decorative Continues," Pam Adler Gallery, New York, NY
"The Fabric of Ornamentalism," The Bruce Museum, Greenwich, CT
"Fascher," Neue Staatsgalerie, Stuttgart, Germany
"Fiber Crosscurrents," Michael Kohler Art Center, Sheboygan, WI
"Humanism: An Undercurrent," University of South Florida, Tampa, FL
"Major Contemporary Women Artists," Suzanne Gross Gallery, Philadelphia, PA
"The New Culture: Women Artists of the '70s," State University of New York, Cortland, NY
"Olympiad," Coplin Gallery, Los Angeles, CA
"17th Annual Artists of the Springs Invitational Exhibition," East Hampton, NY
"Skowhegan Exhibition," Hirschl & Adler Gallery, New York, NY
"Staged/Stages," Bernice Steinbaum Gallery, New York; Kilcawley Center, Youngstown State University, Youngstown, OH; Sarah Campbell Blaffer Gallery, University of Houston, Houston, TX; USF Art Galleries, University of South Florida, Tampa, FL; Freedman Gallery, Albright College, Reading, PA; Brunnier Gallery Museum, Iowa State University, Ames, IA; Pensacola Museum of Art, Pensacola, FL; Joan Whitney Payson Gallery, West Brook College, Portland, ME; Lamont Gallery, Phillips Exeter Academy, Exeter, NH; University Gallery, Ohio State University, Columbus, OH; University Art Gallery, California State University, Long Beach, CA; College of Wooster, Wooster, OH
"Stuff and Spirit: The Art and Craft Media," Twining Gallery, New York, NY
"Women Artist Series," Mabel Douglass Smith Library, Rutgers University, New Brunswick, NJ
"Women Part I," Sidney Janis Gallery, New York, NY
1983
"The Artist & the Quilt," Marion Koogler McNay Art Museum, San Antonio, TX; The Arts Council, Winston-Salem, NC; Jane Voorhees Zimmerli Art Museum, Rutgers University, New Brunswick, NJ; Herron Art Gallery/Indianapolis Art League, Indianapolis, IN; Huntington Gallery, Huntington, WV; Columbus Art Museum, Columbus, OH; Textile Museum, Washington, DC; Pratt Manhattan Gallery, New York, NY
"Artists in the Historical Archives of the Women's Inter Art Center of New York City," Philadelphia College of Art Gallery, Philadelphia, PA
"At Home," Long Beach Museum of Art, Long Beach, CA
"Back to the USA," Kuntsmuseum, Lucerne, Switzerland; Rheinisches Landesmuseum, Bonn, Germany; Wurternbergischer Kunstverein, Stuttgart, Germany
Bard College, Annandale-on-Hudson, NY
"Black and White Bal Masque," Newport Harbor Art Museum, Newport Beach, CA
"Brave New Works," Museum of Fine Arts, Boston, MA
"Collector's Gallery XVIII," Marion Koogler Art Museum, San Antonio, TX
"The Decorative Continues," Pam Adler Gallery, New York, NY
"Exchange of Sources: Expanding Powers," California State College, Stanislaus, Turlock, CA
"Fascher," Neue Staatsgalerie, Stuttgart, Germany
"Habitats," Klein Gallery, Chicago, IL
"Humanism—An Undercurrent," University of South Florida, Tampa, FL
"Komposition Im Halbrund," Staatsgalerie, Stuttgart, Germany; Museum Bellrive, Zurich, Switzerland
"A Love Story," Just Above Midtown Downtown, New York, NY
"Major Women Artists," Suzanne Gross Gallery, Philadelphia, PA
"Miriam Schapiro and Joyce Kozloff," Barbara Gilman Gallery, Miami, FL

"The New Culture: Women Artists of the '70s," Ruth E. Dowd Gallery, State University of New York at Cortland, NY
"New Decorative Art," Berkshire Museum, Pittsfield, MA
"New Decorative Works: Collection of Norma and William Roth," Loch Haven Art Center, Orlando, FL
"New Directions for the Michener Collection," Huntington Gallery, The University of Texas at Austin, TX
"Olympiad," Koplin Gallery, Los Angeles, CA
"1 + 1 = 2," Bernice Steinbaum Gallery, New York, NY
"Opening Exhibition," Fabric Workshop, New York, NY
"Ornamentalism: The New Decorativeness in Architecture and Design," Hudson River Museum, Yonkers, NY
"Printed by Women: National Exhibition of Photographs and Prints," Port of History Museum, Penn's Landing, Philadelphia, PA
"Skowhegan Celebration Exhibition," Hirschl & Adler Gallery, New York, NY
"Stuff and Spirit: The Arts and Crafts Media," Twining Gallery, New York, NY
1982
"The Americans: Collage 1950–1982," Contemporary Arts Museum, Houston, TX
"Nature as Image and Metaphor," Judith Christian Gallery, New York, NY
"Stroke/Line/Figure," Gimpel Fils, Ltd., London
Sydney Biennial, Sydney, Australia
"Women's Art, Miles Apart," Aaron Berman Gallery, New York, NY; Valencia Community College, Orlando, FL
1981
"Alive at the Parrish," Parrish Art Museum, Southampton, NY
"College Union Collection of Contemporary Art—New Acquisitions," Wake Forest University, Winston-Salem, NC
"Currents: The New Mannerism," Jacksonville Art Museum, Jacksonville, FL
"Exhibition of Morton G. Neumann Family Collection," Chicago Art Institute, Chicago, IL
"Fiber in Collusion," University Art Gallery, University of North Dakota, Grand Forks, ND; Banff Centre, Alberta, Canada
"Five on Fabric," Laguna Gloria Art Museum, Austin, TX
"Home Work," sponsored by CAPS, Women's Hall of Fame, New York, NY
"Insights," The New Gallery of Contemporary Art, Cleveland, OH
"Islamic Allusion," Alternative Museum, New York, NY
"Museum Choice," Loch Haven Art Center, Orlando, FL
"The New Decorative Movement," Hodgell Hartman Gallery, Sarasota, FL
"Patterning and Decoration," McIntosh/Drysdale Gallery, Washington, DC
"Retrospective Show—Women Artist Series," Douglass College, Rutgers University, New Brunswick, NJ
Thomas Segal Gallery, Boston, MA
"Typisch Frau," Bonner Kunstverein and Galerie Philomene Magers, Bonn; Stadtisches Museum, Regensburg, Germany
"Women and Art," Suzanne Brown Gallery, Scottsdale, AZ
1980
"All That Glitters," Marilyn Pearl Gallery, New York, NY
"Beauty and the Board Room, Kansas City Businesses Collect Art," University of Missouri, Kansas City Gallery of Art, Kansas City, MO
"Decade, Los Angeles Painting in the Seventies," Art Center College of Design, Pasadena, CA
"Decorative Fabrications," Virginia Museum, Richmond, VA
"Drawings to Benefit the Foundation for Contemporary Performance Arts, Inc." Leo Castelli Gallery, New York, NY
"Fabric into Art," College at Old Westbury, State University of New York, Old Westbury, NY
"Femmages," Muse Gallery, Philadelphia, PA

"Glitter," Kathryn Markel Gallery, New York, NY
"Great Lakes Colleges Association Artist Sponsors Exhibition," Ohio Wesleyan University, Delaware, OH
"Les Nouveaux Fauves di Neuen Wilden," Ludwig Museum, Aachen, Germany
Modern Art Gallerie, Vienna, Austria
"New Work? New York," Delahunty Gallery, Dallas, TX
"Originals," Graham Gallery, New York, NY
"Painting and Sculpture Now," Indianapolis, IN
"Pattern," Collegiate School, New York, NY
"Pattern Painting/Decoration Art," Galerie Krinzinger, Innsbruck, Austria
"R.O.S.C. 1980: The Poetry of Vision," University College, Dublin, Ireland
"25th Annual Contemporary American Painting," Lehigh University, Lehigh, PA
1979
"The Decorative Impulse," Institute of Contemporary Art, University of Philadelphia, PA
"Feministische Kunst Internationaal," Gemeentemuseum Haags, The Netherlands, eight museums in The Netherlands
"Pattern and Decoration," Sewall Art Gallery, Rice University, Houston, TX
"Pattern on Paper," Gladstone/Villani Gallery, New York, NY
"Pattern Space: The Second through the Fourth Dimension," Jacksonville, FL
"Persistent Patterns," Andre Zarre Gallery, New York, NY
"Recent Work by Artists of the Fabric Workshop," Marion Locks Gallery, Philadelphia, PA
"Women Artists in Washington Collections," University of Maryland, College Park, MD
1978
"Patterning Painting," Palais des Beaux Arts, Brussels, Belgium
1977
"Collage," Bard College, Annandale-on-Hudson, NY
"Consciousness and Content," Brooklyn Museum Art School, Brooklyn, NY
"Hi Mom, What's New," Norton Gallery of Art, West Palm Beach, FL
"Pattern Painting," P.S. 1, Long Island City, NY
"Patterning and Decoration," The Museum of the American Foundation for the Arts," Miami, FL
"Selected Paintings," Mulvane Art Center, Topeka, KS
"Ten Approaches to the Decorative," Allesandra Gallery, New York, NY
1976
"American Artists '76: A Celebration," Marion Koogler McNay Art Institute, San Antonio, TX
"Artists of East Hampton, 1850–1976," Guild Hall Museum, East Hampton, NY
"Contemporary American Painting," Lehigh University, Bethlehem, PA
"118 Artists," Landmark Gallery, New York, NY
1975
"American Women Printmakers," University of St. Louis, St. Louis, MO
"Artists of the Hamptons," Guild Hall Museum, East Hampton, NY
"Collage and Assemblage in Southern California," Los Angeles Institute of Contemporary Art, Los Angeles, CA
"Women Artists Here and Now," Ashwagh Hall, Springs, NY
1974
"The Audacious Years 1961–1971," Newport Harbor Art Museum, Newport Beach, CA
"Quilts," Mount St. Vincent University Museum, Halifax, Nova Scotia, Canada
"Then and Now (Artists of the Region)," Guild Hall Museum, East Hampton, NY
"Women's Work—American Art '74," Philadelphia Civic Center Museum, Philadelphia, PA
1973
"Female Sexuality/Female Identity," Womanspace, Los Angeles, CA
"14 Women," University Art Gallery, University of North Dakota, Grand Forks, ND
"The Four," de Saisset Art Gallery, University of Santa Clara, Santa Clara, CA
"New Acquisitions," University Art Museum, Berkeley, CA

1972

"American Women: Twentieth Century," Lake View Center for the Arts and Sciences, Peoria, IL

"21 Artists—Invisible/Visible," Long Beach Museum of Art, Long Beach, CA

"Womanhouse," Los Angeles, CA

1971

"Tamarind: A Renaissance in Lithography," International Exhibition Foundation, Los Angeles, CA

"Twentieth-Century Painting from the New York University Collection," Hudson River Museum, Yonkers, NY

"Women in the Collection of the Whitney Museum," Whitney Museum of American Art, New York, NY

1969

"An Exhibition of Contemporary American Drawings," Fort Worth Art Center, Fort Worth, TX

"New Acquisitions," Whitney Museum of American Art, New York, NY

"Paul Brach and Miriam Schapiro," Newport Harbor Art Museum, Newport Beach, CA; La Jolla Museum of Art, La Jolla, CA

1967

"Brach, Harrison, LewAllen, Rifat, Schapiro," John Muir College, University of California, San Diego, CA

"Contemporary American Painting and Sculpture, 1967," University of Illinois, Urbana, IL

"International Selection 1967," Dayton Art Institute, Dayton, OH

"180 Beacon Collection: '67 Group," Boston, MA

1965

"Contemporary American Painting and Sculpture 1965," University of Illinois, Urbana, IL

"New Prints," Museum of Modern Art, New York, NY

"One Hundred Contemporary American Drawings," University of Michigan Museum of Art, Ann Arbor, MI

1964

"Recent American Drawings," The Rose Art Museum, Brandeis University, Waltham, MA

1963

"American Prints from the Hilton at Rockefeller Center," Whitney Museum of American Art, New York, NY

"New Directions in American Painting," Poses Institute of Fine Arts, Brandeis University, Waltham, MA

"Symbolist Legacy," Contemporary Art Association, Houston, TX

"Toward a New Abstraction," The Jewish Museum, New York, NY

1962

"65th Annual American Exhibition," The Art Institute of Chicago, Chicago, IL

1962–64

"Museum of Modern Art Traveling Show; Abstract Drawings and Watercolors, U.S.A.," United States and Latin America

1961

"Contemporary American Painting and Sculpture," University of Illinois, Urbana, IL

"64th Annual American Exhibition," The Art Institute of Chicago, Chicago, IL

1959

"Annual Exhibition," Whitney Museum of American Art, New York, NY

"The Fifth International Art Exhibition of Japan," American selection, The American Federation of Arts, traveled to nine cities in Japan

1958

"The 1958 Bicentennial International Exhibition of Contemporary Painting and Sculpture," Carnegie Institute, Pittsburgh, PA

1957

"New Talent Exhibition," Museum of Modern Art, New York, NY

1955

"Seventeen Contemporary Paintings," The University of Florida, Gainesville, FL

1952–1955

"1st, 2nd, 3rd, 4th Annual Exhibition," Stable Gallery, New York, NY

1951

"Fifth National Print Annual Exhibition," Brooklyn Museum, Brooklyn, NY

1950

St. Louis City Art Museum, St. Louis, MO (print show)

1949

Brooklyn Museum, Brooklyn, NY (print show)

"A New Direction in Intaglio," Walker Art Center, Minneapolis, MN; Colorado Springs Fine Art Center, Colorado Springs, CO

1948

Denver Art Museum, Denver, CO (print show)

University of Indiana, Bloomington, IN (print show)

1947

Brooklyn Museum, Brooklyn, NY (print show)

MAJOR COMMISSIONS

1991 *Opening Night*, painting, Pasquerilla Performing Arts Center, Johnstown, PA

1989 *Eden*, fan, Marriot Hotel, San Francisco, CA

1987 *Anna and David*, sculpture, 1525 Wilson Boulevard Building, Rosslyn, VA

1984 *Four Matriarchs*, stained-glass windows, Temple Sholom, Chicago, IL

1980 *Scherzo*, Acrylic on canvas, Orlando Airport, Orlando, FL

SELECTED PUBLIC COLLECTIONS

Albion College, Albion, MI

Allen Memorial Art Museum, Oberlin, OH

Amstar Corporation, New York, NY

Art Gallery of New South Wales, Sidney, New South Wales, Australia

Associates in the Arts Co., Oradell, NJ

Avco, Newport Beach, CA

Bank of America, Spring St., Los Angeles, CA

Bates Fabric, New York, NY

Best Products, Ashland, VA

Brevard Art Center, Melbourne, FL

Brooklyn Museum of Art, Brooklyn, NY

Colgate University, Hamilton, NY

Guild Hall Museum, East Hampton, NY

Harvard University Fogg Art Museum, Cambridge, MA

Hirshhorn Museum and Sculpture Garden, Washington, DC

Hunter Museum of Art, Chattanooga, TN

I.B.M., Atlanta, GA

Illinois Wesleyan University, Bloomington, IL

The Israel Museum, Tel Aviv, Israel

Jane Voorhees Zimmerli Art Museum, Rutgers University, New Brunswick, NJ

The Jewish Museum, New York, NY

John Muir College, University of California at San Diego, CA

Kalamazoo Institute of Fine Arts, Kalamazoo, MI

Leusiana Museum, Denmark

Martin Foundation, New York, NY

Metropolitan Museum of Art, New York, NY

Miami University Art Museum, Oxford, OH

Mills College, Oakland, CA

Milwaukee Art Museum, Milwaukee, WI

Minneapolis Institute of Art, Minneapolis, MN

Missoula Museum of the Arts, Missoula, MT

Mulvane Art Center, Topeka, KS

Muscarelle Museum of Art, College of William and Mary, Williamsburg, VA

Museum of Contemporary Art, San Diego, CA

Museum of Fine Arts, Boston, MA

Museum of Modern Art, New York, NY

Nathan D. Rosen Museum Gallery, Adolph & Rose Levis Jewish Community Center, Boca Raton, FL

National Gallery of Art, Washington, DC

National Museum of American Art, Smithsonian Institution, Washington, DC

National Museum of Women in the Arts, Washington, DC

Neuberger Museum, State University of New York, Purchase, NY

Newark Museum, Newark, NJ

Newport Harbor Art Museum, Newport Beach, CA

New York Hilton Hotel, New York, NY

New York University Permanent Collection, New York, NY

Orlando Museum of Art, Orlando, FL

Parrish Museum, Southampton, NY

Pensacola Museum, Pensacola, FL

Peter Ludwig Collection, Aachen, Germany

Polk Museum of Art, Lakeland, FL

Prudential Insurance Collection, NJ

Rockwood Computer Corporation, New York

Santa Barbara Museum of Art, Santa Barbara, CA

Security Pacific Bank, Los Angeles, CA

Stanford University Hospital, Palo Alto, CA

Stephens College, Columbus, MO

St. Louis City Art Museum, St. Louis, MO

Tougaloo College, Tougaloo, MS

University Art Museum, Berkeley, CA

University of California, Santa Cruz, CA

University of Iowa Art Museum, Iowa City, IA

Wake Forest University, Winston–Salem, NC

Whitney Museum of American Art, New York, NY

Williams College Museum of Art, Williamstown, MA

Worcester Art Museum, Worcester, MA

Yale University, New Haven, CT